ALL YOU NEED IS LOVE

The complete story of The Beatles historical performance highlighting the first-ever live global satellite broadcast.

EDITORIAL BY PAUL SKELLETT AND SIMON WEITZMAN

DESIGN AND ILLUSTRATION BY PAUL SKELLETT

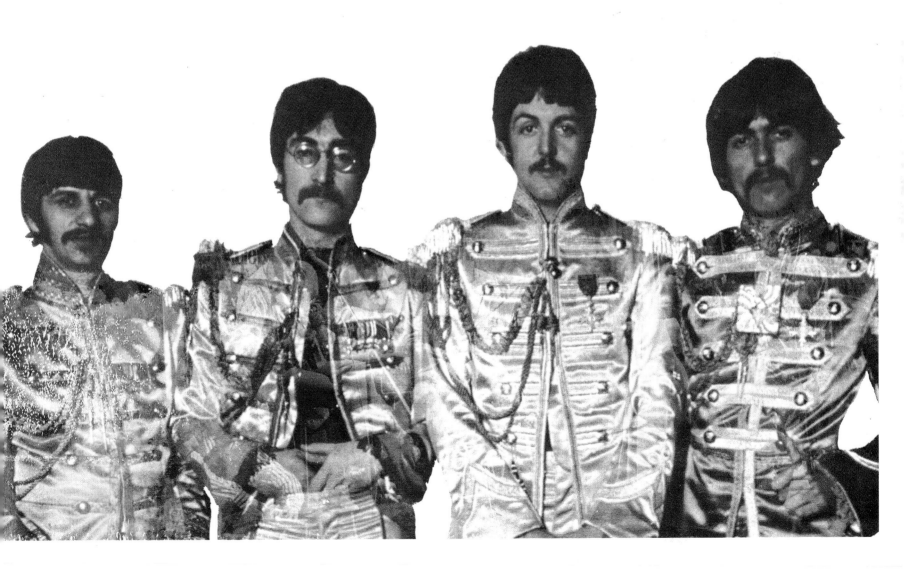

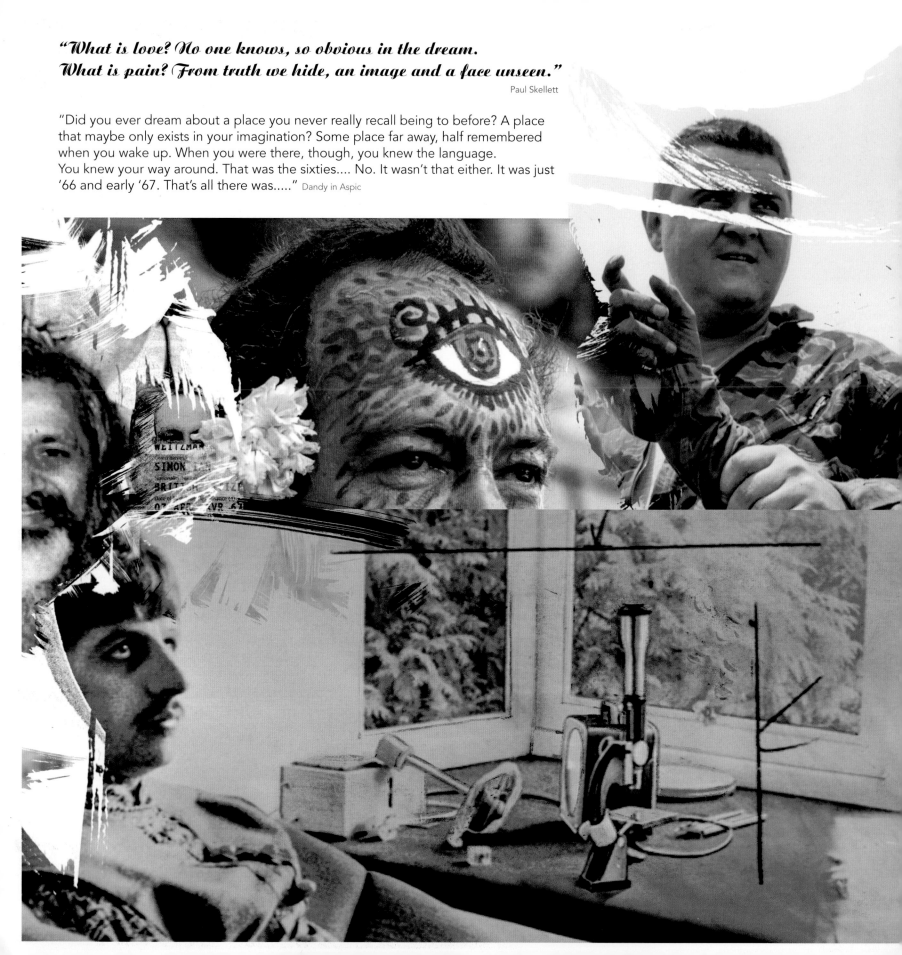

"*What is love? No one knows, so obvious in the dream.*
What is pain? From truth we hide, an image and a face unseen."

Paul Skellett

"Did you ever dream about a place you never really recall being to before? A place that maybe only exists in your imagination? Some place far away, half remembered when you wake up. When you were there, though, you knew the language. You knew your way around. That was the sixties.... No. It wasn't that either. It was just '66 and early '67. That's all there was....." Dandy in Aspic

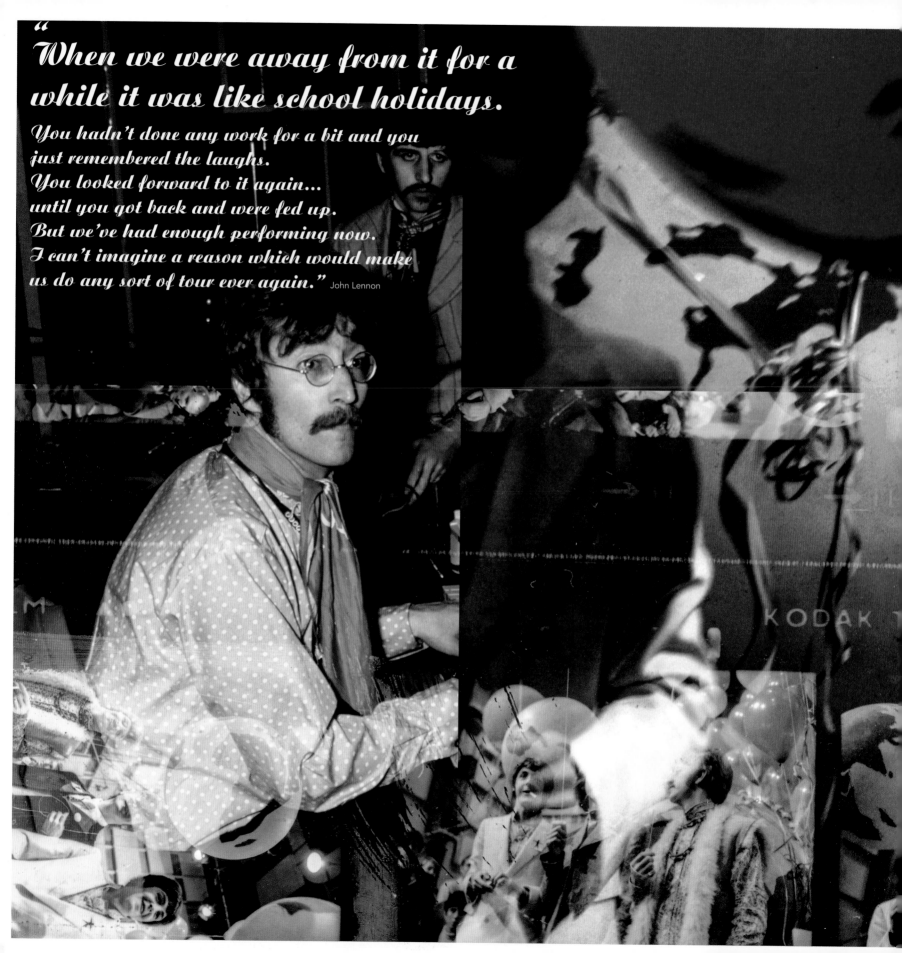

"**When we were away from it for a while it was like school holidays.**
You hadn't done any work for a bit and you just remembered the laughs.
You looked forward to it again... until you got back and were fed up.
But we've had enough performing now.
I can't imagine a reason which would make us do any sort of tour ever again." John Lennon

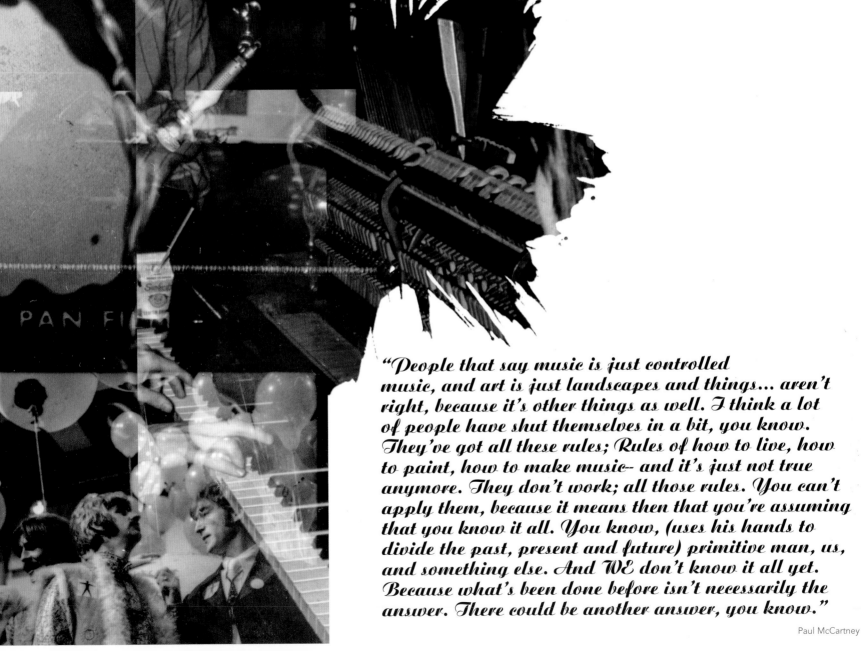

"*People that say music is just controlled music, and art is just landscapes and things... aren't right, because it's other things as well. I think a lot of people have shut themselves in a bit, you know. They've got all these rules; Rules of how to live, how to paint, how to make music-- and it's just not true anymore. They don't work; all those rules. You can't apply them, because it means then that you're assuming that you know it all. You know, (uses his hands to divide the past, present and future) primitive man, us, and something else. And WE don't know it all yet. Because what's been done before isn't necessarily the answer. There could be another answer, you know.*"

Paul McCartney

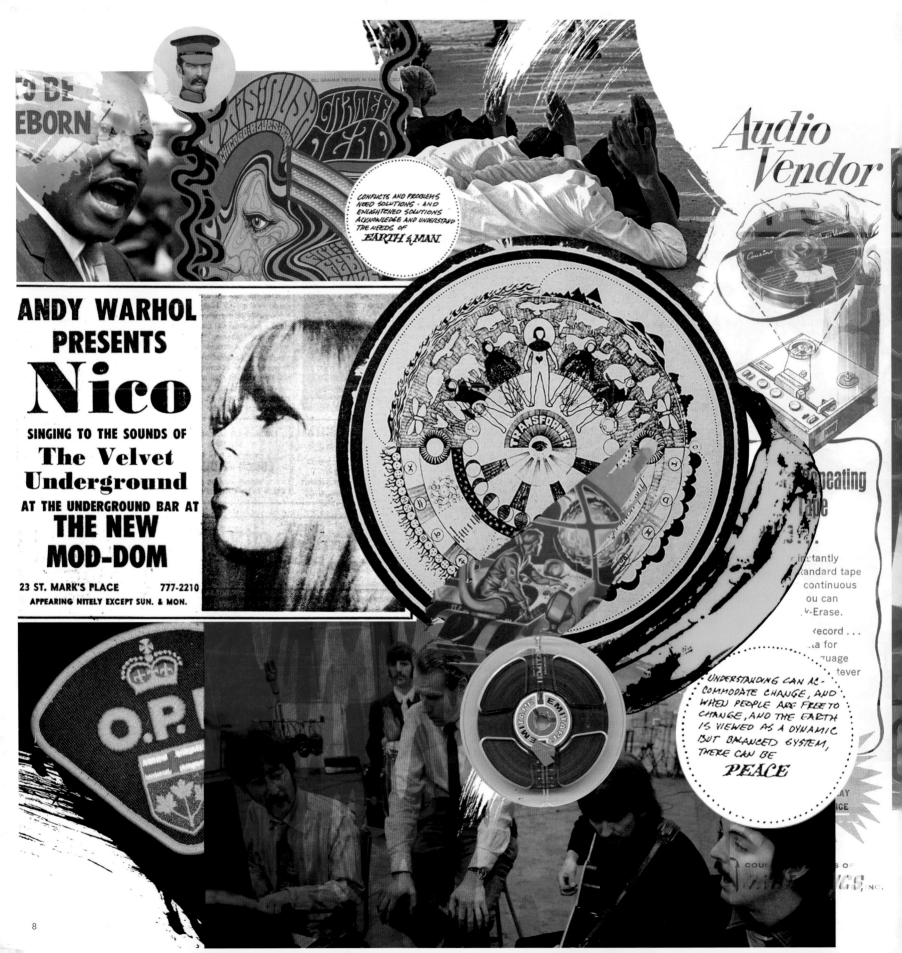

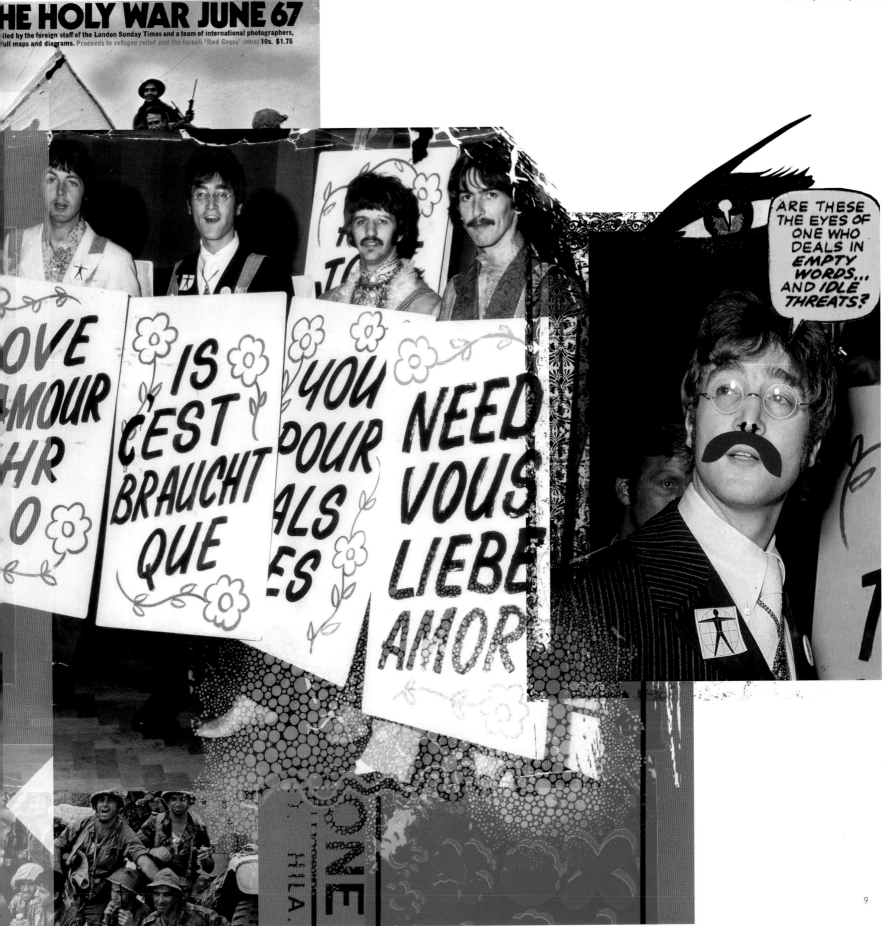

"Out here on the perimeter there are no stars, out here we is stoned, immaculate."

Jim Morrison

With an audience of 400 million people throughout 30 countries, The Beatles live performance of 'All You Need is Love' during the worlds first global satellite transmission is a defining moment in human communication, in a period of social revolution, spiritual realisation and abstract projection that would influence art and technology for generations to come. Welcome to 1967, the year of polarising politics, beliefs, lifestyle and social reinvention.

"The picture of the world's greatest superpower killing or seriously injuring 1,000 non combatants a week while trying to pound a tiny backward nation into submission on an issue whose merits are hotly disputed, is not a pretty one."

Martin Luther King, Jr., civil rights, anti-poverty, and antiwar activist, 1967

The Beatles performance on June 25, 1967, was unique but not wholly accepted as a success by the general public. The old guard decried that its transmission was a stain on the character of our proud nation. The song, penned by Lennon only days before climaxed with a menagerie of backing vocals supplied by what The Beatles believed to be influential rock 'n' roll royalty, it was basically their mates. Those in attendance were Mick Jagger, Marianne Faithfull, Keith Richard, Keith Moon, Eric Clapton, Pattie Harrison, Jane Asher, Mike McCartney, Graham Nash, Gary Leeds, Hunter Davies, Terry Condon, Allistair Taylor and Brian Epstein. The problem was that 'the straights' considered these individuals a lesser breed compared to other nations celebrity output, for example the entrepreneurial artist Pablo Picasso.

A memo unearthed from the clutches of 'the man (BBC)' via the freedom of information act quotes;

"This country has produced something more meritorious and noteworthy than The Beatles (much as I admire them); We did not do ourselves justice; Have wenothing better to offer? Surely this isn't the image of what we are like. What a dreadful impression they must have given the rest of the world; We flaunted The Beatles as the highlight of British culture, no wonder we have lost our image in the eyes of the world; "After all the culture etc shown by the other countries, The Beatles were the absolute dregs (incidentally I am a Beatles fan), no wonder people think thing we are going to the dogs!"

Tomorrow never knows
by *Paul Skellett*

TURN ON, TUNE IN, DROP OUT

With a huge investment of time and money by the BBC, a period of 10 months planning involving 14 countries, the BBC could not been seen to have a sour face post broadcast. On July 3, 1967, the BBC wrote to Brian Epstein, reporting that the performance had been highly regarded by both the BBC and the British audience. Good, bad or indifferent, The Beatles appearance, and their performance of a song that has become a contemporary hymn ushering in the most beautiful, idyllic and necessary of human emotions, all be it a little naive, is the only remaining memory most people have of the whole technological stride into the future.

We have to remember this was a first, the first global satellite broadcast. Most of us can barley remember the world without mobile phones that have the ability to not only make calls but they contain a myriad of Apps that are more technologically advanced than the 'moon landing'. It's incredible to think that The Beatles during '66 were given the first portable tape recorders. I often wonder what the lads would have thought about having the equivalent of the most advanced recording studio in your phone. I still maintain that analogue has a magical 'hands on' quality. I call it organic recording.

The Beatles signed the contract for the 'Our World' gig on the 19th of May and the announcement was made to the world on the 22nd.

Leading up to the event the Beatles took it all in their stride, as they did with pretty much everything, it was just another 'gig', something to worry about closer to the time. In the wake of "Sgt Pepper" new creative techniques and continuing their personal journeys far beyond the doors of working class perception, they continued to experiment as they recorded.

Prior to recording the foundations of 'All You Need is Love' they were busy falling down the studio rabbit hole, composing and recording the bizarre 'You know my name (Look up my number)'. George was busy expanding his writing merits by continuing sessions of 'It's all to much'.

On June the 14th, with a realisation that the performance was just around the corner, The Beatles entered Olympic Sound Studios on Church Road in Barnes, London to begin "All You Need is Love". Geoff Emerick states that he wasn't even sure that any preparation had been done prior to entering the studio. This was the only time that the Beatles had been subjected to a brief.

The BBC had specified that the song had to be simple so that it could be appreciated by all nationalities, a true international affair. Paul had put forward the proposition that his composition of "Hello Goodbye" should be considered, but the band opted for John's hastily penned "All You Need is Love".

The recording process began with the structuring of a basic rhythm track, John on harpsichord, Paul on a double-bass, bow in hand, and George attempted violin for the first time. Rhythm on this track was crucial, so Ringo, as always, was seated behind the cymbals and skins. With creativity at an all time high, The Beatles had become so left-field in their thinking whilst in the studio that even mistakes or recording anomalies became a creative opportunity.

Tape operator George Chkiantz accidentally made an unusual sound on the tape, rather than be annoyed by the inconvenience, The Beatles decided to highlight the sound and even asked for it to be spliced as a repeating audio effect throughout the track.

It's no secret that the 'crafting' of The Beatles work had become sloppy. Gone were the days were John and Paul would painstakingly carve out every chord, note or word. At the end of the session they did a four track to four track mix down, even George Martin commented on how little care had been taken.

33 takes were recorded during this first session with a tape reduction of Take 10 considered to be the best. It would take a following four sessions to produce a final piece. On the 19th, now back in studio 3 at the EMI (Abbey Road) Studios with George Martin as Producer, Geoff Emerick as Engineer 1 and Richard Lush as Engineer 2, overdubbing of lead and backing vocals was undertaken with John also recording a banjo track and George Martin on piano.

On the 21st of June re-mixes of the Olympic Sounds Studio rhythm tracks were created with an acetate being cut for Derek Burrell Davis, the director of the BBC outside broadcast team, to use on the 25th. Friday the 23rd was the day that the orchestra was introduced to the track. Saturday the 24th of June, the eve of the event is upon them. This session consisted of The Beatles inviting a press call of over 100 journalists and photographers. This photo opportunity consumed most of the morning. Between 2 and 4pm there was a rehearsal with the BBC orchestra. After this a decision was made to alter parts of the rhythm track due to the fact that on this same day it had been decided that "All You Need is Love" would be released as a single after the broadcast.

The event would equate to roughly an audience of 400 million people.

This would be the first time that humankind would get the opportunity to gaze upon its own species and its diversity in real time, linking five continents. From Canberra to Moscow, from Montreal to Takamatsu and Tunis, the realisation that the world would observe the cutting of the next Beatles single opened the gateway to nerves. It was time to make it happen.

Sunday the 25th of June 1967. Geoff Emerick described the day as

"Horrendous"

From an engineers perspective the day began and ended in hectic technical chaos

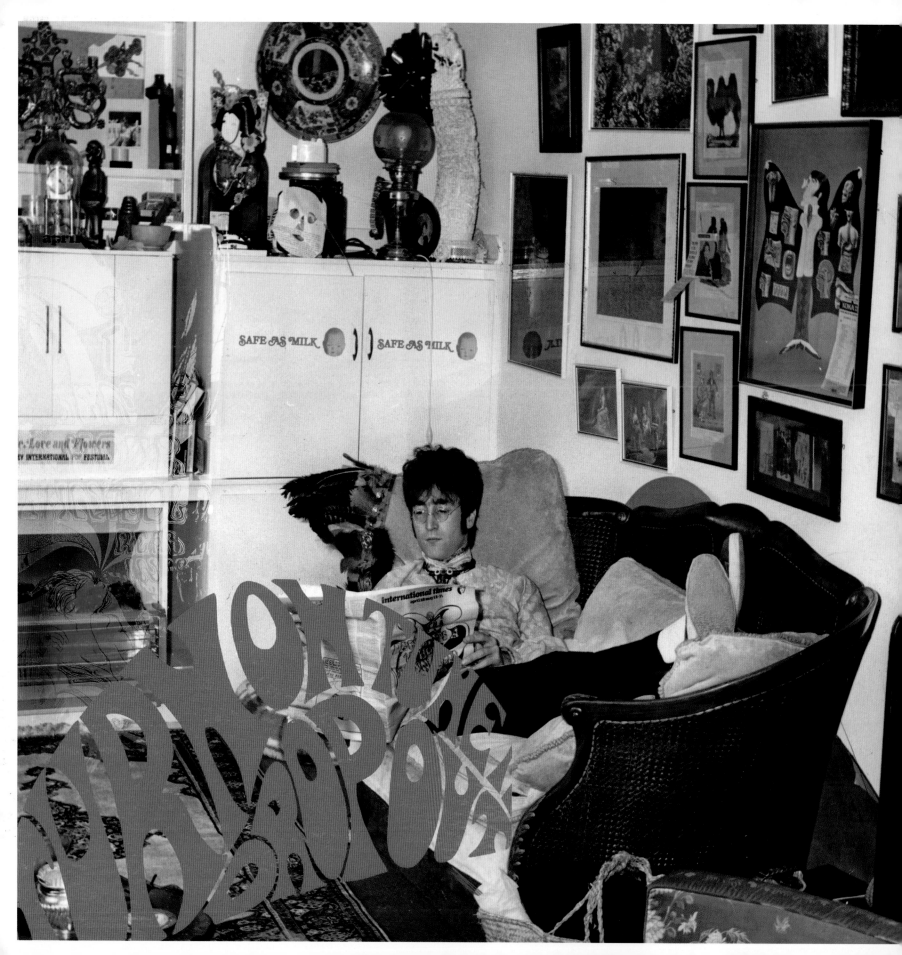

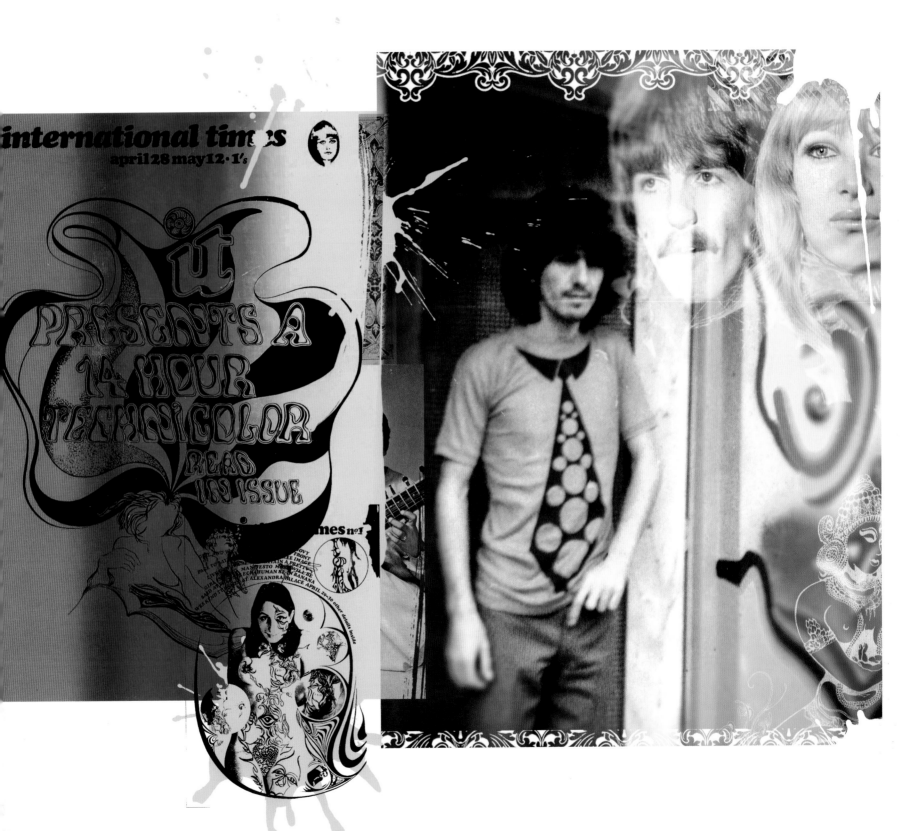

Reflecting on '67
by Simon Weitzman

One Hell of a Year

1967 was one hell of a year. The world was embroiled in numerous controversial wars and technology was preparing to take one more giant leap forward, two years before man would finally stand on the moon, or in a studio, depending on whether you are a truth believer or a conspiracy theorist.

The flower powered swinging population at the time often had a drug problem - That problem being if they couldn't find any, man! Mind expansion and human ambitions were evolving at a rate that has only been recaptured over the past few decades.

Wars were raging but it was still a hopeful stage in our evolution. The traumas of World War Two were beginning to fade and The Beatles had taken the world by storm, helping heal the pain of the loss of President Kennedy in the USA and distracting many from the harsh realities of Vietnam.

The FAB4 were imparting their influences over the airwaves and in schools, as crew cuts turned to mop tops and girl's skirts started to get shorter, much to the appreciation of the now long haired boys.
Even school authorities had little power to stop the fashion and sexual revolutions from flowing through the school gates. Mainly because many of the younger teachers had also been swept up in Beatlemania and instead of being looked up to as respectable conservative role models, they had become the groovy cats that the kids aspired to be like.

The older generations had seemingly lost control and in typical fashion, had put on a scarf, donned a pipe and retreated to the local fine restaurant, where they were securely protected from the anarchy of mini skirts, kinky boots, drain pipe trousers, bell bottoms, drums, guitars, rowdy rockers and screaming girls. Meanwhile, beyond the confines of suburbia's Chez Boring Bistro life really was spinning in huge psychedelic swirls.

Making love not war was the order of the day. In New York City 10,000 people gathered for the Central Park 'be-in', one of the first smaller mass group protests against the Vietnam war, with none other than The Grateful Dead performing for the minglers. Recreational drugs and free love were the two main ingredients for any peaceful protest and at some points Edwin Starr's soon to be released track (1969), War, seemed to have taken on a new pre-emptive meaning. War, what is it good for? Well, in 1967 at protest meetings it turned out that it was pretty good if you wanted to get high and have really good, mind expanding sex.

Groovy dudes and groovier chicks weren't the only ones turning their backs on war. In the same year boxing champion Muhammad Ali refused U.S. Army military service, being a Muslim, citing religious reasons and was immediately stripped of his heavyweight title.

"I ain't got no quarrel with those Vietcong," he stated, before being convicted of draft evasion, sentenced to five years in prison, fined $10,000 and banned from boxing for three years. Thankfully, he stayed out of prison after his case was appealed.

Ali may have been floating like a butterfly and stinging like a bee but we were also reaching into space. NASA had launched Lunar Orbiter 3 and announced the crew for the Apollo 7 space mission (the first manned Apollo flight) featuring astronauts Walter M. Schirra, Jr., Donn F. Eisele, and R. Walter Cunningham.

We also had satellites spinning around the world. Not the 21st century garbage pile of strewn metal that has formed a manmade ring around the planet, but a small selection of new satellites that would change our living rooms forever, bring the world into our homes, whilst allowing prying government eyes from around that same world to see exactly what we were up to.

Closer to earth the world was becoming a smaller place with the advent of a new super jet, the Boeing 737. This was a jet that made european and state to state travel much quicker and more comfortable. It also meant that airlines could increase their routes and staff, leading to a lot more air stewardesses being employed, which was, as we know, no bad thing if you were a Beatle!

The boys meanwhile released the world changing, life changing, everything changing Sgt. Pepper's Lonely Hearts Club Band album, nicknamed "The Soundtrack of the Summer of Love". The Beatles had suddenly taken studio production to an entirely new level and unsurprisingly it stayed in the number one position on the albums charts throughout the summer of 1967.

Love was certainly in the air and the case of Loving v. Virginia changed America forever in this year.
The case, brought by a black woman called Mildred Loving, involved her relationship with Richard Loving, a white man, who was sentenced to a year in prison in Virginia when they married.

By law, their marriage violated the state's anti-miscegenation statute, known as the Racial Integrity Act of 1924. It prohibited marriage between people classified as "white" and people classified as "coloured". However, the Supreme Court's unanimous decision was that this prohibition was unconstitutional, in turn posthumously reversing the Pace v. Alabama ruling of 1883 and, more importantly, ending all race-based legal restrictions on marriage in the United States.

"If everyone demanded peace instead of another television set, then there'd be peace." John Lennon

It led to a dramatic increase in interracial marriages in the U.S, remembered annually on June 12, a day known as 'Loving Day'. Nearly fifty years on this famous ruling would also help change another restricting same-sex marriage in the United States.

But in 1967 people's values, aspirations and dreams were rising and there was a feeling that love and life were entering a whole new phase. We were on the verge of a population boom. Take me, I was about the 2.5 billionth baby on the planet that year, added to the pile in early April. Now, about half a century later, even with the benefit of better sex education and contraception, we have cruised past 7.2 billion human beings. Back in the 1960s, with free love worldwide and England winning the world cup, many of us were in 'training' for this awesome jump in the human race.

On June the 25th around 400 million viewers tuned in from around the globe to watch a show called Our World. It was the first live, international satellite television production. Each country represented nominated segments of life and culture to showcase to people from all four corners of the earth. But the United Kingdom had a distinct advantage in that they had The Beatles. A reason for anyone around the world to tune in. And not only did they get to see the legendary Liverpool band, they also got to witness the live debut of their new song, "All You Need Is Love".

"We had been told we'd be seen recording it by the whole world at the same time. So we had one message for the world– Love. We need more love in the world."

"And in the end, the love you take, is equal to the love you make."

Paul McCartney

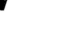

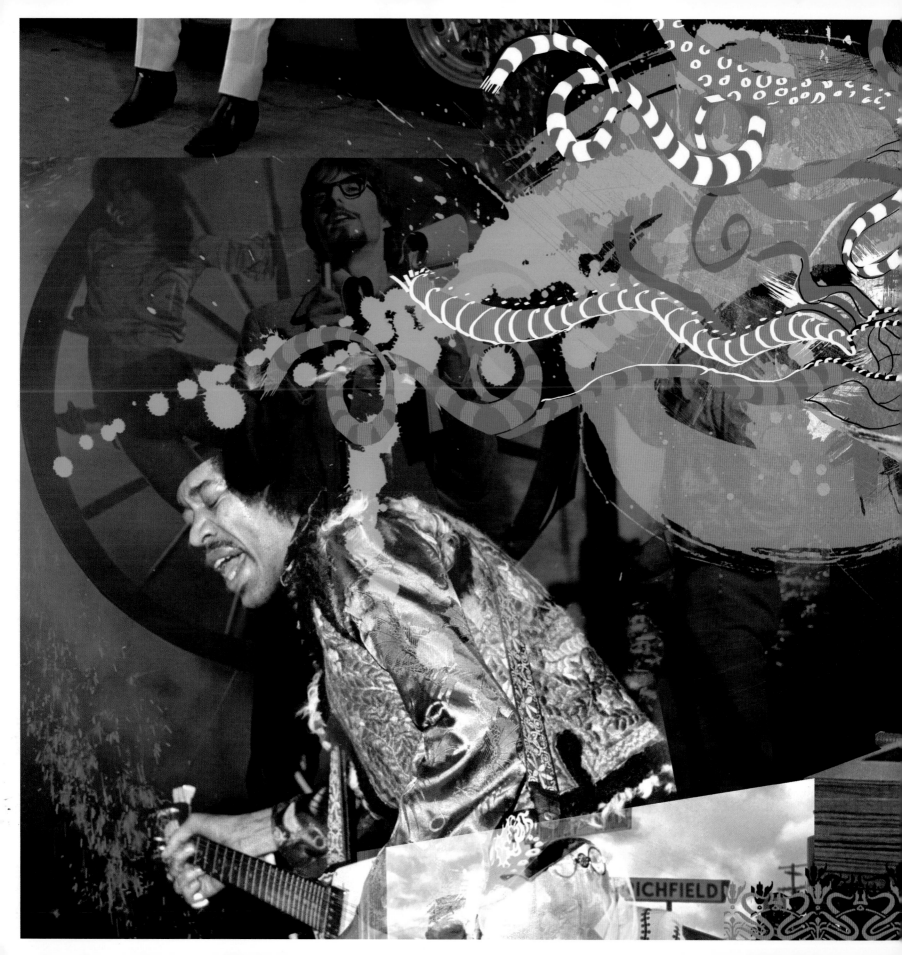

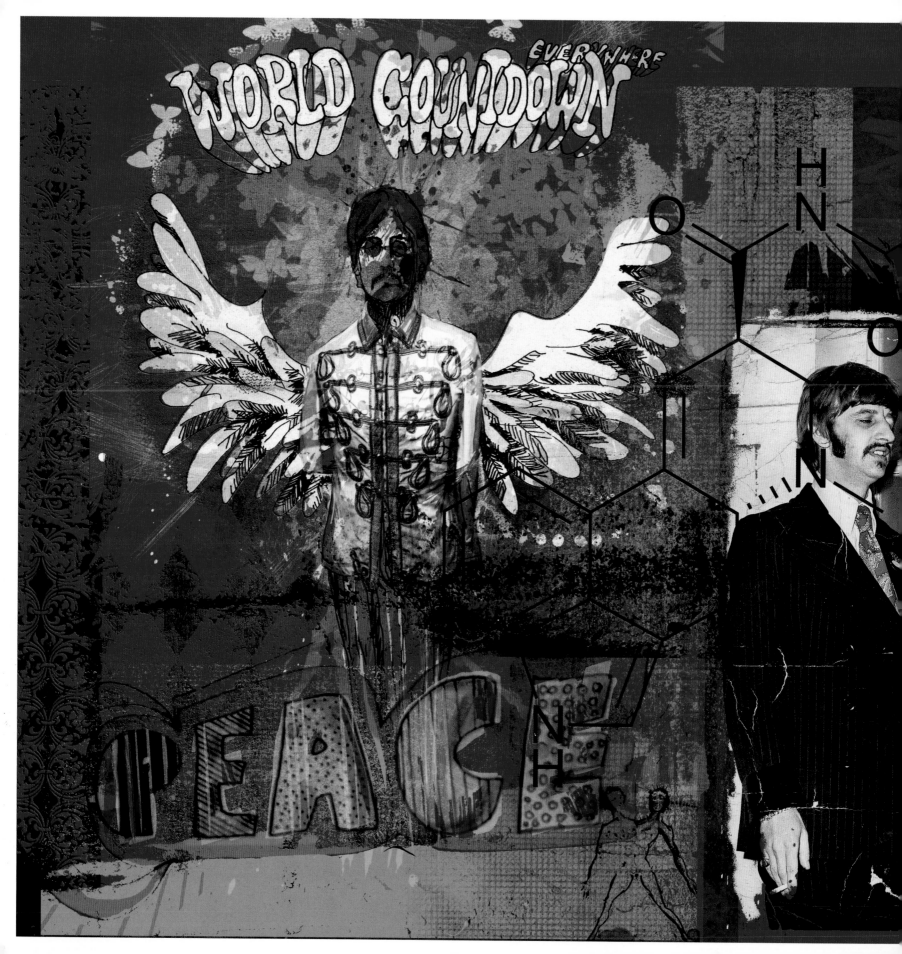

A Carnival of Lights
by *Paul Skellett*

THE OTHERSIDE OF NOWHERE

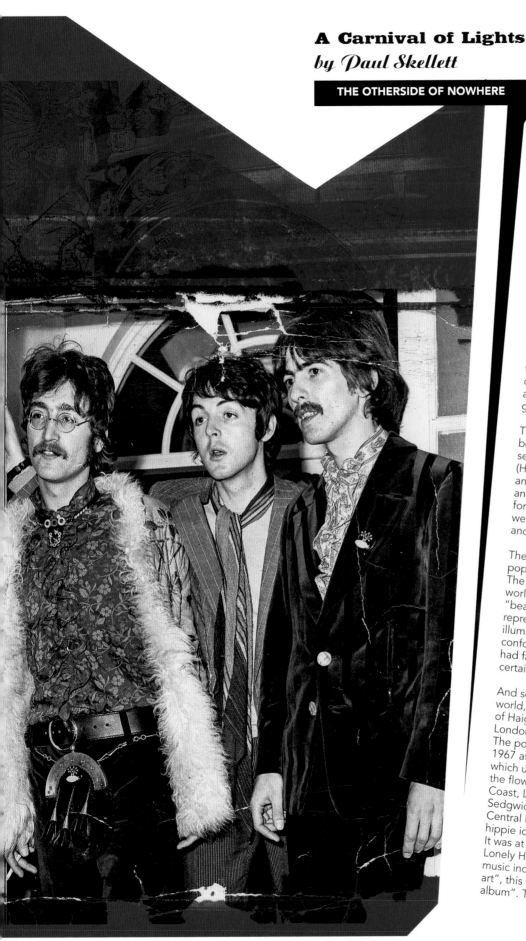

Amidst the head whirling highs of the cultural shift evolving through '67 and an apogee of youth vocalising a need for change, it has to be said that behind the brightest of light stretches the darkest of shadows. No longer is it the beatniks and kook's 'waiting for the sun', now, everyday Jane's and Joe's are calling for an end to the killing and corruption tarnishing the ever shrinking world. As the media serves breakfast to the world, cornflakes and napalm, the technicolour dream of hope, a 'painting by numbers' mural of love and peace offers the prospect of a brighter tomorrow. Is there a primal position for living within a world of love and peace, or are we hard wired to self destruct and take down those around us in the process? Maybe The Beatles approach to preach to the world with a universal prayer would be the only way to find out?

We all know that The Beatles did not create 'flower power' or 'the summer of love' but they did popularise it. The Beatles bridged the far reaches of esoteric teachings with the young people of the world, translating the poignant content into a medium that everyone could understand.

The dream was all but fading by the time 'All You Need Is Love' was released, it offered resurgence but it wasn't enough. It has to be said, that although the battle was ultimately lost, the war continues among artists and musicians to this day with The Beatles and 'All You Need is Love' remaining a mantra of hope for future generations.

The road that leads to the 'Our World/All You Need is Love' event begins by understanding the birth of the liberal counter-culture that served as a platform by which it was inspired. The 'Hep' or 'Hip' cats (Hippies) were individuals considered to be cultural, sophisticated and current. By inheriting the language and values of counter culture and the former 'Beat generation' of the 50s they evolved into forming opinions on free thinking, drugs, the sexual revolution as well as exploring altered states of consciousness in a bid to find truth and spiritual nirvana.

The term hippie is an African American jive slang and was popularised by journalist Herb Caen of the San Francisco Chronicle. The adjective "Beat" comes from underworld slang, the shadowed world of hustlers, thieves, addicts and hookers. "Beat" is slang for "beaten down". To Allen Ginsberg and Jack Kerouac "Beat" represented the wild distorted beauty of the elegant sultry illuminated hipster thumbing his way across America in search of non conformist freedom. Maybe Lennon's insight into naming his band had far deeper roots than originally considered. The BEATles were certainly beaten down before rising to their iconic status.

And so the hippies are born, setting up strongholds around the world, Greenwich Village on the East Coast and their spiritual home of Haight-Ashbury in San Francisco with it's inspiration spilling into London via The Beatles associations with bands such as The Byrds. The popularisation of the hippie culture began on January 14th of 1967 at the "Human Be-In" in Golden Gate Park (San Francisco) which ultimately led to the "Summer of Love" later that year. As the flowers grew on the West Coast, on March the 26th on the East Coast, Lou Reed, actress, art socialite and Warhol beauty Edie Sedgwick along with 10,000 hippies gathered in Manhattan for the Central Park Be-In. By June '67 and with increased exposure the hippie ideals had gained traction.

It was at this point (June 1st) that The Beatles released "Sgt. Peppers Lonely Hearts Club Band", an album that would redefine the music industry, turning "pop" to "rock" and "popular music" to "fine art", this was "art rock". The Beatles had ushered in the era of "the album". These times they are a changin'.

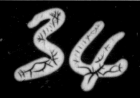

From June 16th to the 18th rock music from the world
of counter-culture was delivered to the masses via the
Monterey Pop Festival.
This was the official start of

"the summer of love"

Another dimension we have to consider, and an
important ingredient is that of the psychedelic
experience. American psychologist and writer Timothy
Leary, known for his advocating of drug experimentation
founded an organisation called the
"League for Spiritual Discovery".

Leary created a number of literary works,
"The Psychedelic Experience", LSD, and in January of
'67 he produced a pamphlet called
"Start your own religion".

Maybe this was something read by George Lucas? Leary
was invited to speak to the 30,000 hippies that were in
attendance at Golden Gate Park.
During his speech he coined the phrase
"Turn on, Tune in, Drop out".

It was Leary's earlier work of
"The Psychedelic Experience"
that inspired John Lennon's
"Tomorrow Never Knows".

Another spiritual inspiration that fuelled
the Hippie consciousness was the English Occultist
and Ceremonial Magician, Aleister Crowley.
Crowley was openly acknowledged
by Leary as an inspiration.
He also appeared on the albums of Sgt. Pepper,
The Doors and Led Zeppelin.

All of these elements go towards the event that the
world remembers not as the first ever satellite global
broadcast, but as the day The Beatles performed
"All You Need is Love".

The Beatles had thrown a cultural stone into the social ocean, and its now infinitely radiating ripples have become the inspiration for fusions of art and music, helping illuminate the minds and voices of future generations. Although the light of love and peace was illuminating popular culture, the shadows of reality were also being expressed.

The brighter the light the deeper the shadow.

The Los Angeles quartet, The Doors had begun their ascent. This was a rock 'n' roll band of no quarter, a band with a charismatic Dionysus styled front man that was prepared to deliver its audience into the heart of darkness. Each member of The Doors had a unique and concentrated element they delivered, but at the groups heart lies the soul and mystique, the magnetic presence that is singer-poet Jim Morrison, the leather-clad "Lizard King" wielding the power of a shaman to the microphone challenging the idealism of 'flower power'. Epic songs such as 'The End', 'When the Musics Over' and 'Five to One' portrayed the reality of an unveiled existence, emotions laid bare. The Byronesque, Neitzsche and Huxley inspired essence of The Doors was a sharp contrast to the love laden rose tinted vision that even the straights of Madison Avenue was now cashing in on, mainly due to the market reach and influence of The Beatles and their embrace of 'hippy' sentiment. The Doors were not the only musicians beginning to paint with darker tones. The Stones blues mystique was reaching towards 'Sympathy for the Devil' and Hendrix supernatural translation of Gods voice into the fretboard of his guitar was far from a poetic whisper of love.

The fact is Jim Morrison wasn't the only 'Lizard King'. The irony is that although John wrote 'All You Need is Love' his envisaged nature as seen through the eyes of Cynthia Lennon whilst trying acid was seeing John as a razor toothed snake leering and laughing at her.
Leading up to the summer of love John Lennon had begun to massively increase his use of acid. His change in personality was a sharp contrast to his signature moody, sarcastic and sometimes aggressive behaviour.

Johns renowned anti social personality was completely broken down by acid, he even attended the 'Fourteen-Hour Technicolour Dream', a carnival gathering of freaks, kooks and hippies celebrating 'the moment' and tripping to the sound of a new English musical power to be, Pink Floyd. Donning a black cape, a green ruffled flowery shirt, maroon cord trousers, yellow socks, cord shoes and a sporran, Lennon's face with a painted acid smile absorbed the experience. The question is; would John have been able to write the anthem for the summer of love unless he had consumed his now habitual love drug in such large quantities?
Love and peace was as much an idealistic facade for John as it was a majority of the populace, the perfect prescription for a world in pain. It was a nice trip while it lasted. Goldman makes the claim that by the time 'Our World' and 'All You Need is Love' were broadcast that John was storing over two pints of high grade lysergic acid in his home.

The word of love was being spread, but the conflict between governments and people were beginning to cause frustrations and music was the natural medium of expression, you only had to look at Pete Townsend destroy yet another guitar or Jimi ignite one.

$$C_{20}H_{25}N_{30}$$

The insight that acid lay at the feet of both Lennon, McCartney and Harrison created a new horizon for The Beatles, a new dream to strive for, a chance to heal, an opportunity to evolve themselves by improving the world... but there were cracks, and soon the trip would fall into descent and the cynical blood would begin to spill.

All of these emotional and environmental vibrations within the music industry would continue to resonate for decades. For John, the concept of 'love' would continue, but on a far more serious level and as a manipulative media propaganda tool.

After The Beatles had dutifully serenaded the world with 'love' they quickly rose to the challenge of equalling social sentiment and personal retrospective visions using their unique intuitive insight and humour in the most English and eccentric of ways, once again leading the way and breaking new ground.

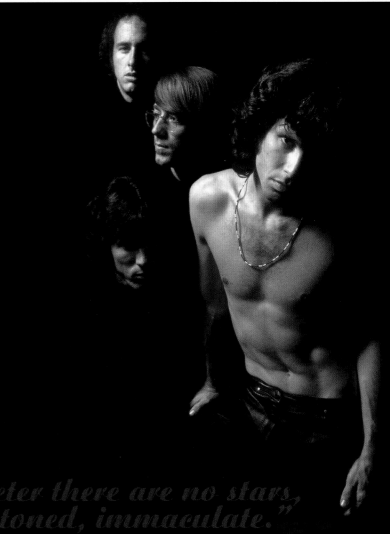

"Out here on the perimeter there are no stars, out here we is stoned, immaculate."

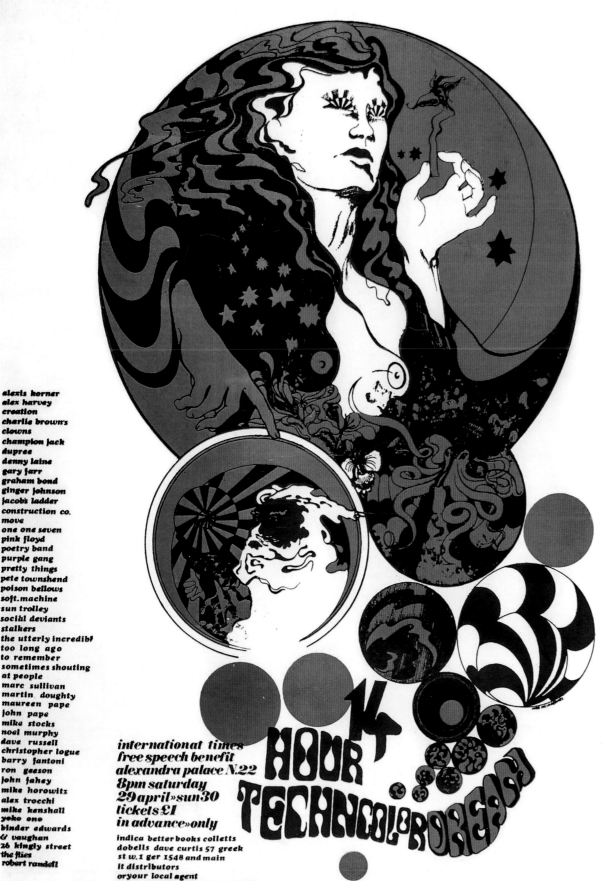

alexis korner
alex harvey
creation
charlie brown's
clowns
champion jack
dupree
denny laine
gary farr
graham bond
ginger johnson
jacob's ladder
construction co.
move
one one seven
pink floyd
poetry band
purple gang
pretty things
pete townshend
poison bellows
soft.machine
·sun trolley
social deviants
stalkers
the utterly incredibl
too long ago
to remember
sometimes shouting
at people
marc sullivan
martin doughty
maureen pape
john pape
mike stocks
noel murphy
dave russell
christopher logue
barry fantoni
ron geeson
john fahey
mike horowitz
alex trocchi
mike kenshall
yoko ono
binder edwards
& vaughan
26 kingly street
the flies
robert randell

international times
free speech benefit
alexandra palace N.22
8pm saturday
29 april » sun 30
tickets £1
in advance » only
indica better books colletts
dobells dave curtis 57 greek
st w.1 ger 1548 and main
it distributors
oryour local agent
bus shuttle from wood green⊖
highgate⊖ 8.12pm

14 HOUR TECHNICOLOR DREAM

The 14 Hour Technicolor Dream was a multi-artist event, a platform for poets, artists and musicians. Pink Floyd headlined the event with an army of other artists billed to perform. Artists such as; The Crazy World of Arthur Brown, Soft Machine, The Move, The Pretty Things, Pete Townshend, Alexis Korner, and Yoko Ono, plus many more. John Lennon was in attendance with his friend John Dunbar, a partner in the Indica Gallery (as in Cannabis indica). Lennon had met Yoko Ono a year earlier when he attended a private preview of an exhibition of her work entitled "Unfinished Paintings and Objects" at Dunbar's Gallery. Now he was watching her perform in the Great Hall of the Alexandra Palace at a landmark 'gathering'.

There were two main stages inside the hall, with a smaller central stage designed for poets and performance artists. Bands could play at either end of the Palace and not interfere with each other. The largest stage for the main events, constructed along the rear wall, was flanked by the large glass windows of the Palace. Light shows and strobes lit up every inch of available space from a massive light tower at the center of the hall. Underground films, (most notably the Flaming Creatures) were screened on white sheets taped to scaffolding. The center piece was a helter skelter, which was rented for the night.

Pink Floyd appeared right at the end of the show, just as the sun was beginning to rise at around five o'clock in the morning. The details of the set-list are rather sketchy; however, one source suggests that they played "Astronomy Domine", "Arnold Layne", "Interstellar Overdrive", "Nick's Boogie", and other material from their then unreleased debut album, The Piper at the Gates of Dawn. Apparently, Pink Floyd members were exhausted from playing another gig in the Netherlands that same night and arrived at Alexandra Palace at around three in the morning.

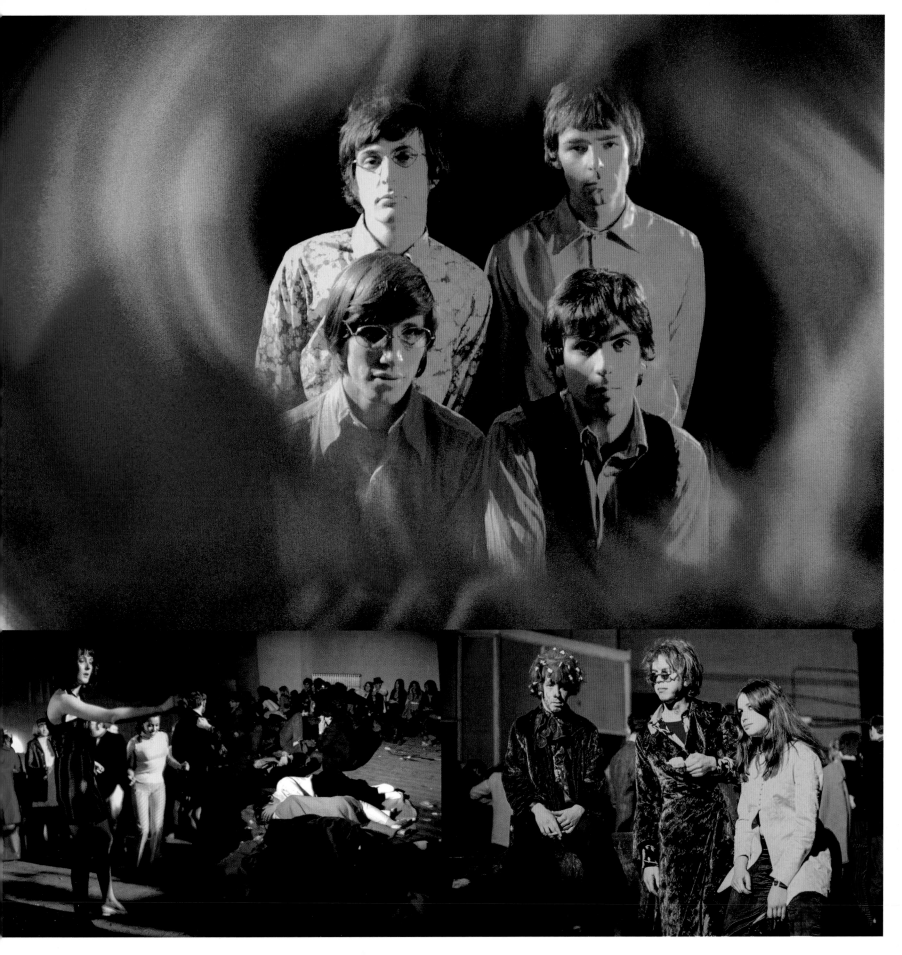

Rock and Rolls (Royce)

During the time John had been filming in Spain his black Rolls Royce had been battered by the sand and grit of the Spanish roads. On returning John announced he was going to have his car re-sprayed. It was apparently Ringo that flippantly suggested he turned it into a fairground carousel. So he did. The car became one of the most iconic images of the whole psychedelic period. It's noted that John would be driven around in the back with guests sipping tea from a Thermos flask spiked with LSD. Once everyone was comfortably tripping he would unleash a myriad of sound effects to the outside world via a custom sound system built into the car.

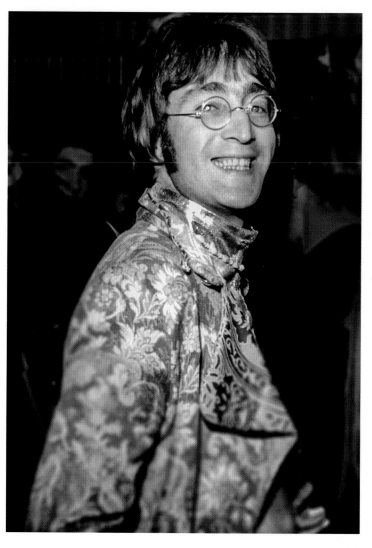

The cover of the very first issue of 'Rolling Stone' magazine carried a still image of John Lennon from the movie in which he attained a role. The film was; How I Won the War. The image completely bridges the mix of politics, culture and music that has come to define the magazine. 'Rolling Stone' magazine was established in 1967.

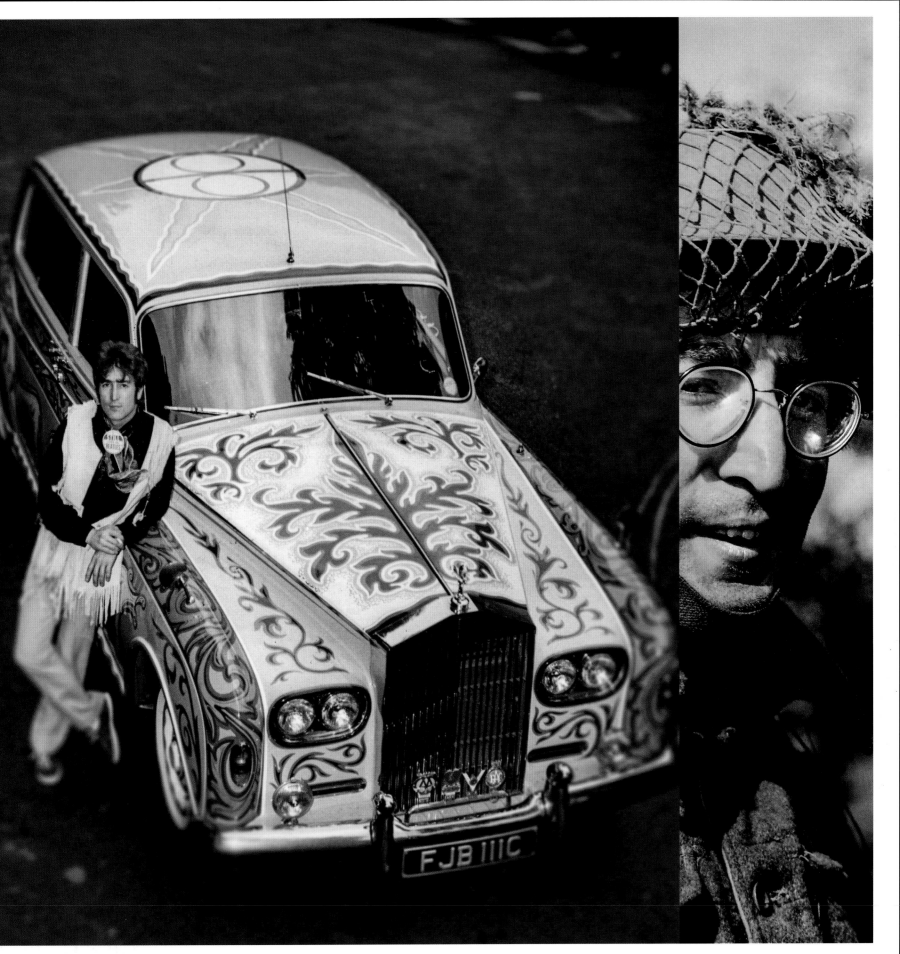

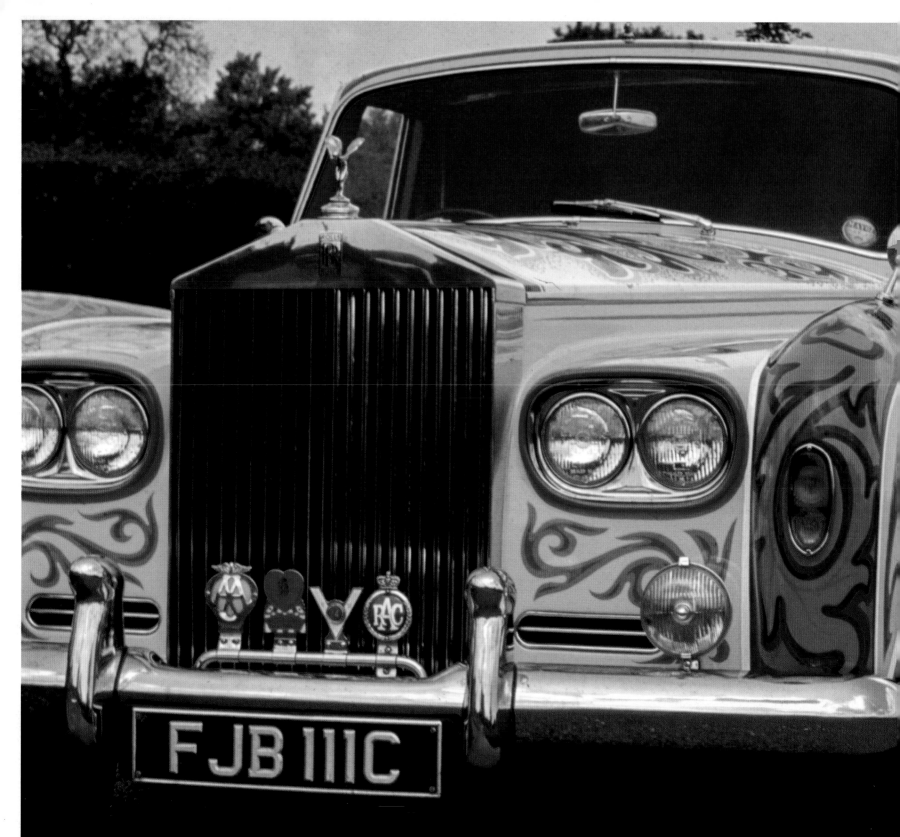

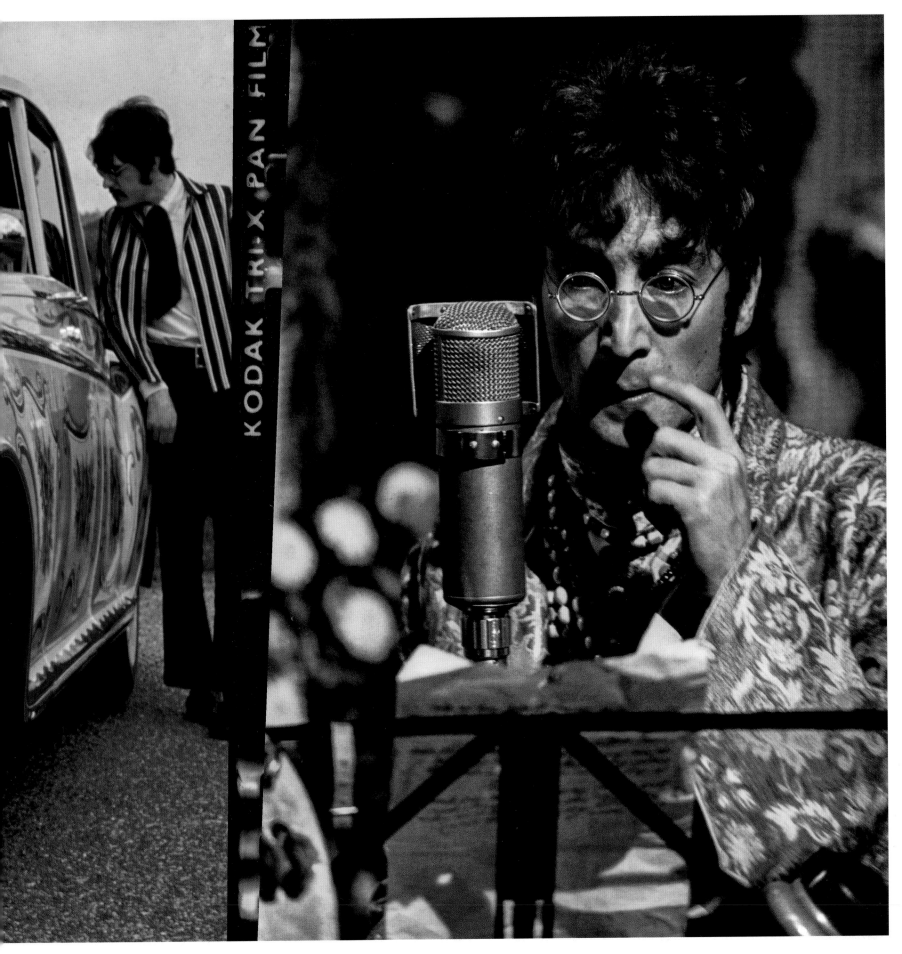

KODAK TRI-X PAN FILM

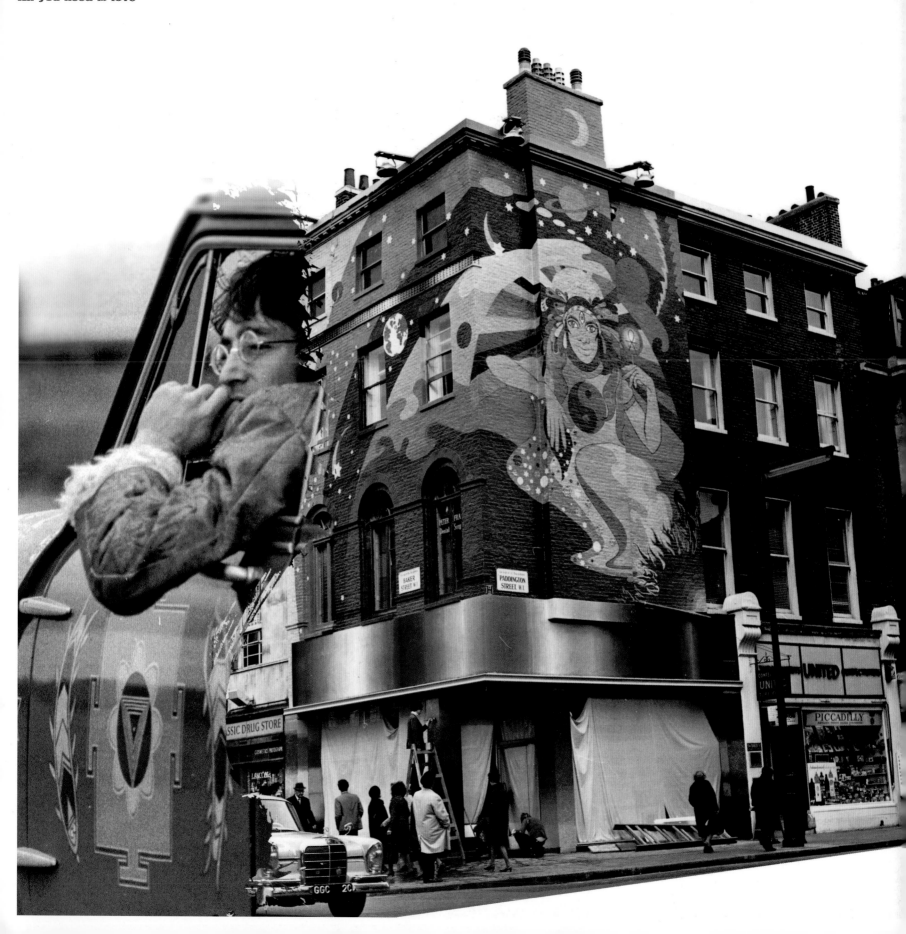

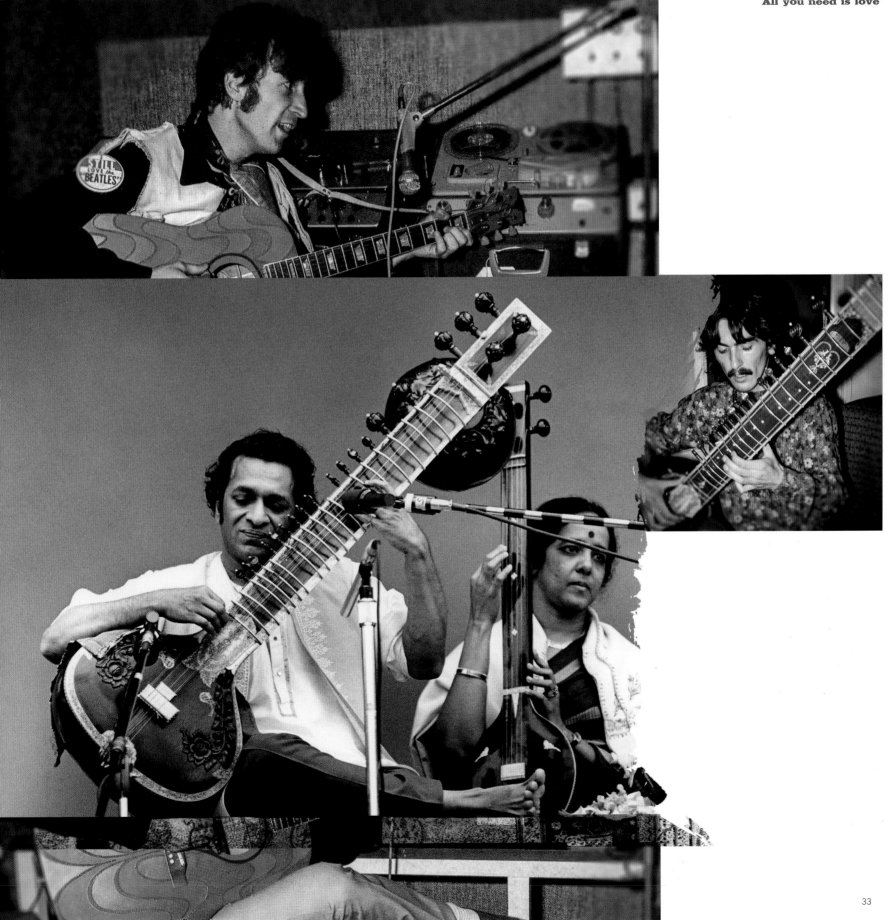

On May the 10th 1967, Brian Jones and Stash Klossowski De Rola were arrested in London on drug charges. Today, it is almost certain that the drugs had been planted. They were eventually cleared of all charges.

Stash Klossowski De Rola often gets a mention in various Rolling Stones biographies - a mysterious young aristocrat and a true Dandy of the 60s, a real 'dedicated follower of fashion'. Stash is the son of one of the greatest painters of twentieth century, Balthus and a distant relative of the great poet Lord Byron. He was friends with Stones, The Beatles, Syd Barrett amongst many other legendary musicians and artists. He was, and still is, a man of wealth and taste. Stash was the definitive icon of Peacock Style which helped define this unique period.

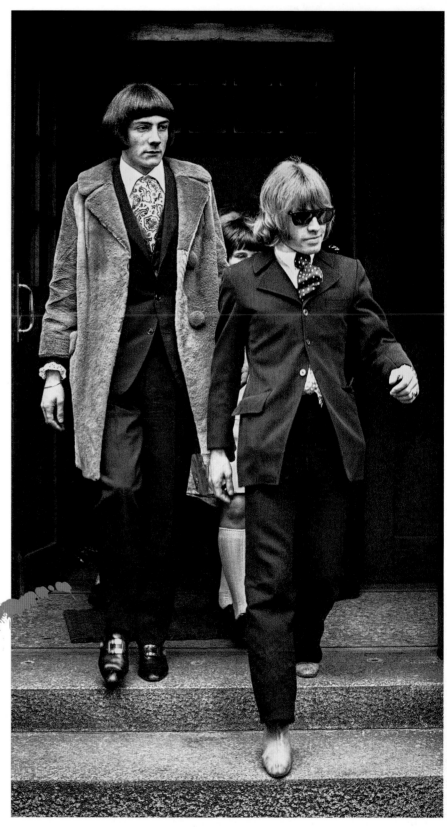

Brian Jones and Stash exit West London Magistrates Court - June 2nd 1967.

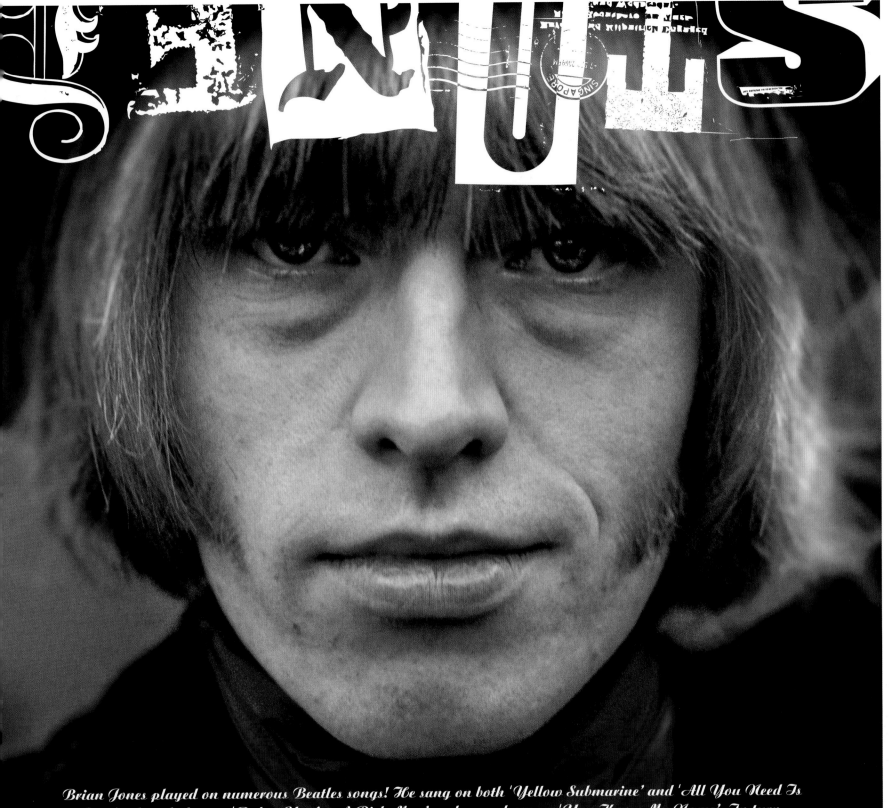

Brian Jones played on numerous Beatles songs! He sang on both 'Yellow Submarine' and 'All You Need Is Love', played oboe on 'Baby, You're A Rich Man' and saxophone on 'You Know My Name'. In turn, John and Paul sang on The Stones' song 'We Love You'.

How the Our World broadcast came to be
by Angela Ballard

MA GRADUATE IN 'THE BEATLES, POPULAR MUSIC AND SOCIETY'

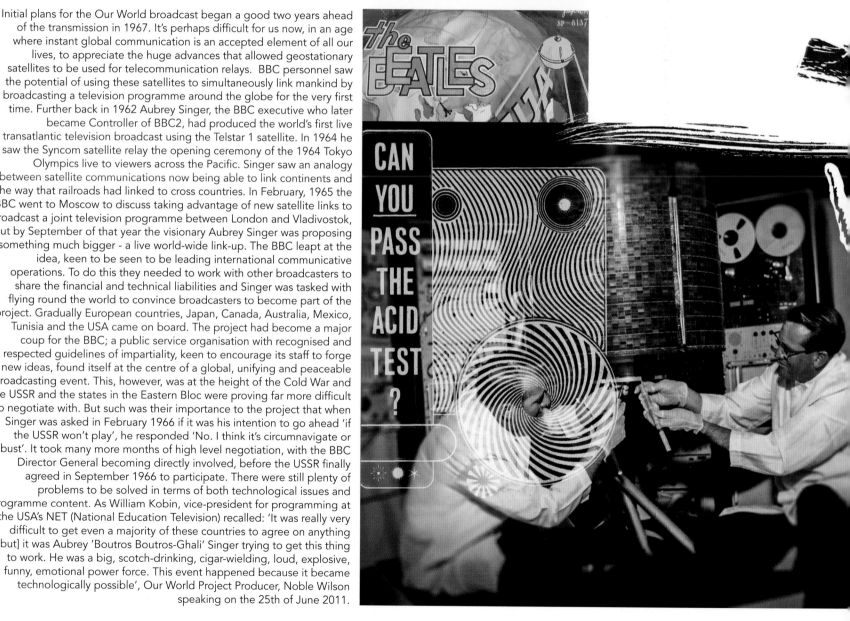

Initial plans for the Our World broadcast began a good two years ahead of the transmission in 1967. It's perhaps difficult for us now, in an age where instant global communication is an accepted element of all our lives, to appreciate the huge advances that allowed geostationary satellites to be used for telecommunication relays. BBC personnel saw the potential of using these satellites to simultaneously link mankind by broadcasting a television programme around the globe for the very first time. Further back in 1962 Aubrey Singer, the BBC executive who later became Controller of BBC2, had produced the world's first live transatlantic television broadcast using the Telstar 1 satellite. In 1964 he saw the Syncom satellite relay the opening ceremony of the 1964 Tokyo Olympics live to viewers across the Pacific. Singer saw an analogy between satellite communications now being able to link continents and the way that railroads had linked to cross countries. In February, 1965 the BBC went to Moscow to discuss taking advantage of new satellite links to broadcast a joint television programme between London and Vladivostok, but by September of that year the visionary Aubrey Singer was proposing something much bigger - a live world-wide link-up. The BBC leapt at the idea, keen to be seen to be leading international communicative operations. To do this they needed to work with other broadcasters to share the financial and technical liabilities and Singer was tasked with flying round the world to convince broadcasters to become part of the project. Gradually European countries, Japan, Canada, Australia, Mexico, Tunisia and the USA came on board. The project had become a major coup for the BBC; a public service organisation with recognised and respected guidelines of impartiality, keen to encourage its staff to forge new ideas, found itself at the centre of a global, unifying and peaceable broadcasting event. This, however, was at the height of the Cold War and the USSR and the states in the Eastern Bloc were proving far more difficult to negotiate with. But such was their importance to the project that when Singer was asked in February 1966 if it was his intention to go ahead 'if the USSR won't play', he responded 'No. I think it's circumnavigate or bust'. It took many more months of high level negotiation, with the BBC Director General becoming directly involved, before the USSR finally agreed in September 1966 to participate. There were still plenty of problems to be solved in terms of both technological issues and programme content. As William Kobin, vice-president for programming at the USA's NET (National Education Television) recalled: 'It was really very difficult to get even a majority of these countries to agree on anything [but] it was Aubrey 'Boutros Boutros-Ghali' Singer trying to get this thing to work. He was a big, scotch-drinking, cigar-wielding, loud, explosive, funny, emotional power force. This event happened because it became technologically possible', Our World Project Producer, Noble Wilson speaking on the 25th of June 2011.

A production team was pulled together, including Noble Wilson as Project Producer, and with Antony Jay as Project Writer to liven up what otherwise could have become 'a sad waste of the television resources assembled for this occasion' and ensuring that 'the programme shall have value as a programme in its own right'. The technological platform came to be seen as an opportunity to promote concepts that would unite mankind through humanitarian principles, focusing heavily on the 'population explosion', a major concern in the 1960s, and the world-wide efforts to live with and solve it, but to also include segments on 'artistic excellence'.

In February 1967 Aubrey Singer first suggested approaching the Beatles to represent the UK. Wilson explained:

'They represented excellence in their field. They would also increase the audience worldwide. Broadcasters are interested in their audience figures. There is no point in broadcasting to a handful of people.'

The rather naive team member tasked with approaching Brian Epstein wrote to him:

'I am working on a unique television programme for which we would very much like to book The Beatles, if this is at all possible?'

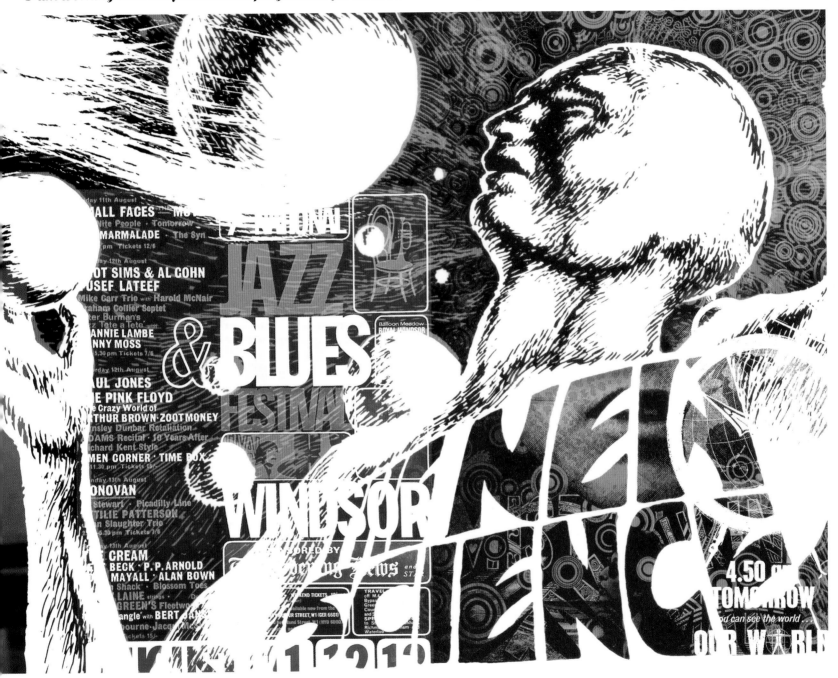

The letter elicited a stern response from Singer:

'People no longer book an act like The Beatles. The Beatles condescend to appear for one and should be treated in this vein.'

The involvement of the Beatles was seen as extremely important to the success of the project. But their involvement came well down the line in terms of the overall planning of the programme. For a couple of months after it was decided to approach them nothing happened because no one could get hold of Brian Epstein (for a variety of reasons) - and they weren't confirmed until relatively soon before the broadcast. This gave them little time to write a song for the programme - and it is well known by Beatle fans that All You Need Is Love was written perilously close to broadcast day.

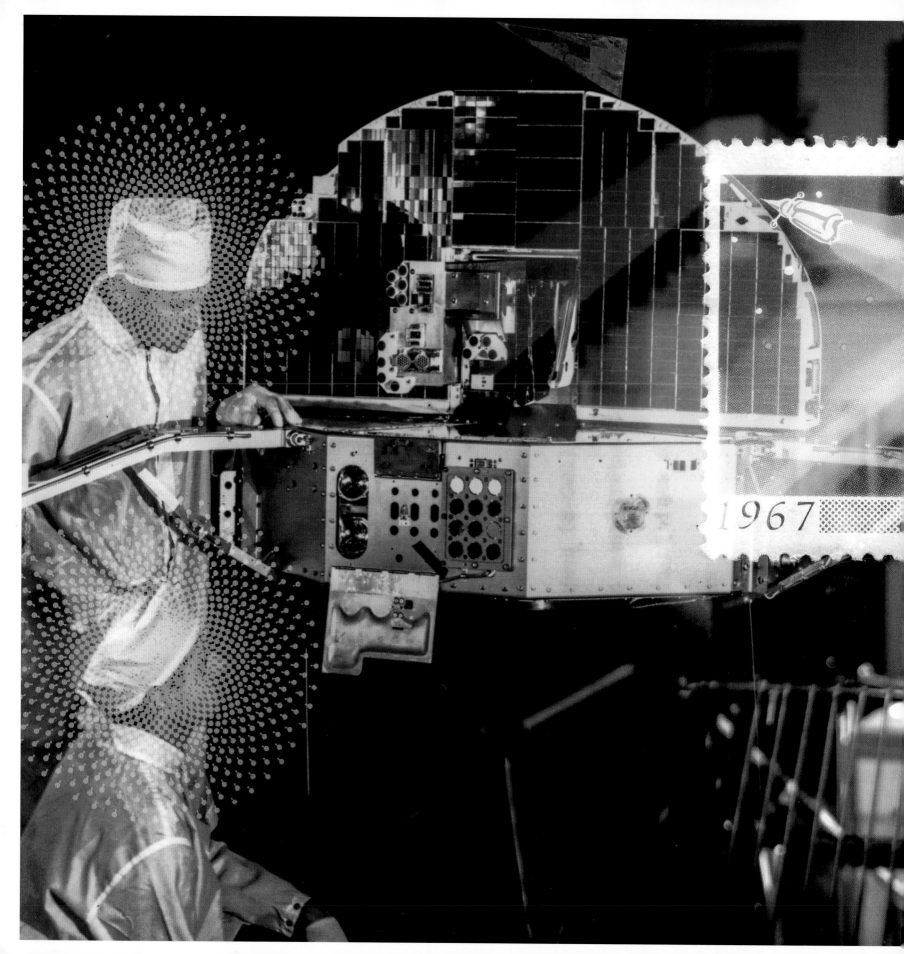

1967

BACK IN THE USSR

A thorough investigation through the BBC records has led Beatles researcher, Angela Ballard to conclude that the inclusion of The Beatles in the programme had immense repercussions that were not understood at the time and that have been 'sidestepped' by researchers and experts ever since.

Just days before the broadcast the entire Eastern Bloc withdrew from the project, citing the alleged support by Western 'imperialist forces' against the Arab peoples in what became known as The Six Day War. Such was the immediate pandemonium caused that no-one sought to question this rationale. But it now seems feasible that the Eastern Bloc withdrew for entirely different reasons. Here you had a Western world live transmission being beamed into millions of soviet homes and neither the government or the KGB could do anything to control or moderate the content. In short the USSR was completely freaked by the inclusion of The Beatles. We have now become aware that Western popular music was regarded as anti-authoritarian and completely subversive. If young people were exposed to it they could be entirely corrupted. A live broadcast involving a group as powerfully influential as The Beatles, no longer sporting the innocent mop top look and now reflecting the perceived immoral values of the Summer of Love would have been deemed culturally and politically unacceptable. Added to which Paul McCartney had, on June 19th, announced that he had taken LSD. The detailed content of The Beatles segment was not known in advance – indeed they wanted to rise to the occasion with something new and original which would only achieve its final form on air live during transmission.

It would take the form of a 'happening' that might 'involve the spontaneous efforts of anything up to 50 people.' How could the repressive USSR possibly allow such a broadcast into the homes of its citizens, especially those who were young and impressionable? Even the words of the song were not yet known. Put simply, the Eastern Bloc withdrew from Our World because they couldn't control what The Beatles did live on air.

PAUL BENTLY Gave me this
after Esmond and he had been
to a Beatles recording session
ACCORDIAN thing.

George Martin

All You Need Is Love

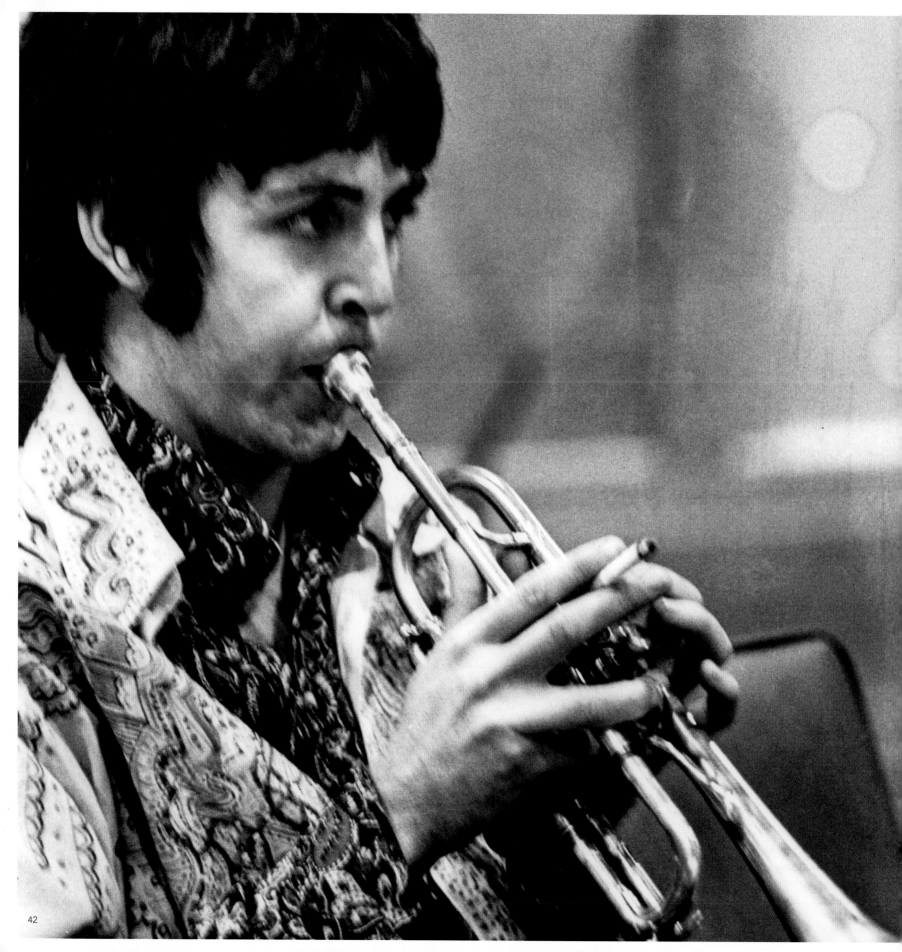

Expressing the inexpressible
by Paul Skellett

THE COLOURS OF FREQUENCY

When I was first introduced to psychedelic rock music, my understanding of music and art exploded, it was like the unlocking of the door in 'The Wall'. Excitement and revolution, this was where you could create worlds, this wasn't weird, it was wonderful, audio freedom. The 'identity' of psych rock was a brave transition for me. Until this point in my life, my mind was still geared towards 'uniforms' as a badge of identity, school, the Scouts, joining the Air Training Corp, and then rebelling a little by being a Mod. These were the uniforms of my early days.

My guiding light was always The Beatles, from the boys being in Hamburg through to their emergence into popular culture and then back out the other end. I grew up with The Beatles and I adopted them as my teachers. I made my way through each album until I found my own sense of liberation as both a musician, artist and an individual. Many others such as The Doors, The Yardbirds, Jimi Hendrix, The Zombies, The Who, Love, The Rolling Stones and of course Pink Floyd all served as inspiration, but it was always The Beatles that were my foundation.

As I got deeper into music and forged my own bands, sound and identity (The Reign - Waters Deep), I was always drawn to the studio over playing live. Performing was great, we had an amazing time, but it was sculpting music that really fired my imagination. To be able to take people on a journey and manipulate their mood was where it was at. I could really understand why they made the decision to stop touring, and to be honest, thank God they did.

As colour became frequencies, my love of painting easily transposed into the studio. This led me into wanting to understand the nuances of The Beatles working process, how did they function behind the closed doors of Abbey Road and Olympic Studios, how integral was George Martin within the creative process. The real eye opener was that there are no rules, as long as you're brave enough to experiment and have a great engineer. There are a couple of great books out there covering The Beatles in the studio, Mark Lewisohn's 'The complete Beatles recording sessions' is a wonderful Abbey Road insight, and Curvebender's 'Recording The Beatles' is a studio nuts dream.

Scavenging through numerous sources of information this next section outlines (as best we know) the process that The Beatles, engineers and George Martin went through to deliver this landmark production.

Prior to "All You Need Is Love", the Beatles had recorded "Baby You're A Rich Man" (we'll go into this later in the book) at Olympic Studios. It had been a surprising and fruitful session, so when George Martin was unable organise a session slot at any of the EMI studios for The Beatles to record it was an easy decision to go back to Olympic to record the backing track for "All You Need Is Love". Geoff Emerick was unable to engineer the session due to being on the EMI staff.

On June the 14th, The Beatles entered Olympic Studios to record the rhythm track for "All You Need Is Love." With no Geoff to engineer, the duty fell to an engineer called Eddie Kramer. Eddie would go on to produce future heavy weights, Jimi Hendrix and Kiss. Along side Eddie was George Chkiantz, George was the tape operator and of course, George Martin as producer. Eddie recalls that there wasn't really a plan apart from John having a rough idea for 'All You Need Is Love'. John recorded a guide vocal from the control room through a talkback mic.

"We just put a track down, because I knew the chords. I played a harpsichord and George played a violin, because we felt like doing it like that and Paul played a double bass. They can't play them, so we got some nice noises coming out and then you can hear it going on, because it sounded like an orchestra, but it's just those two playing the violin." John Lennon

Paul commandeered a double-bass left in the studio from a previous session. Accounts show that the band were charged ten guineas for John's use of the harpsichord.

"I remember that one of the minor problems was that George had got hold of a violin which he wanted to try to play, even though he couldn't!" George Martin

It took over 33 takes to capture the rhythm track. This song with it's unusual collection of instruments and John's 'talkback mic' vocal being the only guide for the song was the result of a very 'sketchy' but positive session.

The book "The Beatles Recording Sessions" explains,
"Right from the beginning of take one 'La Marseillaise' (the French national anthem) was a vital part of the song, emphasizing the international flavor of the occasion."

"The Beatles were very opportunistic and very positive. At one point we accidentally made a curious sound on the tape and they not only wanted to keep it on the recording they also asked us to deliberately repeat that same sound again. Other groups would have been annoyed but The Beatles capitalized on the mistake."

George Chkiantz

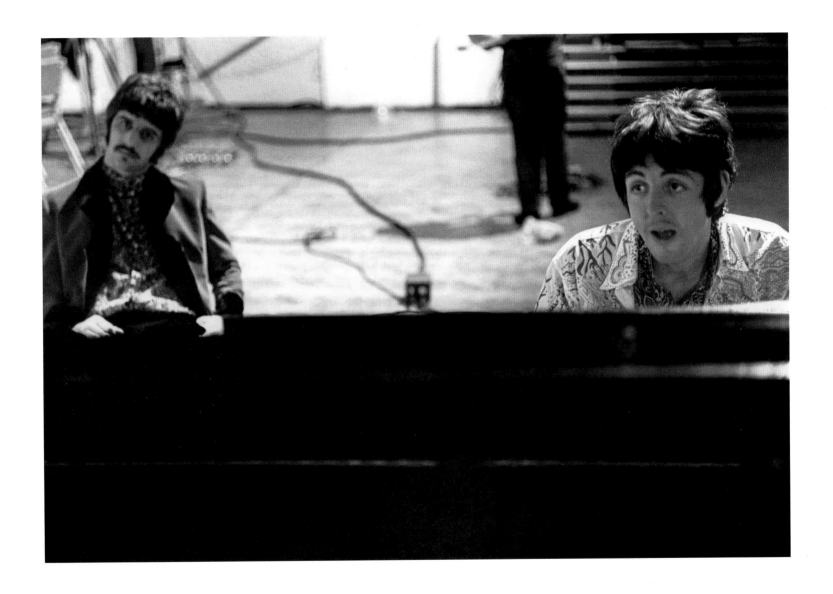

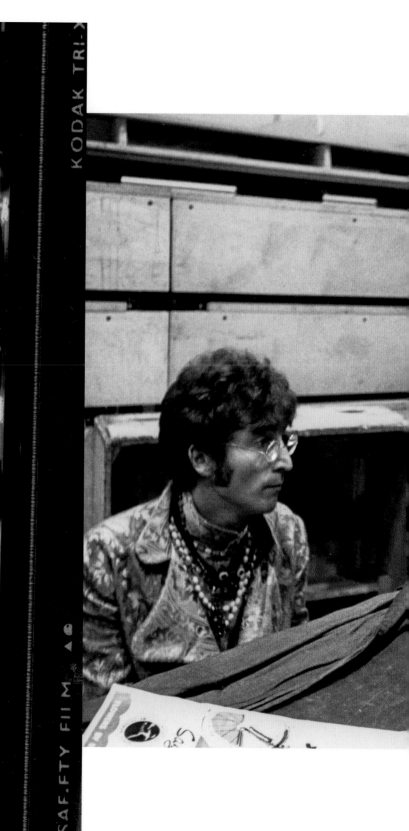

"They did the song from beginning to end for a good half-hour. They'd get to the end of the song and John would count it off again without stopping, doing it again and again until they got the one that they liked."
Eddie Kramer

George Chkiantz recalls that they concluded by creating a four track to four track mix down and was surprised at how little care was taken with the process. Ultimately they came away with a mix of 'Take 10' from the session.

It would be another five days before The Beatles would continue to work on the song. On June the 19th, The Beatles went back into the then called EMI Studio. It was to be a session in studio 3 and would run from approximately 7 pm to 1:45 am.

Geoff Emerick and 2nd engineer Richard Lush prepared a tape copy of the Olympic Studio rhythm track onto track one of a new four-track tape. Onto track two they recorded more drums from Ringo, a piano played by George Martin, and a banjo played by John. Onto tracks three and four were recorded John on lead vocals and Paul and George on backing vocals. Johns lead vocals were apparently replaced later.

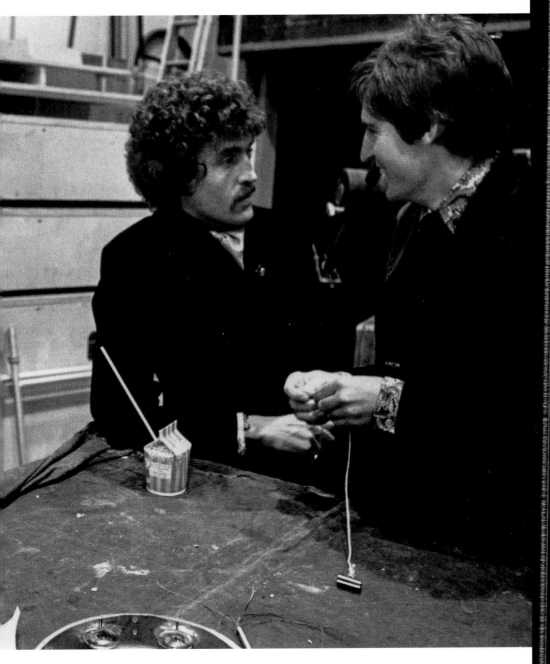

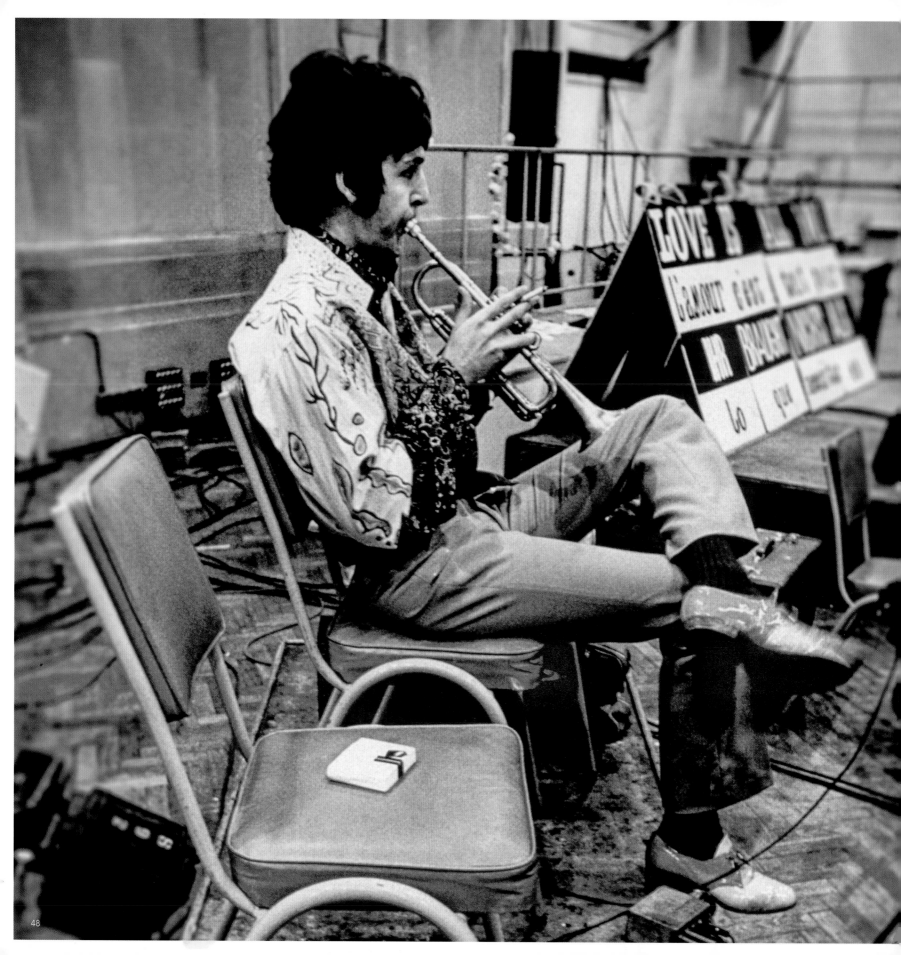

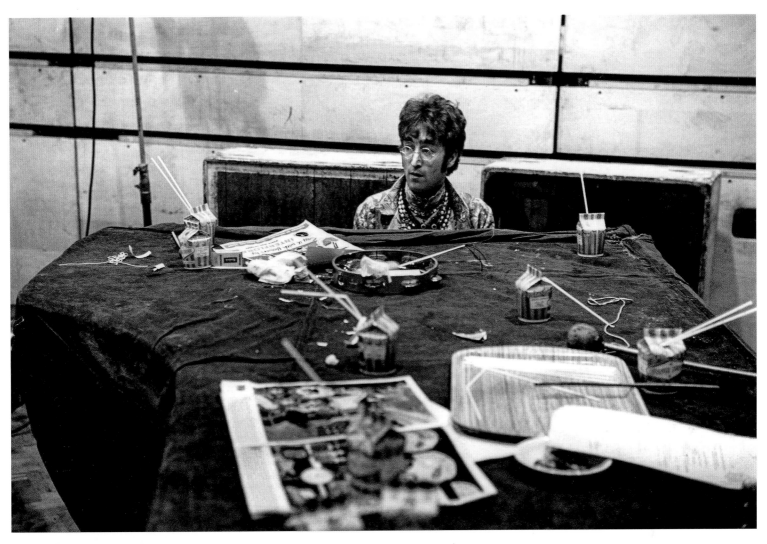

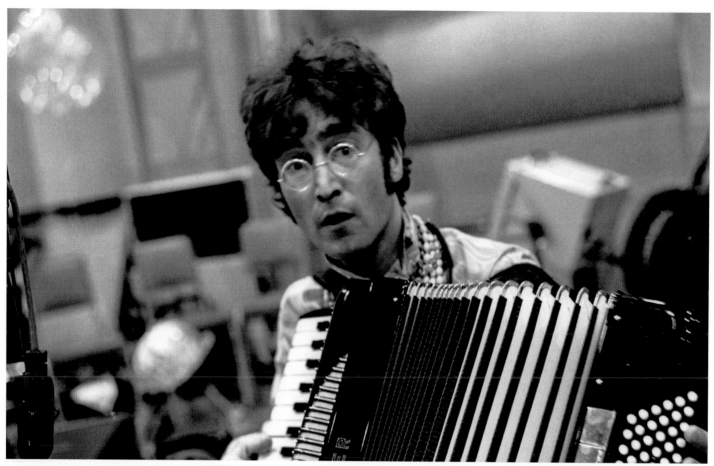

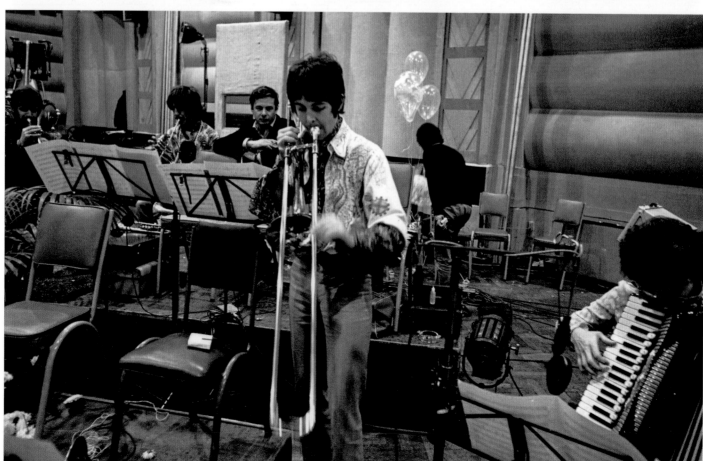

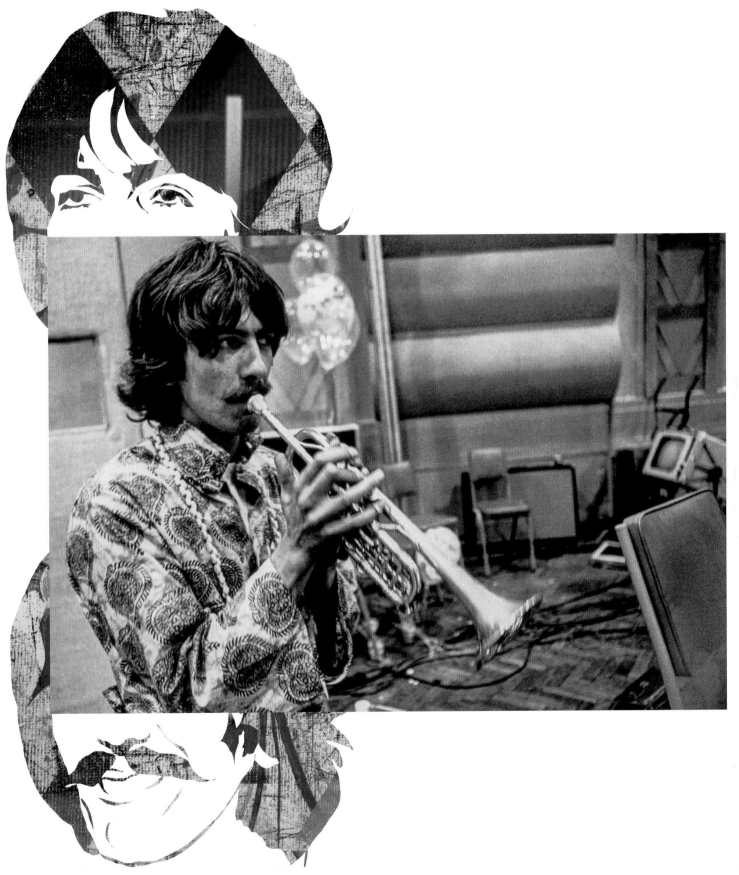

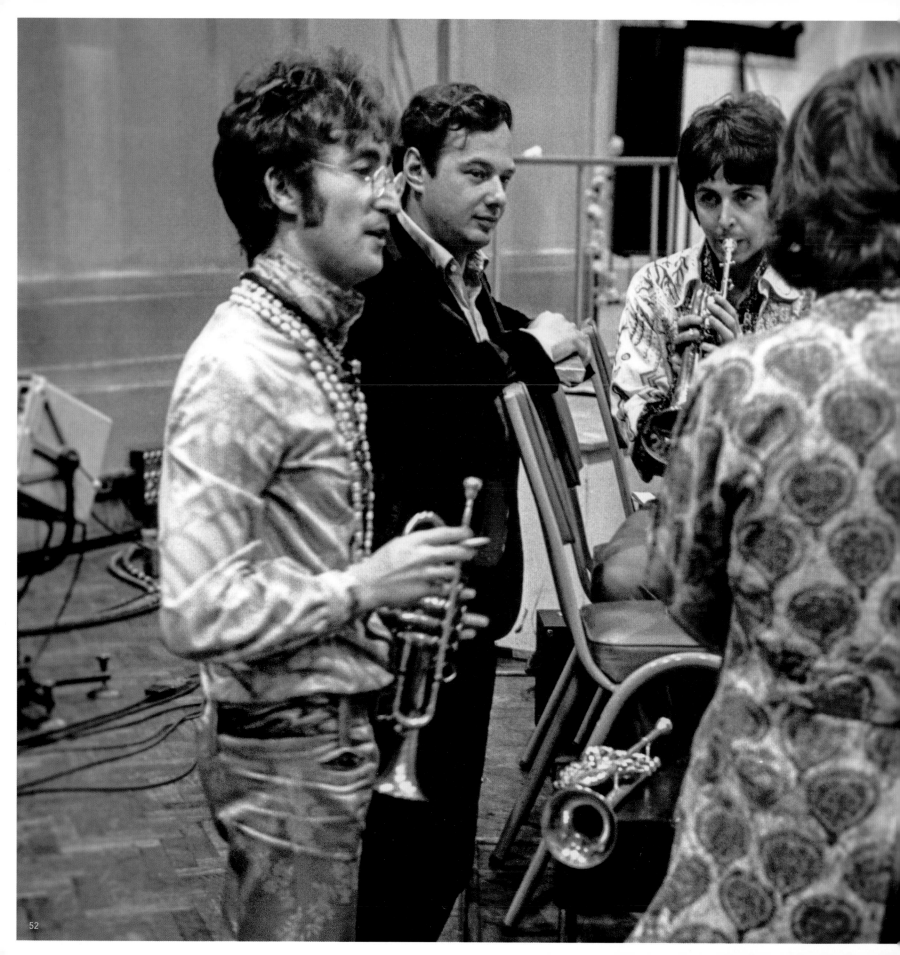

A three-piece with a drum
by Paul Skellett

DON'T FORGET THE ORCHESTRA

June the 21st. In Room 53 of EMI Studios between 4:30 and 5 pm the first mono mix was forged by George Martin and engineers Malcolm Addey, and Phil McDonald. This mono mix was of the rhythm track recorded at Olympic Studios and was documented as "remix 1". Later that evening a similar mono mix, this one unnumbered, was prepared by Martin, Emerick and Lush. This was cut as an acetate and was presented to Derek Burrell Davis, director of the BBC broadcast team, in preparation for the broadcast.

"So then we thought, 'Ah well, we'll have some more orchestra around this little three-piece with a drum."
John Lennon

"I did a score for the song, a fairly arbitrary sort of arrangement since it was at such short notice."
George Martin from his book "All You Need Is Ears"

Although there would be live orchestration on the day, the orchestra did actually record a large section beforehand. Recording for the orchestration happened in Studio 1 on June the 23rd, between 8 and 11 pm.

The four-track tape was now full so a tape reduction (bouncing) was made of the orchestration. Throughout any recording process or pre-production organising, decisions that can sometimes tip the balance are made. In this case they effected the world's first satellite broadcast.

"In a fit of bravado, Lennon announced that he was going to do his lead vocal live during the broadcast, which prompted the ever competitive Paul to respond that if John was going to do that, he would play bass live, too. It seemed to me to be a foolhardy – though brave – decision. What if one of them sang or played a bad note in front of millions of viewers? But they were supremely confident, and they could not be dissuaded by George Martin, who was adamantly opposed, but as was usual by this point, had no real authority.

In an act of further defiance, John and Paul even talked George Harrison into doing his guitar solo live, which we all knew was a tricky proposition.

To my surprise, Harrison gave in without a whole lot of argument; my sense was that he was afraid of being embarrassed in front of his band mates. Only Ringo was completely safe, for technical reasons: if the drums were played live, there would be too much leakage onto the microphones that were going to be picking up the sound of the orchestra. Ringo nodded his head solemnly when I explained that to him. I couldn't tell whether he was relieved at being absolved of the responsibility of playing live, or whether he felt left out."
Geoff Emerick

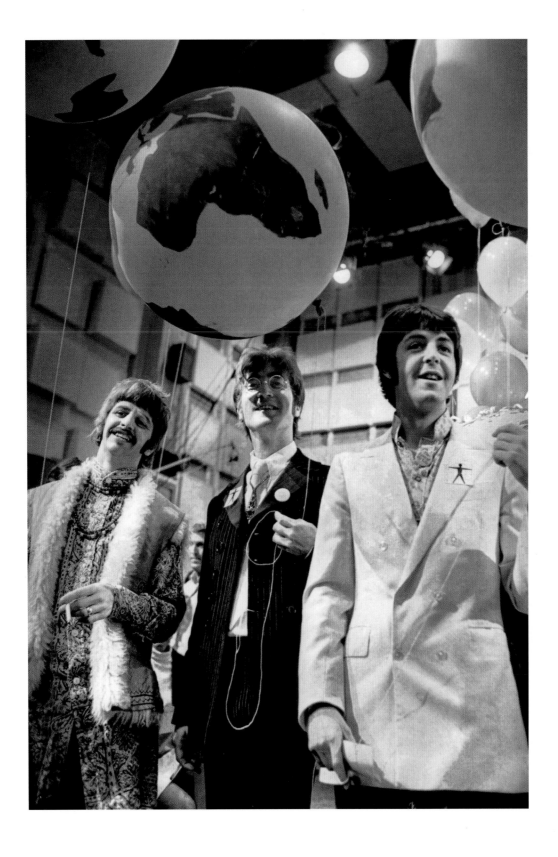

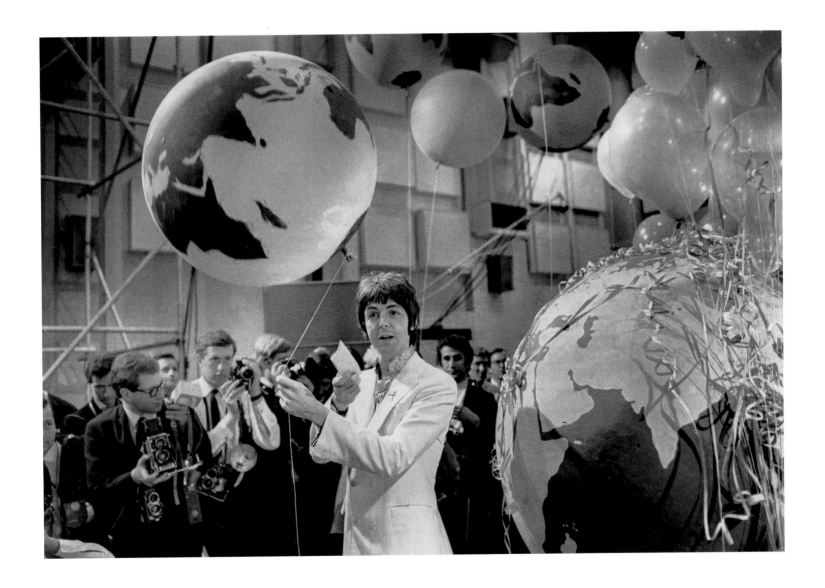

Saturday June the 24th, 1967 (tomorrow is the big day)! In anticipation of this momentous occasion EMI opened the normally closed gates to the mansion of music and allowed in more than 100 journalists and photographers. The Beatles paraded and posed for the media for most of the morning. The BBC rehearsal was planned for between 2 and 4 pm. The rehearsal for the following day's events were conducted in Studio One. All were in attendance, The Beatles, the orchestra and Michael Vickers. Mike was the former guitarist, flautist and saxophonist with the band, Manfred Mann. Mike was asked if he could conduct the orchestra due to George Martin being fully engaged in the control room.

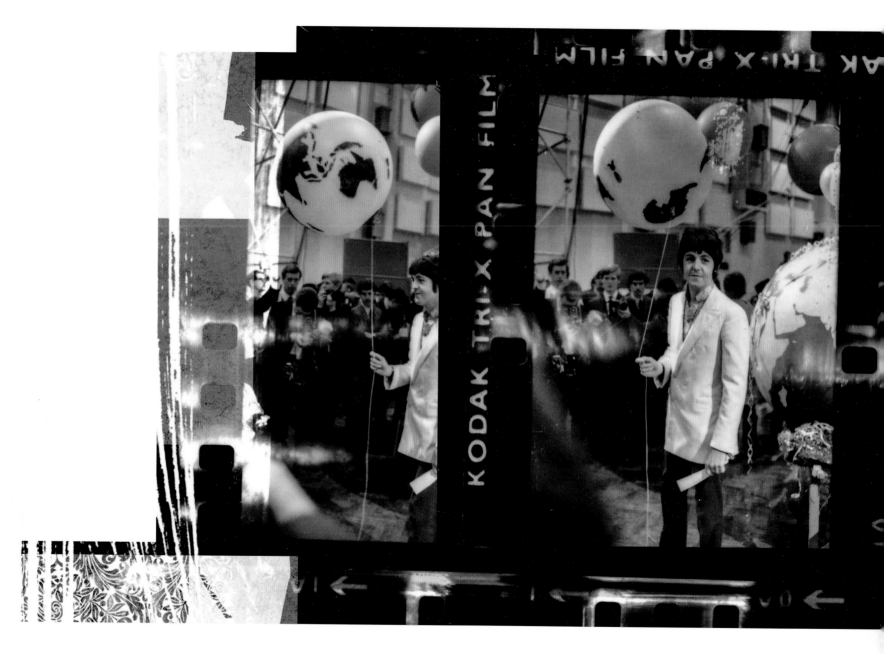

During the rehearsal Brian Epstein called a meeting with The Beatles and George Martin.
Brian wanted to talk about the prospect of the next day's performance being released as The Beatles next single release. No objections from John, of course, it was his song. Paul was talked into it, but George was against the idea. Geoff Emerick believes it may have been a confidence issue due to nailing the guitar lead break. George was finally talked around when George told him he could re-overdub the guitar if required.

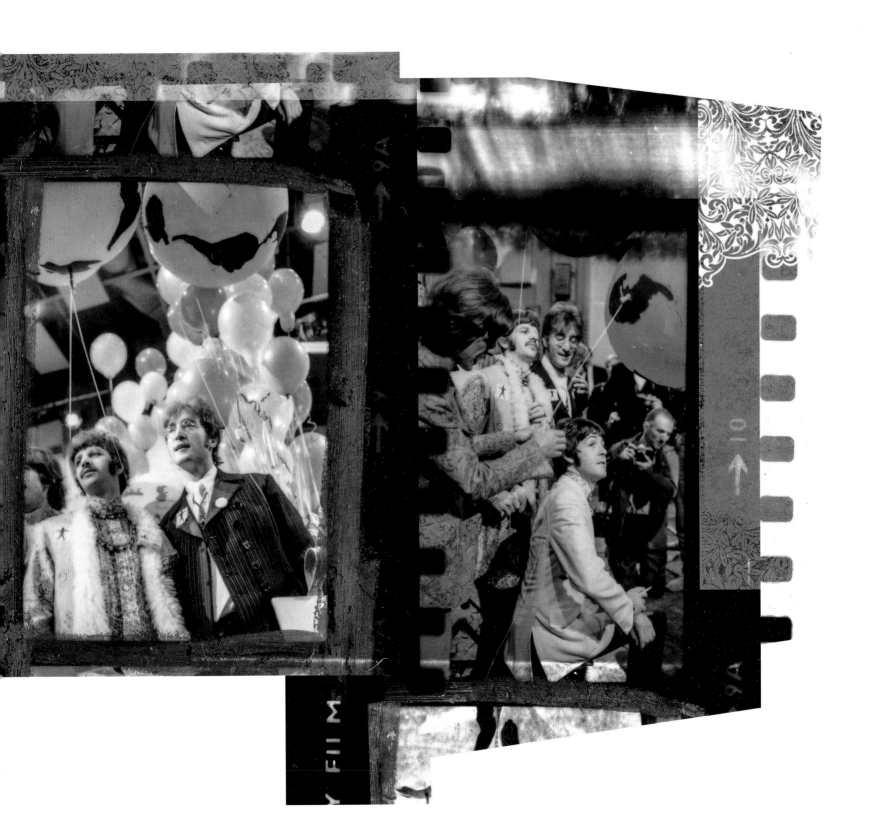

R 56

A **ALL YOU NEED IS LOVE**
(LENNON AND McCARTNEY)

B **BABY YOU'RE A RICH MAN**
(LENNON AND McCARTNEY)

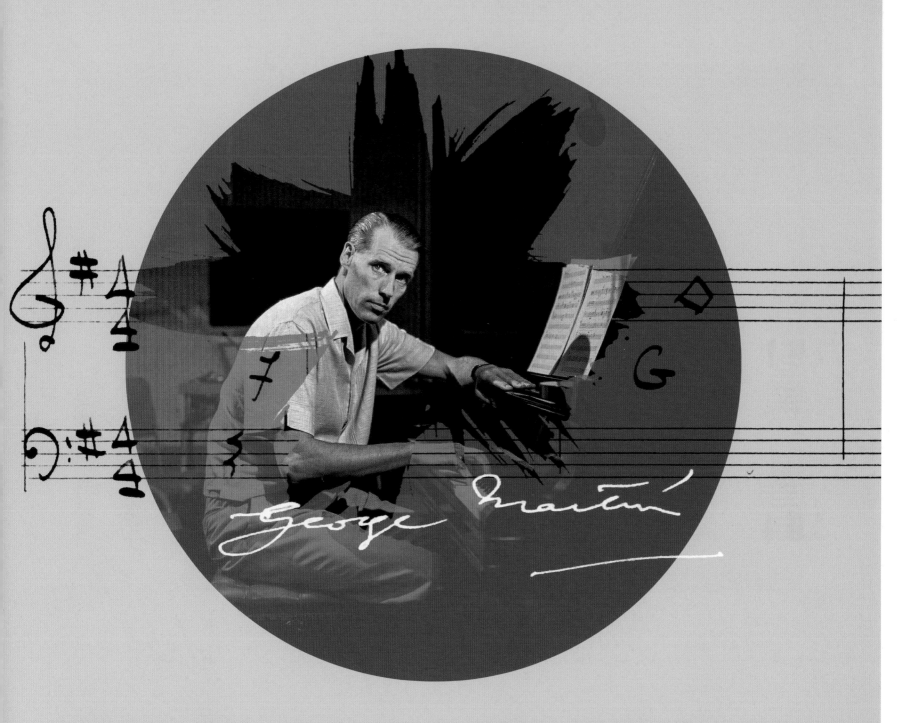

Once rehearsals were concluded further overdubbing was undertaken in preparation for the following day, based on the decision to release the recording as The Beatles' next single.

"Adding to the chaos was John's insistence on making a last minute change to the arrangement, which sent George Martin into a tizzy – he was doing the orchestral score and had to rapidly come up with new sheet music for the musicians, who milled around impatiently waiting for him. To his credit, George came up with a spectacular arrangement, especially considering the very limited time he had to do it in and the odd meters that characterized the song." From the book "Here, There And Everywhere" by Geoff Emerick

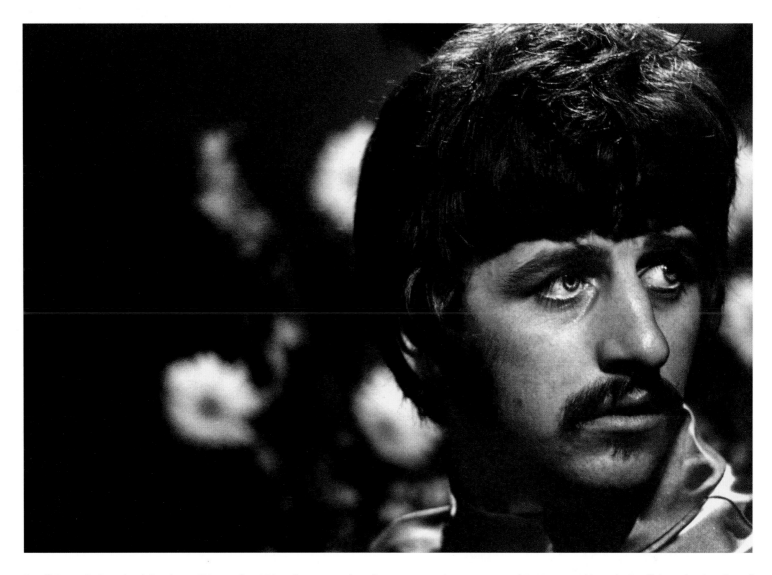

Geoff Emerick described the day as"Horrendous!" It only goes to show how amazing the engineers of EMI were. Although Geoff thought the idea of recording what they did without the link-up was ridiculous, they did. It can't be denied, it was an amazing feat.

The cameras were linked by way of a carpet of cables, all configured and connected to the BBC outside broadcast vans that had been ushered into the tight Abbey Road car park. High above all the action the Early Bird, Lana Bird and ATS/B satellites were waiting to receive and deploy.

With the rhythm track completed (Take 58 was the broadcast version), the live elements that would be performed were; vocals, bass, lead guitar for the mid eight, drums and of course, the orchestra.

"The day of the performance came, with television cameras rolling into the big Number One studio at Abbey Road. But I was still worried about the idea of going out totally live. So I told the boys: 'We're going to hedge our bets. This is how we'll do it. I'll have a four-track machine standing by, and when we go on the air I'll play you the rhythm track, which you'll pretend to be playing. But your voices and the orchestra will really be live, and we'll mix the whole thing together and transmit it to the waiting world like that.' The BBC's mobile control unit was set up in the forecourt at Abbey Road, and I was to feed them the mix from our control room inside the studios. Geoff Emerick, my engineer, was sitting right next to me but, even so, communication was rather hampered by the fact that a television camera was sitting right over us, watching our every move." George Martin

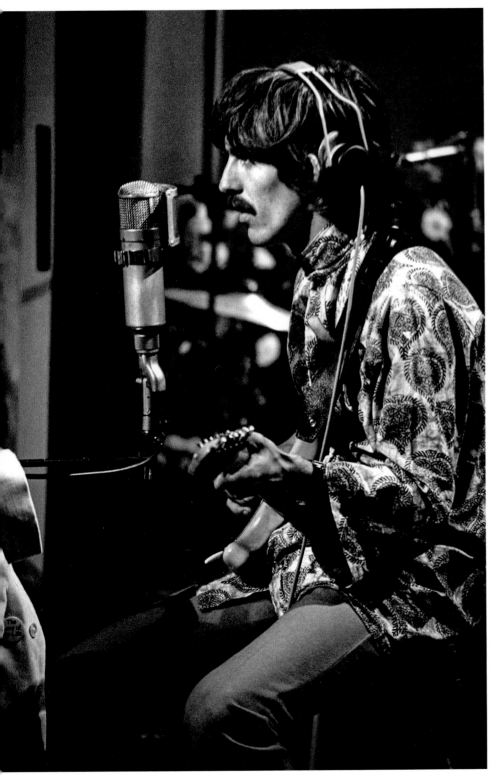

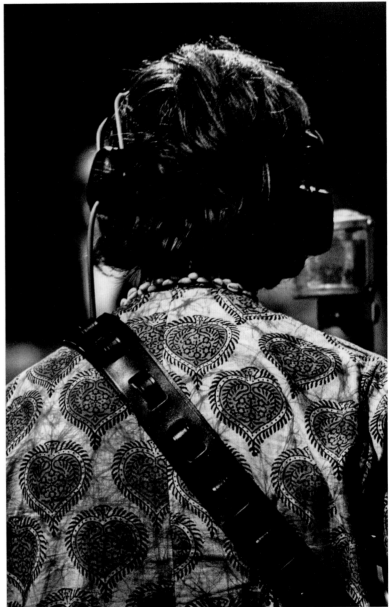

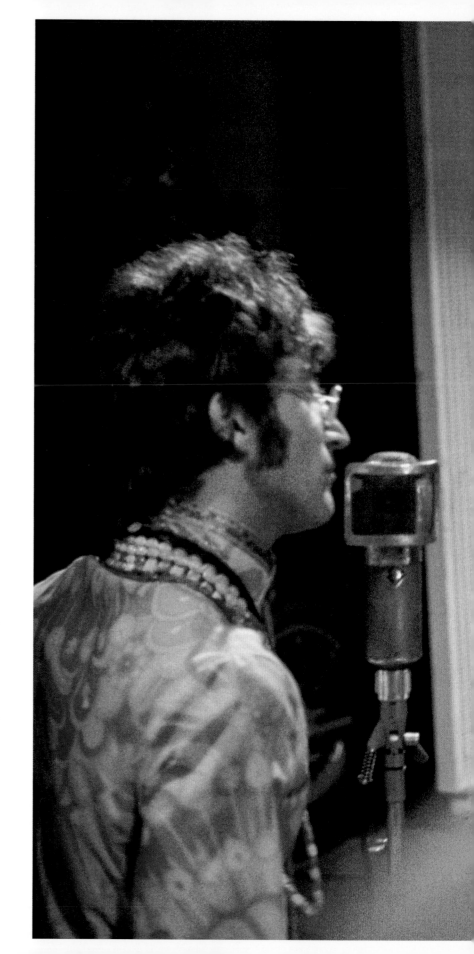

"I noticed George Harrison engaged in conversation with the television director for quite a long time. I had no idea what they were talking about, but I did notice during the broadcast that the camera was not trained on George during his guitar solo. Perhaps he requested that specifically, either because he didn't have confidence in his playing, or because he felt it was likely that he would replace the part later."

Geoff Emerick

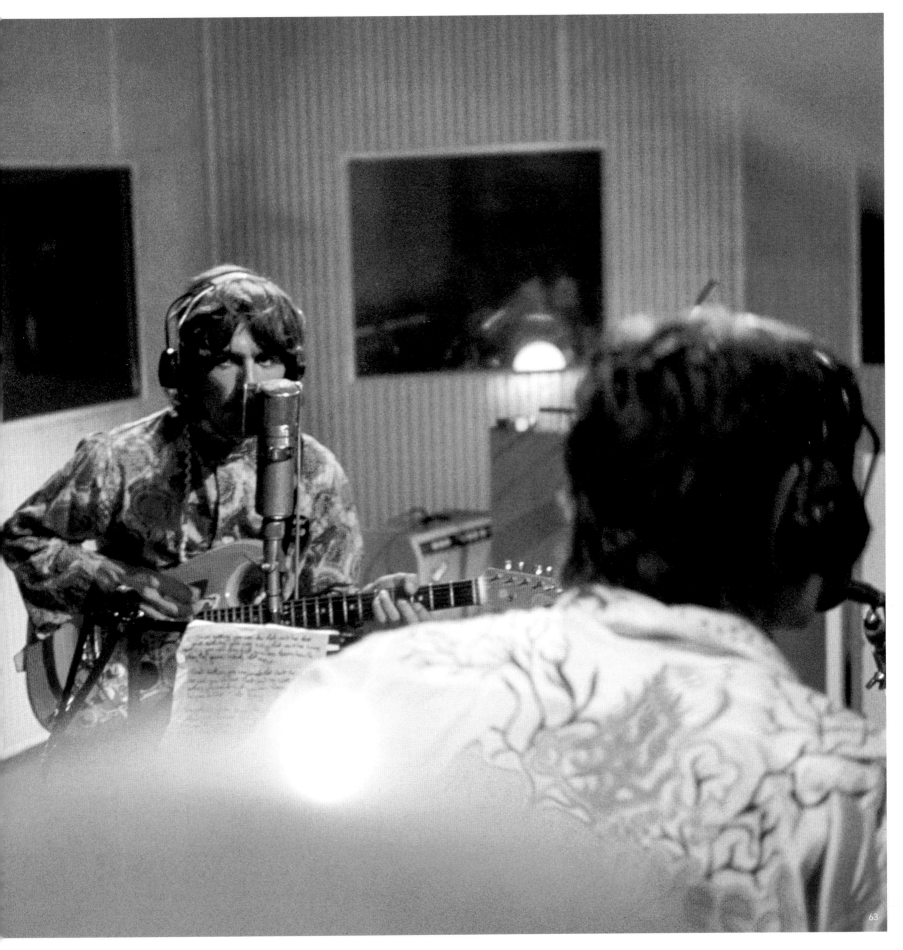

"George Martin...wrote the end of 'All You Need Is Love," Paul explains. *"It was a hurried session and we said, 'There's the end, we want it to go on and on.' Actually, what he wrote was much more disjointed, so when we put all the bits together, we said, 'Could we have "Greensleeves" right on top of the little Bach thing?' And on top of that, we had the 'In The Mood' bit." Trumpeter David Mason remembers, "We played bits of Bach's Brandenburg concerto in the fade-out."* Paul McCartney

All good things have to come to an end and ultimately it was The Beatles decision as to how the song should come to a close.

'How do you want to get out of it?' 'Write absolutely anything you like, George,' they said. 'Put together any tunes you fancy, and just play it out like that.' The mixture I came up with was culled from the 'Marseillaise,' a Bach two-part invention, 'Greensleeves,' and the little lick from 'In The Mood.' I wove them all together, at slightly different tempos so that they all still worked as separate entities." George Martin

Unfortunately, George Martin's creative freedom turned on him. Thinking that all the tunes he mixed together to create the song's conclusion were out of copyright was a miscalculation.

"I was being paid the princely sum of fifteen pounds for arranging the music and writing the bits for the...ending, and I had chosen the tunes for the mixture in the belief that they were all out of copyright. More fool me. It turned out that although 'In The Mood' itself was out of copyright, the Glenn Miller arrangement of it was not. The little bit I had chosen was the arrangement, not the tune itself, and as a result EMI were asked by its owners for a royalty. The Beatles, quite rightly I suppose, said: 'We're not going to give up our copyright royalty.' So Ken East, the man who had by then become managing director of EMI Records, came to me and said: "Look here, George, you did the arrangement on this. They're expecting money for it.' 'You must be out of your mind,' I said. 'I get fifteen pounds for doing that arrangement. Do you mean to say I've got to pay blasted copyright out of my fifteen quid?' His answer was short and unequivocal. 'Yes.' In the end, of course, EMI had to settle with the publishers." George Martin

"Paul had requested a working microphone so that he could shout out ad-libs. The problem was that the mic I had set up blocked Paul's face on the camera angle they wanted to use. In the end, I acceded to the director's request that a smaller mic be substituted even thought it was not the mic I would normally have employed. I felt it was unlikely that whatever Paul ended up ad-libbing would be of significant importance to the record, and even if it turned out that it was, it was something we could easily overdub later. Geoff Emerick.

It's recalled that John Lennon was incredibly nervous on the day. When you take into consideration environmental factors, the after effects of acid surging through him, his reported current frame of mind and of course the nerve shredding realisation of what was about to happen, it's not surprising he was wandering around mumbling to himself.

"Richard and I were both struck by how visibly nervous John was, which was quite unusual for him: we'd never seen him wound up so tightly. He was smoking like a chimney and swigging directly from a pint bottle of milk, despite warnings from George Martin that it was bad for his voice – advice that Lennon studiously ignored. One time as I passed by, I heard John mumbling to himself, 'Oh, God, I hope I get the words right.' On this night he was forced to rely on his memory because his ever-present lyric sheet had to be placed off to the side due to the camera angle; if he turned his head to consult it, he'd be singing off-mic"

Geoff Emerick.

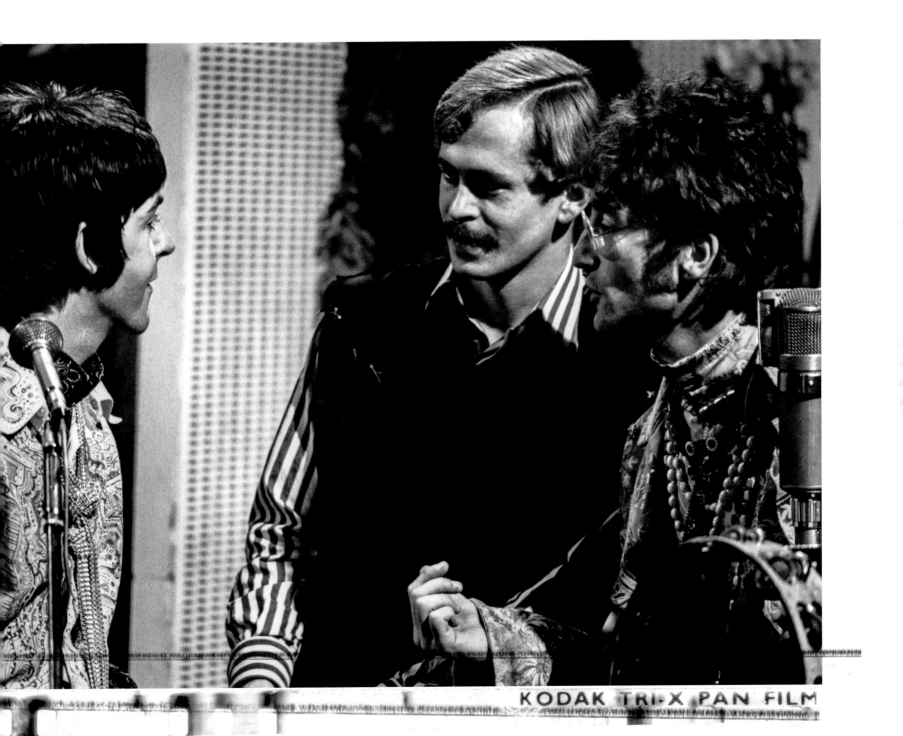

KODAK TRI·X PAN FILM

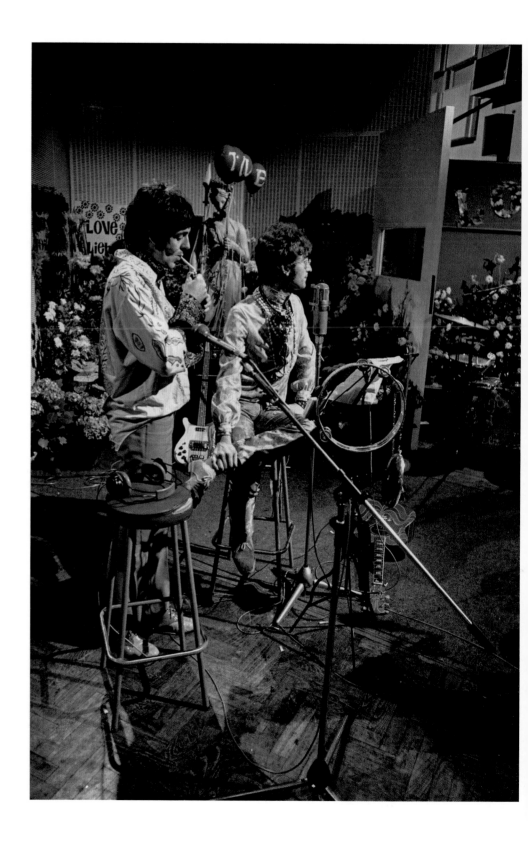

'Oh, God, I hope I get the words right.'

"I had Keith Moon next to me," Ringo recalls.

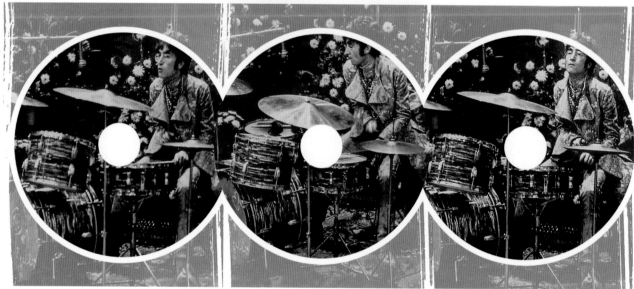

"Ringo isn't the best drummer in the world. He isn't even the best drummer in The Beatles!"?

John didn't actually make this comment. It was a joke coined by the British comedian, Jasper Carrott, in 1983.

Having been granted a break from rehearsals, on returning (around 6 pm), a party of celebrity friends had arrived for the broadcast.
Everyone had come in full psychedelic attire. These are the details which really emblazoned the hippie dream into the populace of the world, commercialising the extravaganza of beauty and love as well as offering hope to those toiling the shift work and nine to five rat race.
The Beatles wanted to invite those who they considered to be 'the beautiful people' of the day. In other words, their friends.

"If you look closely at the floor, I know that Mick Jagger is there. But there's also an Eric Clapton, I believe, in full psychedelic regalia and permed hair, sitting right there." George Harrison

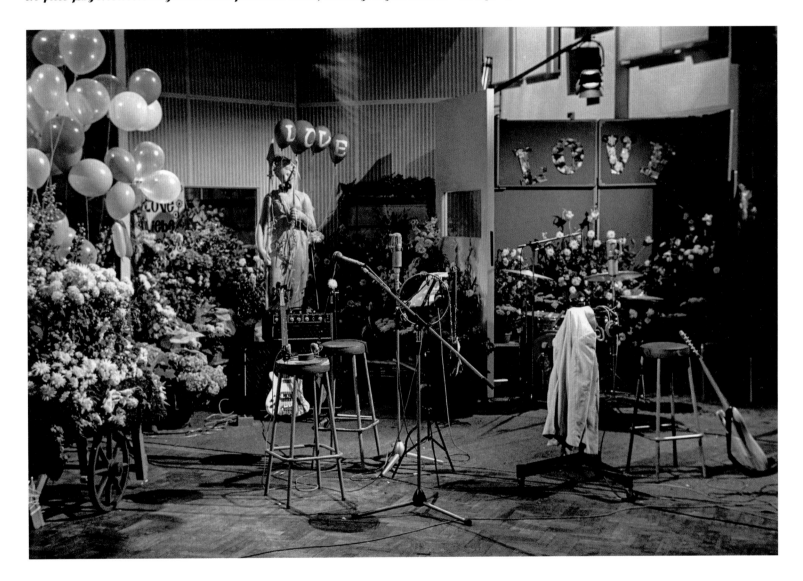

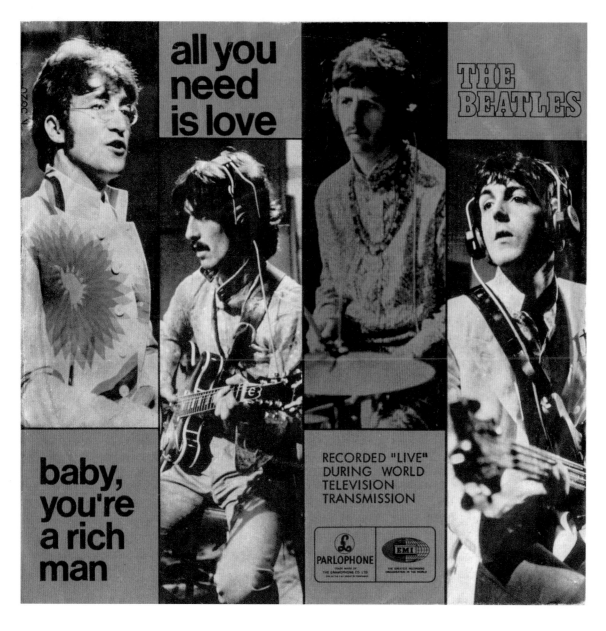

Organising the tape recording on the four track machine worked as follows;

Track One had a reduced mix of the rhythm section that had been pre-recorded by The Beatles.

Track Two was to accommodate the live bass guitar, lead guitar and drums.

(The drums had to be mic'd in order for Ringo to perform a live snare drum roll at the beginning of the song).

Track Three was to contain the live orchestra feed.

Track Four would take the live vocals from John and Paul.

Peter Vince, the balance engineer at EMI said that he would not have wanted to be in Geoff Emerick's shoes for all the tea in china. Apparently the level of stress and panic was becoming overwhelming as they got closer to the 'on air' announcement. The broadcast did actually kick in 40 seconds early, George Martin and Geoff were having a quick shot of whiskey. There was a mad panic to hide the bottles and glasses.

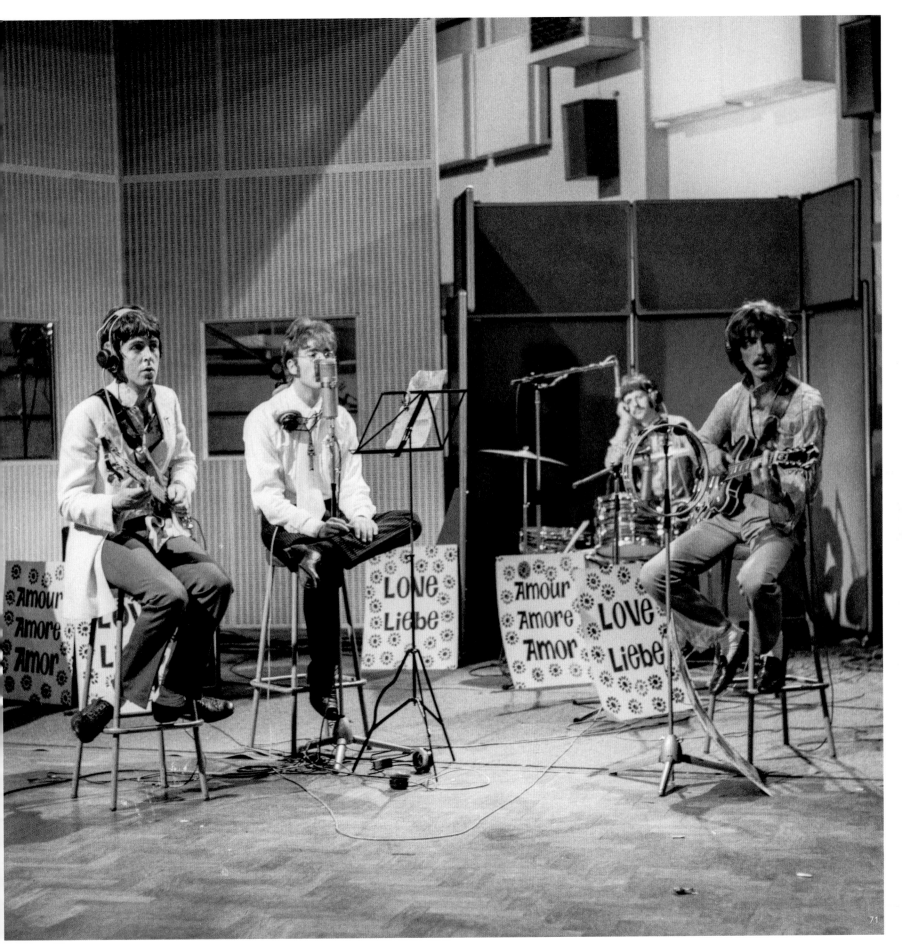

"*Paul strode into the control room at one point, and spent some time working on the bass sound with me. It struck me as a smart thing to do. Not only was he making certain that his instrument would come across the way he wanted it to, but getting out of the studio, away from the others and out of the line of fire, had a calming effect on both of us.*

NEW PARLOPHONE SINGLE R5620

EMI

ALL YOU NEED IS LOVE

THE · BEATLES

C/W BABY YOU'RE A RICH MAN

E.M.I. Records (The Gramophone Co. Ltd.) E.M.I. House, 20 Manchester Sq. London W.1

It gave us both a little sanctuary where we could focus on just one specific thing and not think about the monumental technical feat we would soon be attempting to pull off."

Geoff Emerick

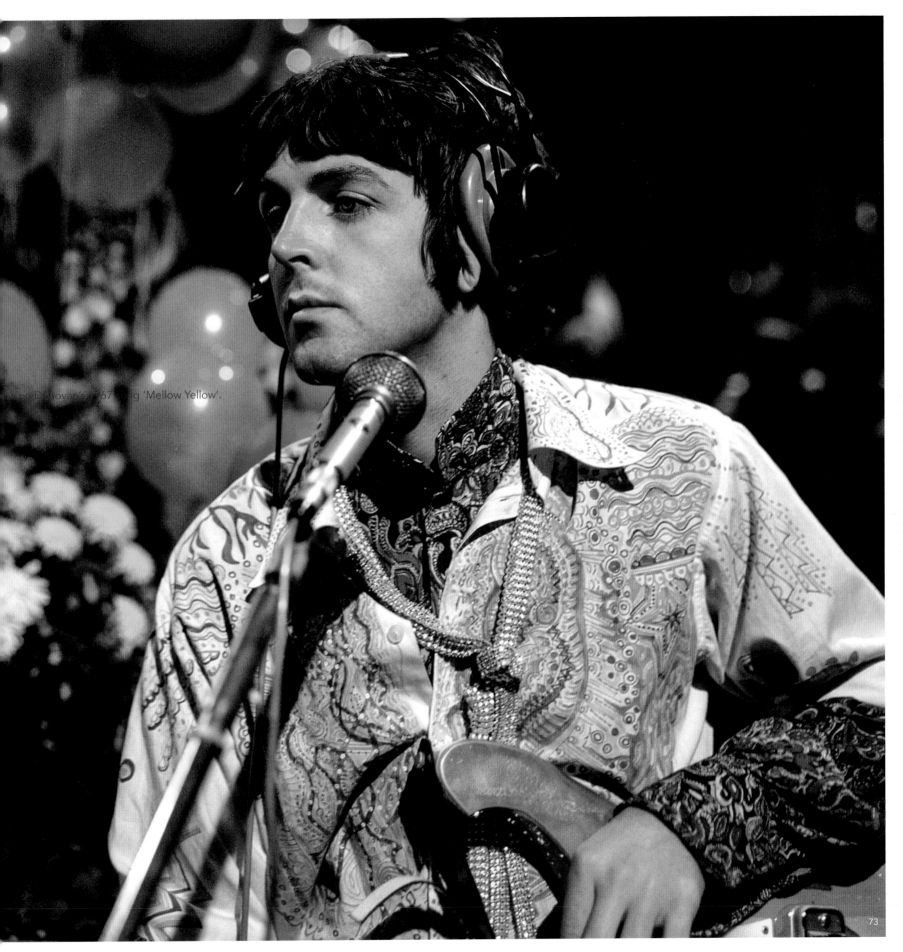

Peter Donovan's 1967 song 'Mellow Yellow'.

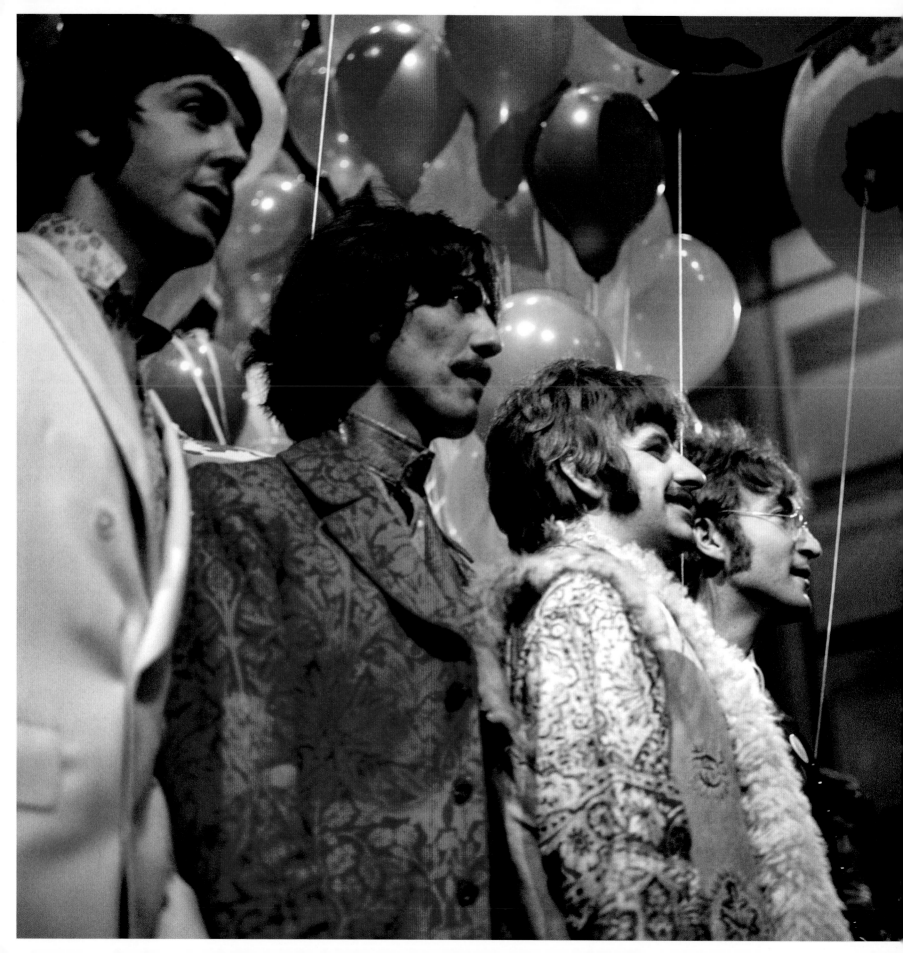

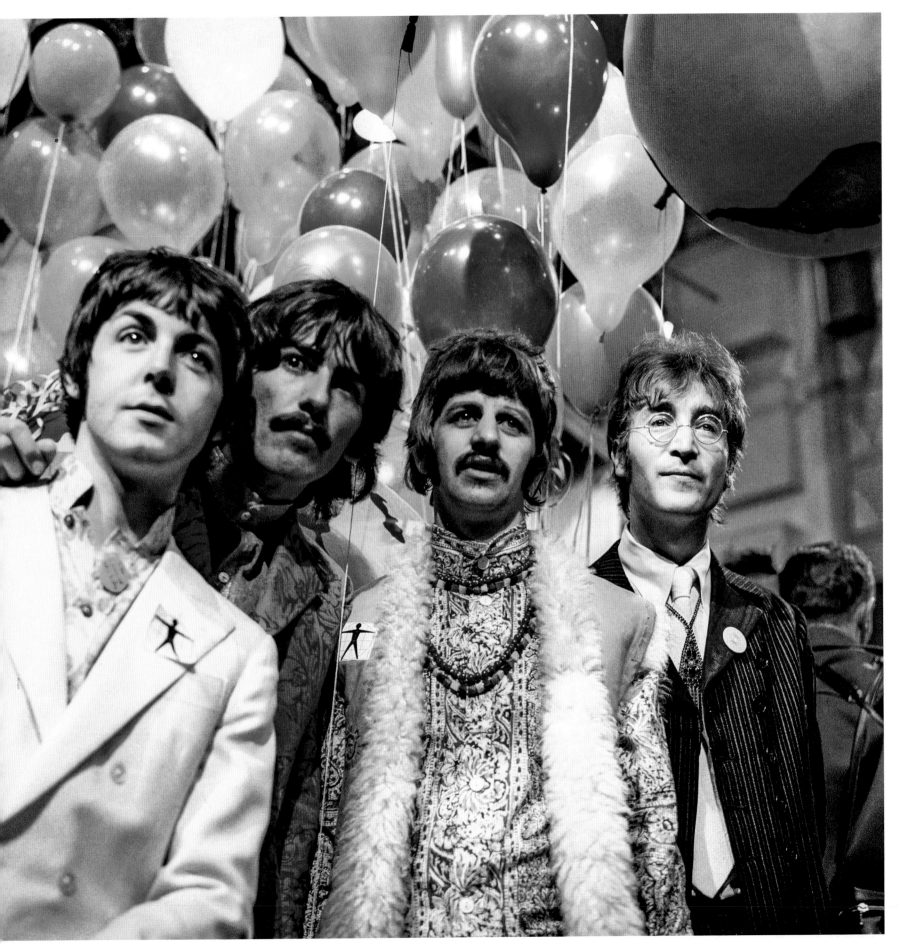

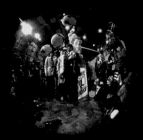
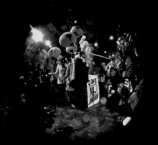
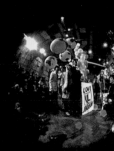

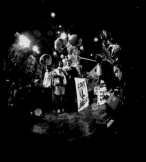
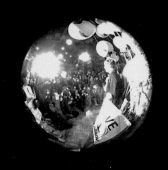
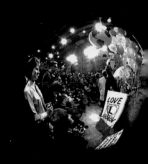
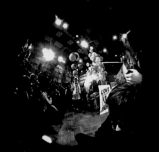
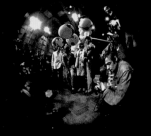
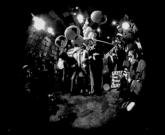
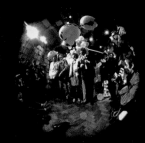

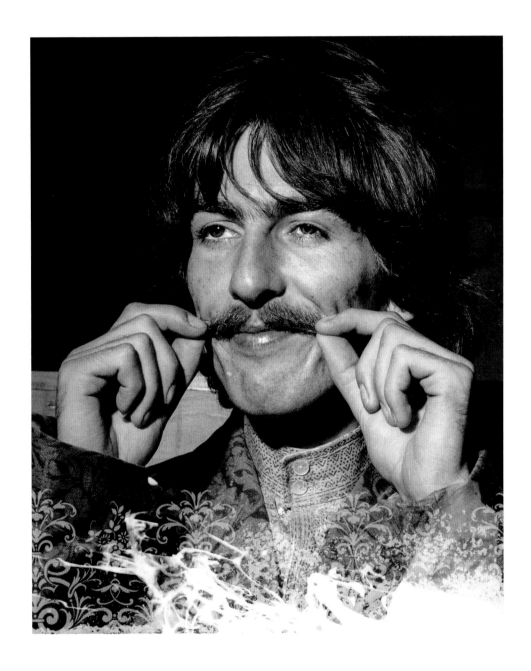

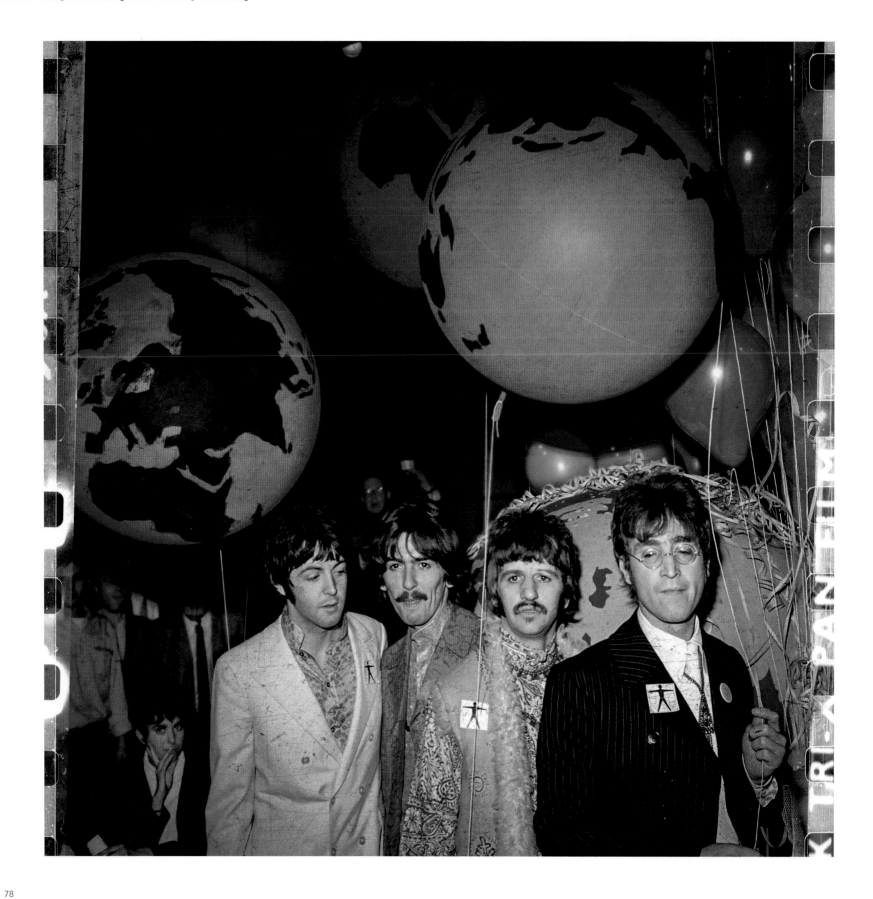

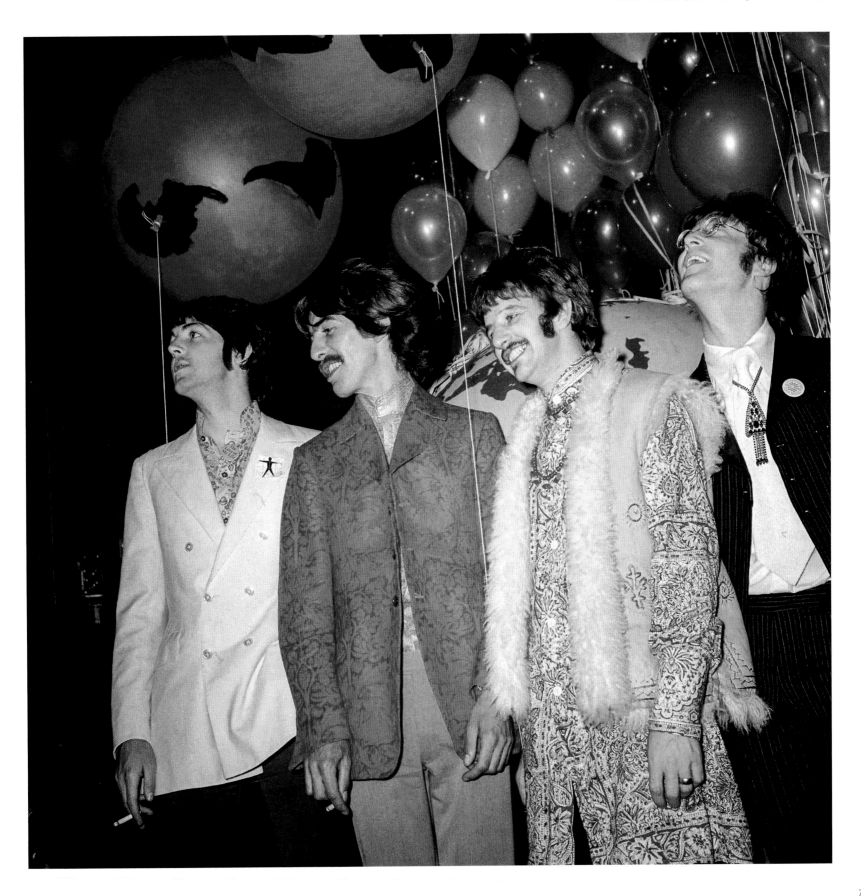

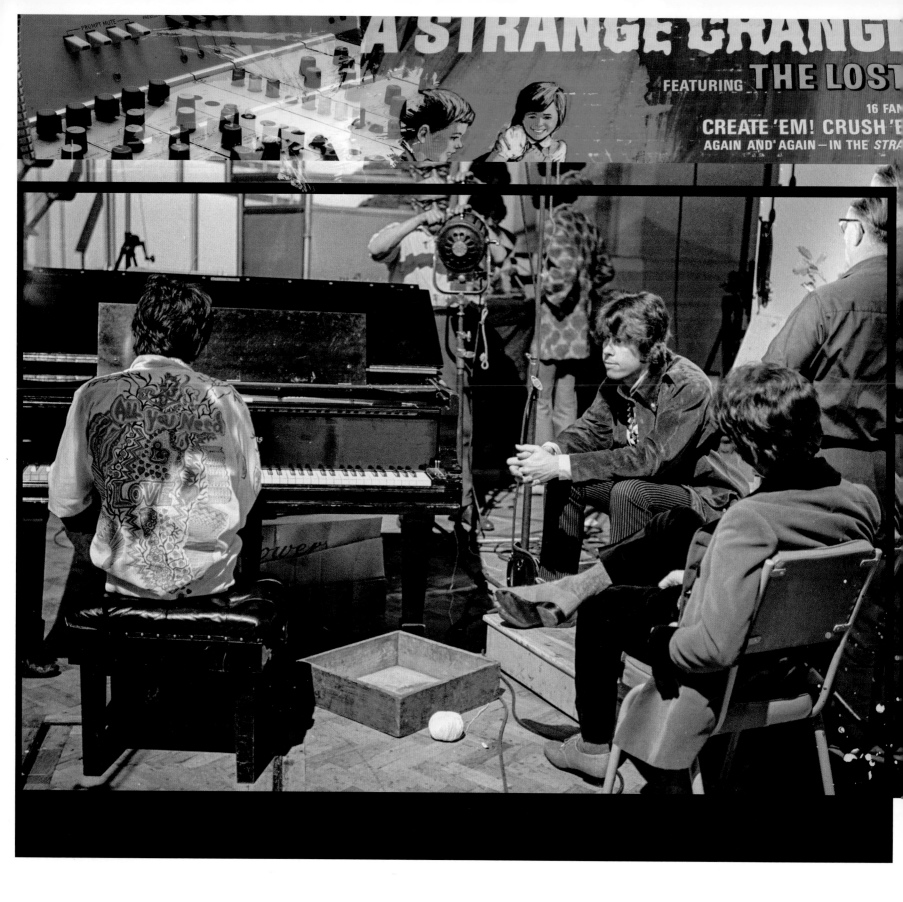

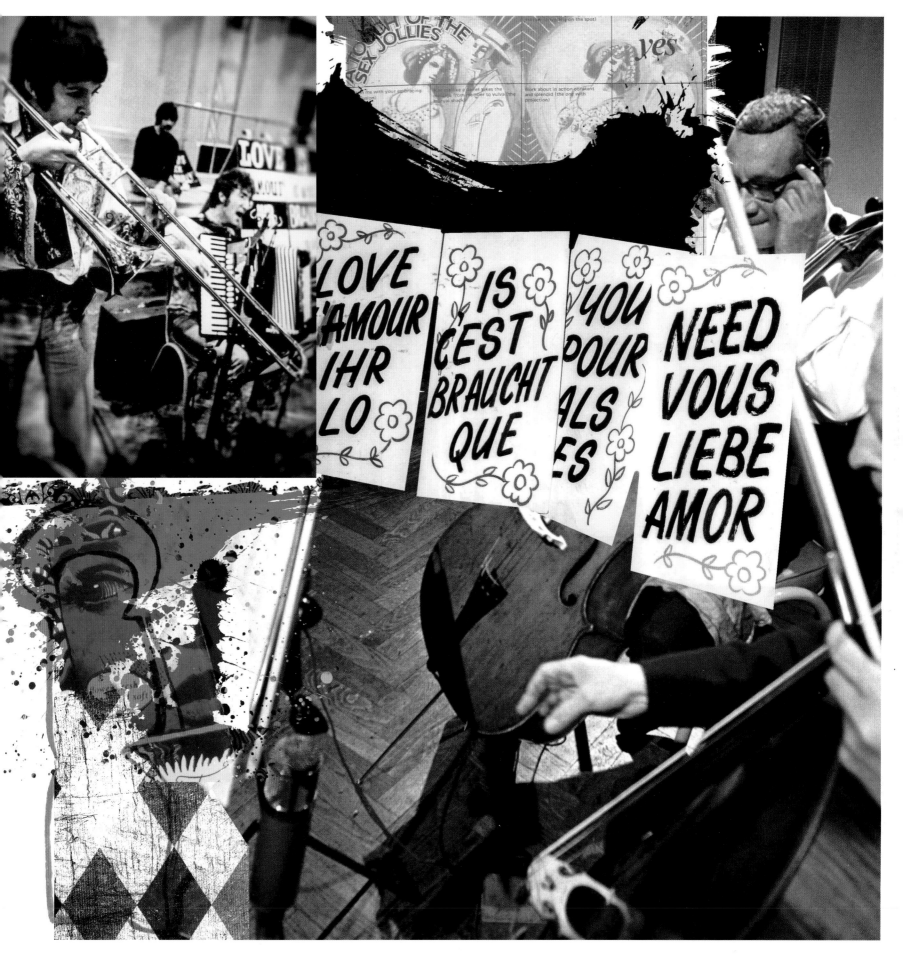

DTOA-8312

LOS BEATLES

nene eres un hombre rico
todo lo que necesitas es amor

The BEATLES

MONDOVISIONE

QMSP 16408

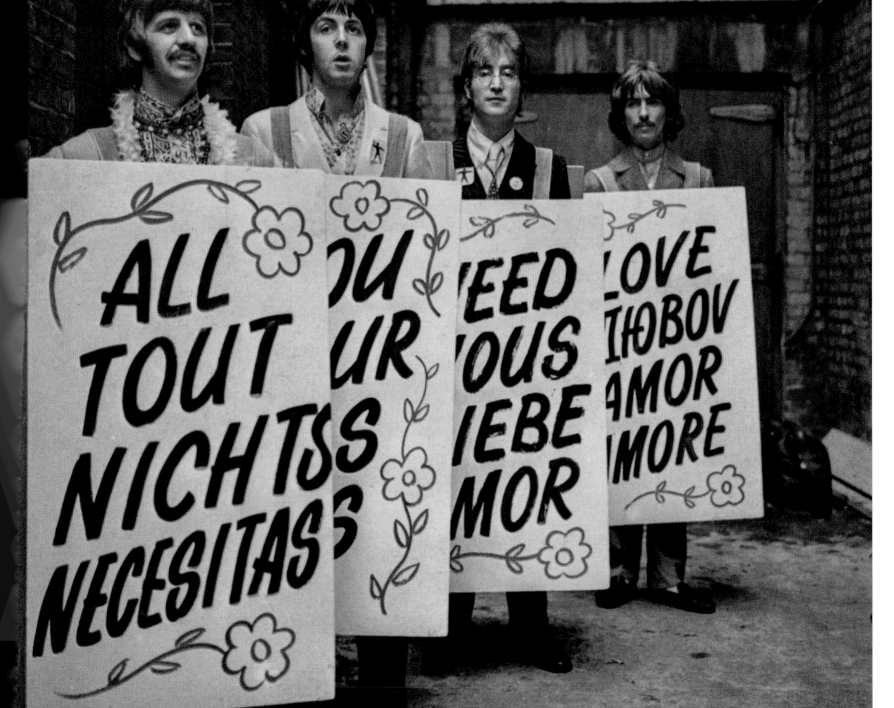

THIS TAPE RECORD

has been made on

EMITAPE

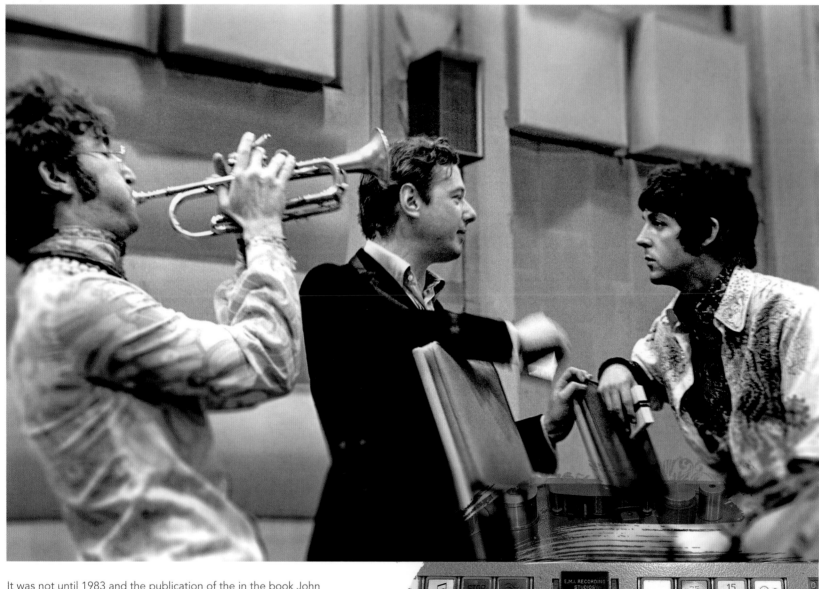

It was not until 1983 and the publication of the in the book John Lennon: In My Life by Pete Shotton and Nicholas Schaffner that it was revealed that John Lennon was the primary composer of the song.

It is typical of Lennon: Three long notes ("love -love -love") and the rise of excitement with at first speaking, then recital, then singing, then the climax and finally the redemption. This as opposed to McCartney's conventional verse, verse, middle part, verse or A,A,B,A.
Lennon felt that a good song must have a rise of excitement, climax and redeeming.

(thanks to Johan Cavalli, who is a music historian in Stockholm)

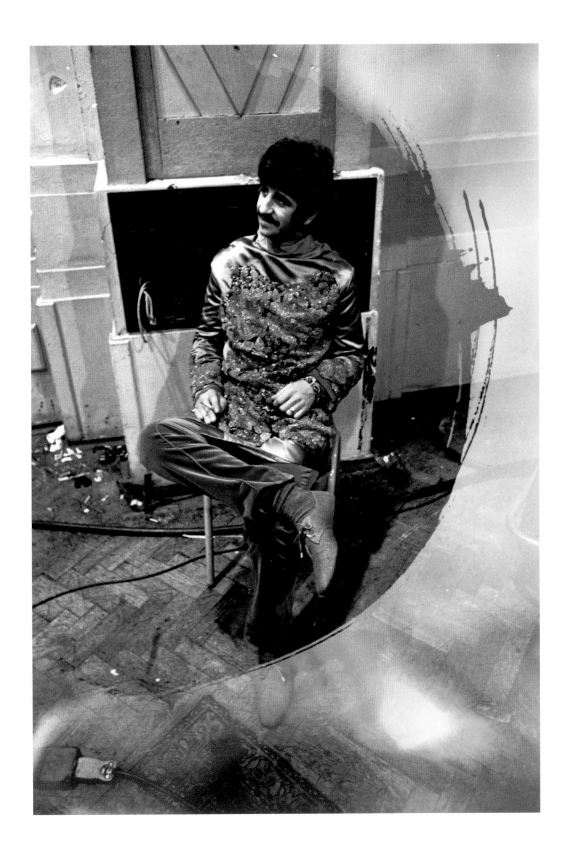

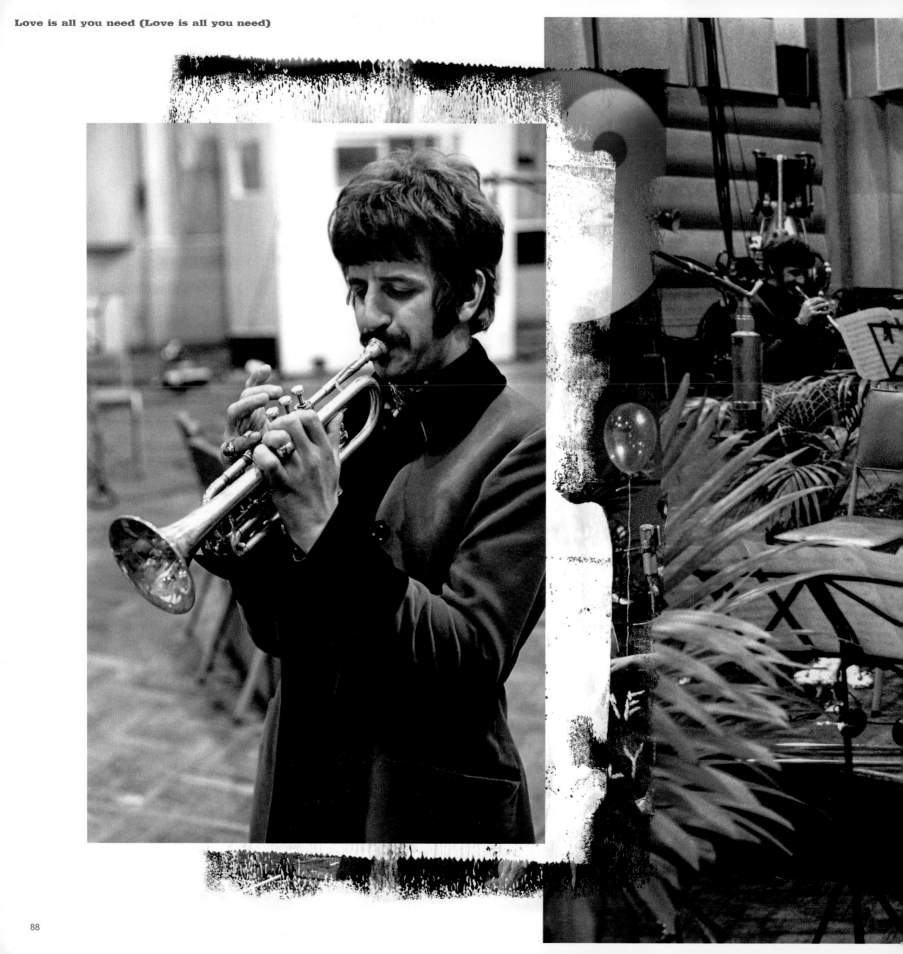

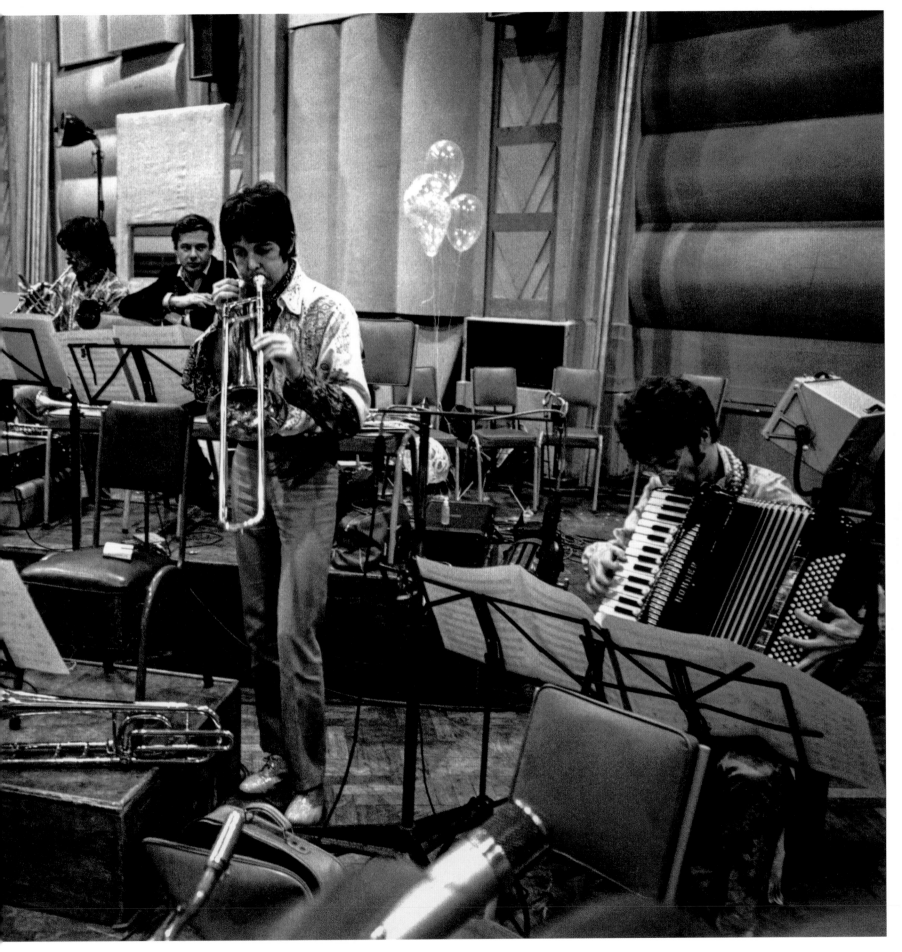

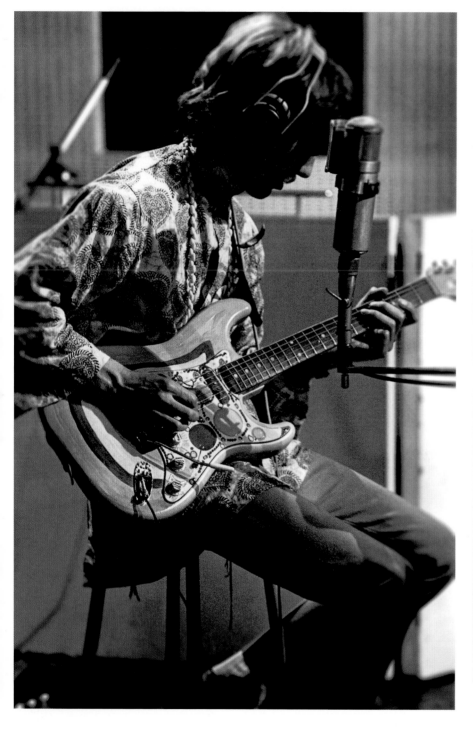

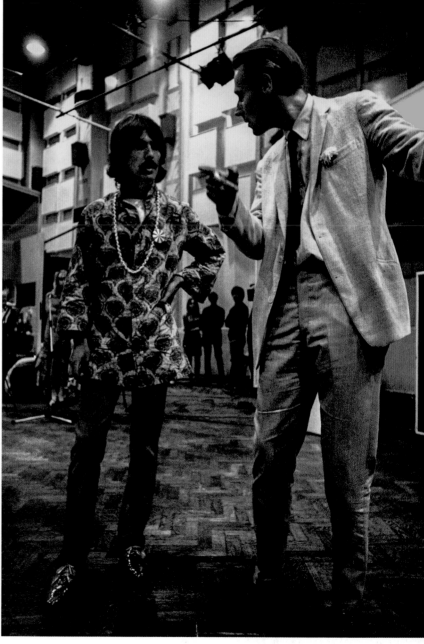

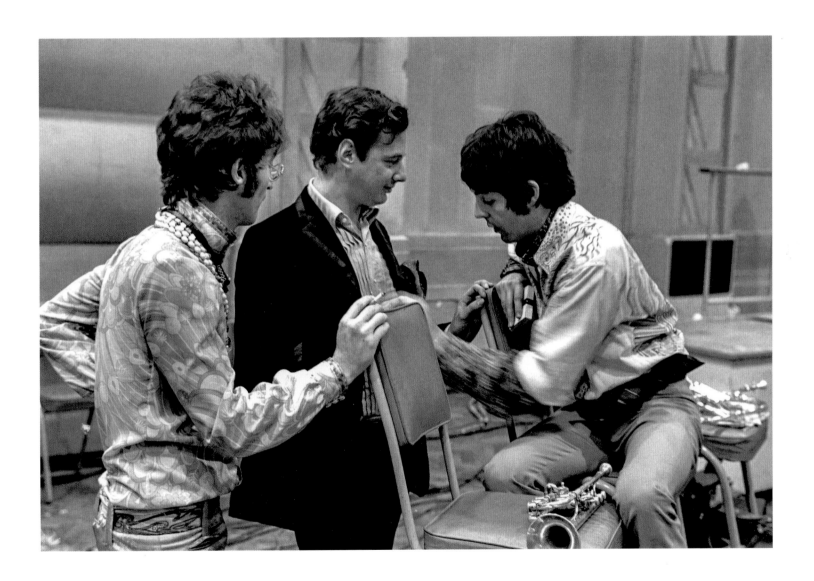

Rehearsals continue whilst waiting for the cue from the BBC that they were ready for broadcast. As you'd expect there were last minute technical problems linking the comms to the BBC truck in the car park. Mal Evans was there to get in on the act clearing away glasses and bottles of scotch before the world looked in on them all. The moment had arrived -

"Going on air...NOW!"

As the veil of Abbey Road was lifted, and the world gazed into the very heart of the mother that had conceived the recordings of The Beatles, studio one was filled with the sound of a midstream 'take 57', taking the reins, George Martin poised in the control room, thanked The Beatles for their work on the "vocal backing". He then instructed the tape operator:

"Run back the tape please, Richard."

As The Beatles sat waiting for the tape to be rewound and cued for the main performance, The Beatles could be heard nervously goofing around, a humorous resilience in the face of performance adversity. Fooling with their instruments and John singing, the boys were back in the foxhole of public exposure. John continues to sing:

"She loves you, yeah, yeah, yeah."

(During rehearsals, John is also heard singing "Yesterday"
and "She'll Be Coming Round The Mountain When She Comes.")

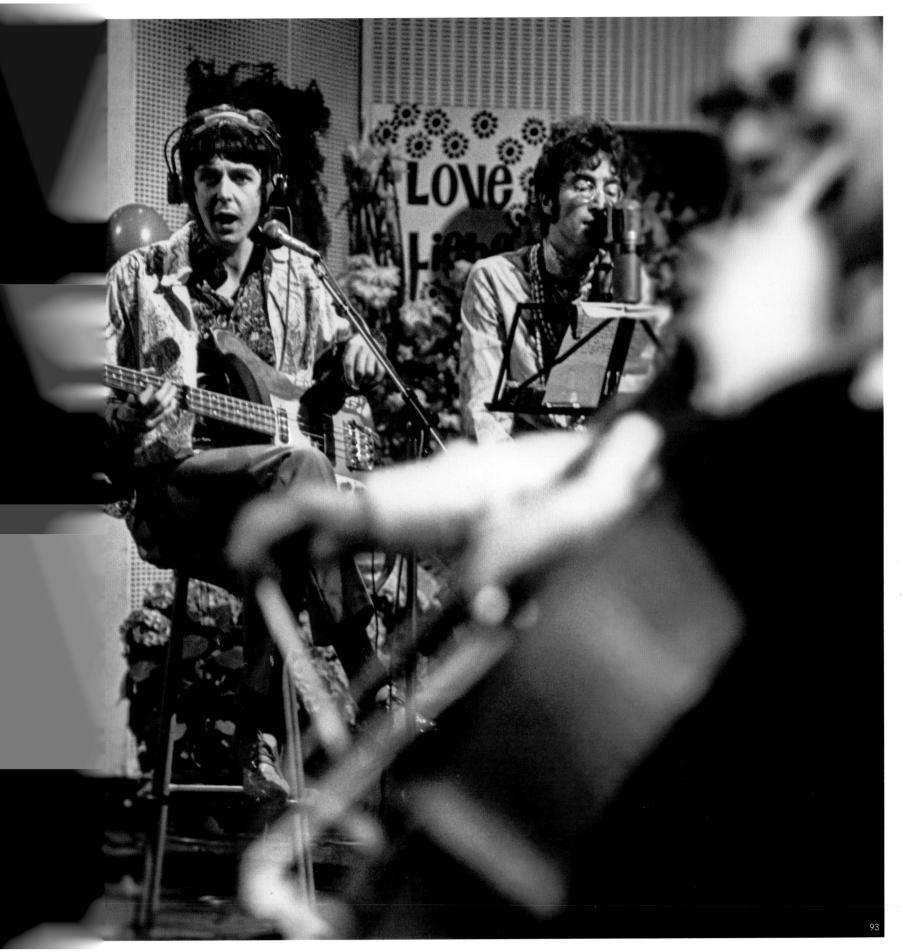

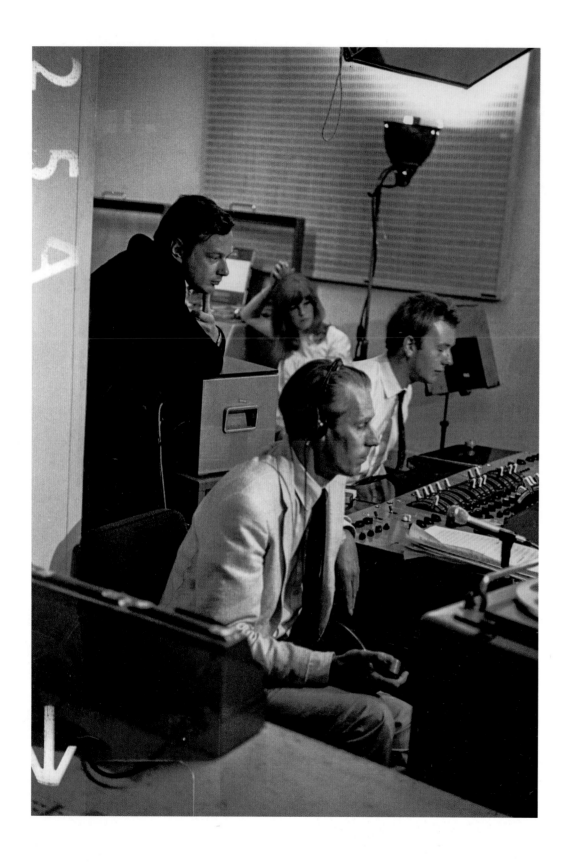

After John takes a sip of milk,
roadie Mal Evans collects
some empty tea cups,
the orchestra enters the
studio and takes their seats,
the previously recorded tape
is cued up and begins
to be played.

So starts 'take 58,'
the official take of the song for
the "Our World"
broadcast which spanned the
globe thanks to the Early Bird
'space booster', Lana Bird
and ATS/B satellites.

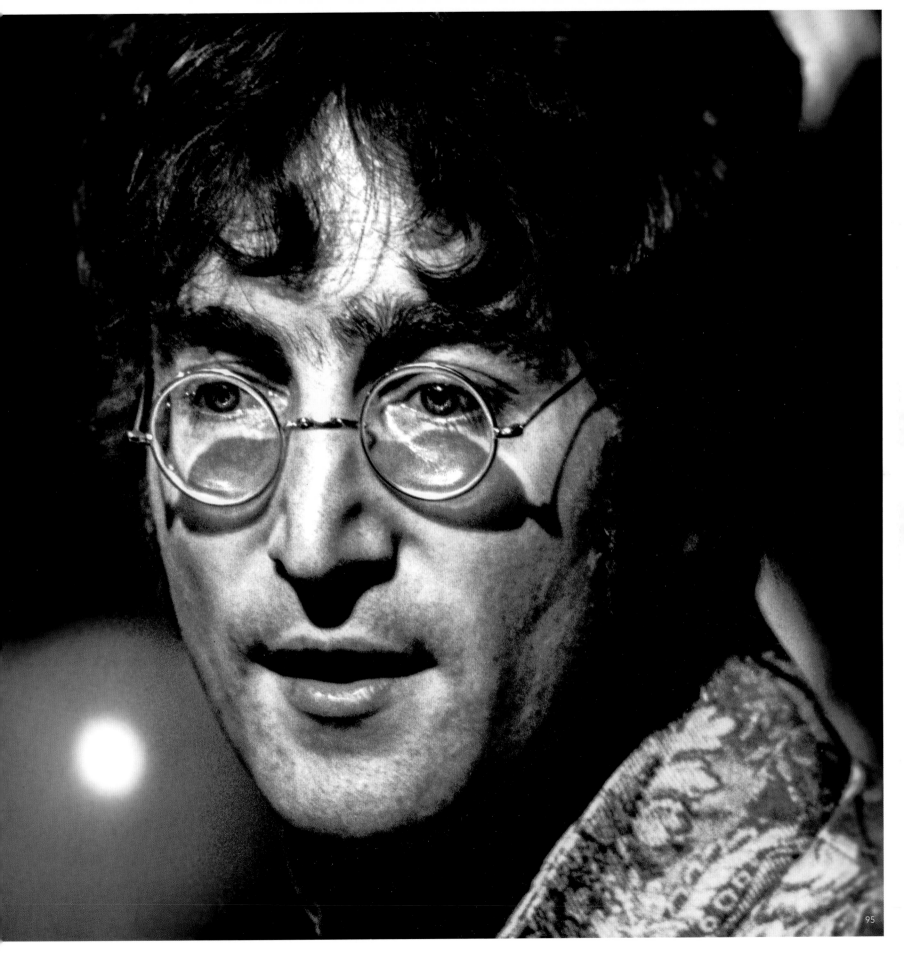

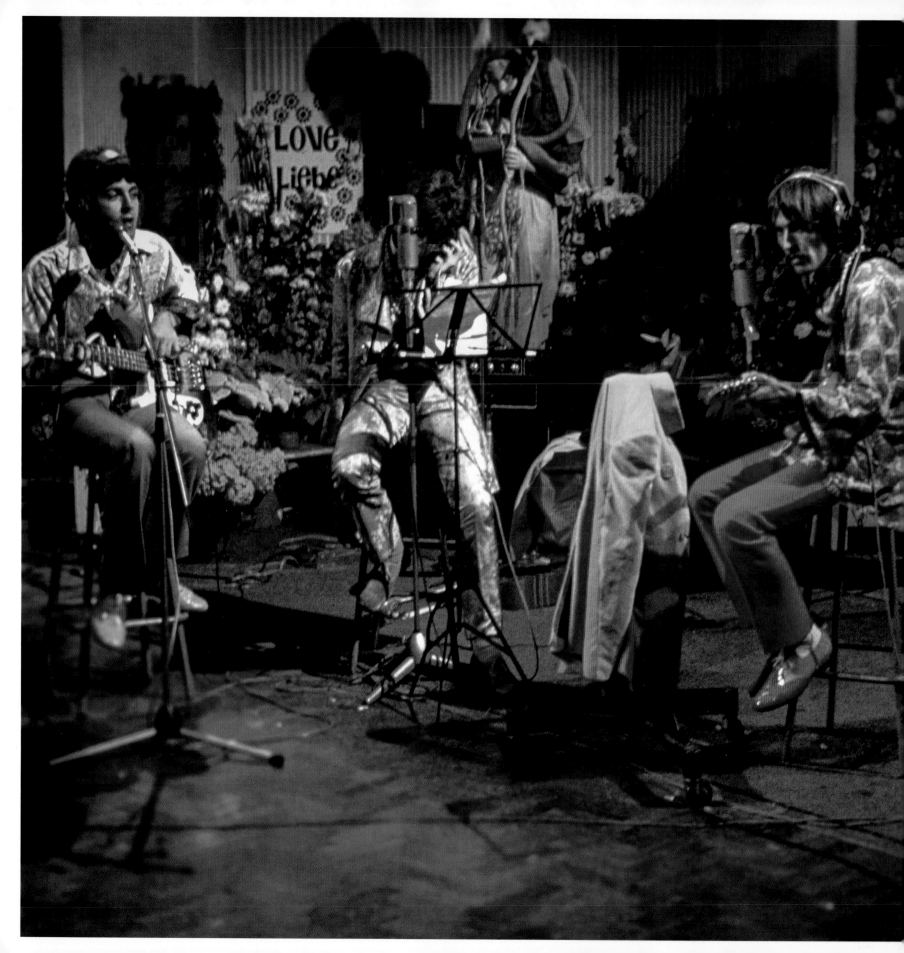

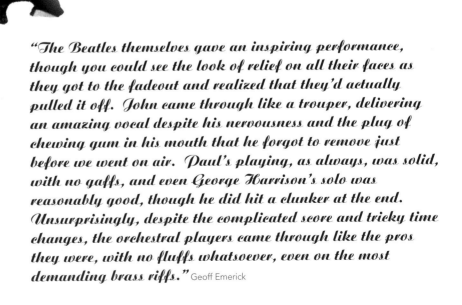

"*The Beatles themselves gave an inspiring performance, though you could see the look of relief on all their faces as they got to the fadeout and realized that they'd actually pulled it off. John came through like a trouper, delivering an amazing vocal despite his nervousness and the plug of chewing gum in his mouth that he forgot to remove just before we went on air. Paul's playing, as always, was solid, with no gaffs, and even George Harrison's solo was reasonably good, though he did hit a clunker at the end. Unsurprisingly, despite the complicated score and tricky time changes, the orchestral players came through like the pros they were, with no fluffs whatsoever, even on the most demanding brass riffs.*" Geoff Emerick

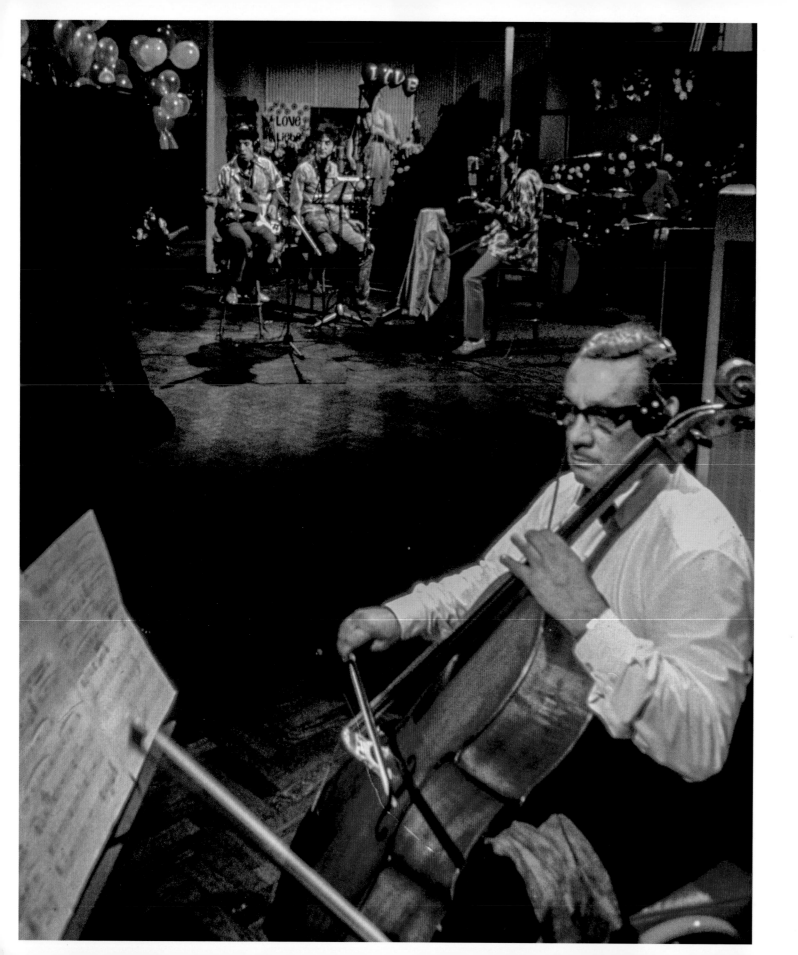

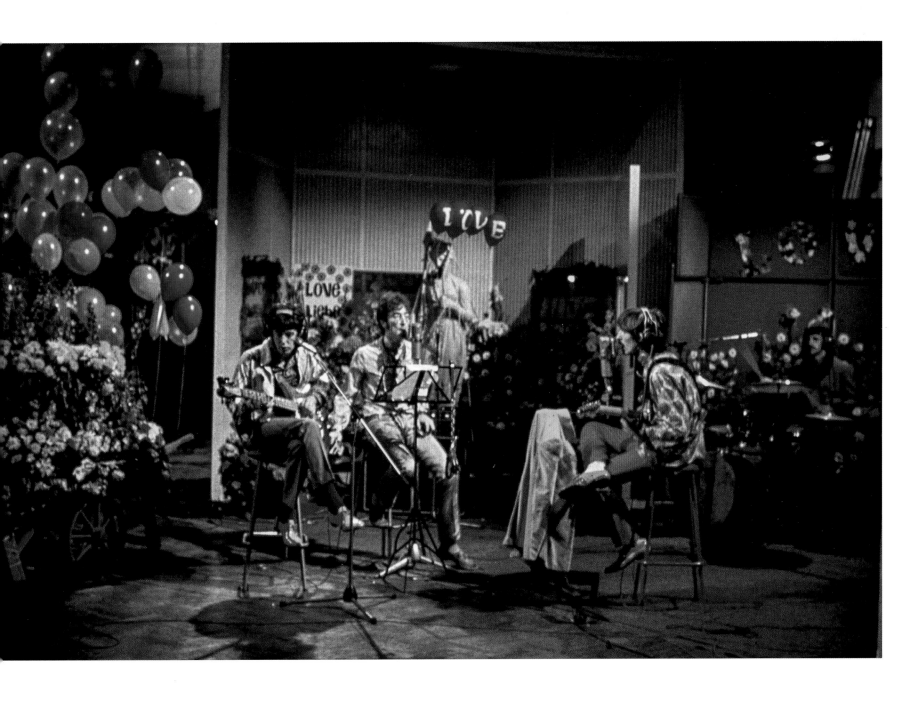

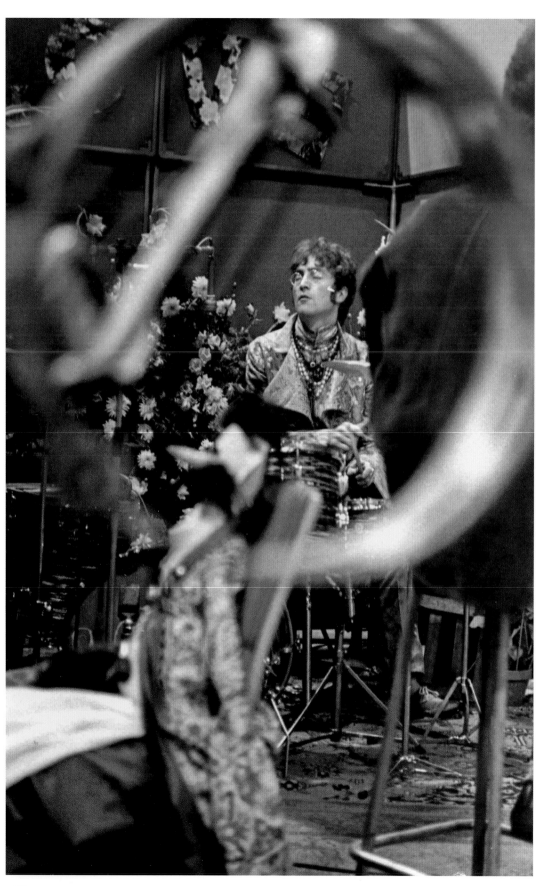

Prior to John wearing his granny glasses as a style/identity statement, he first wore them in the scene for Help! This scene is where The Beatles are in the airport, about to head off to The Bahamas. It's remarkable that all four of The Beatles in that scene ended up adopting those very images only two years later.

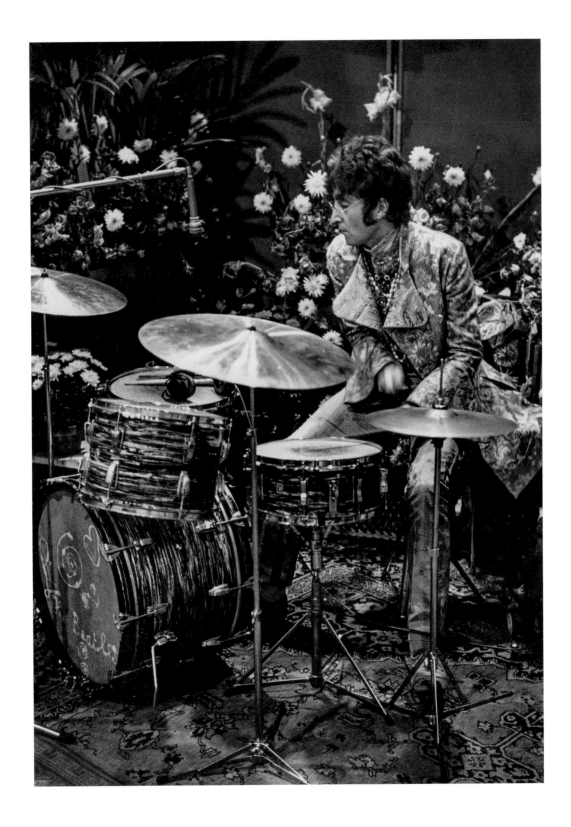

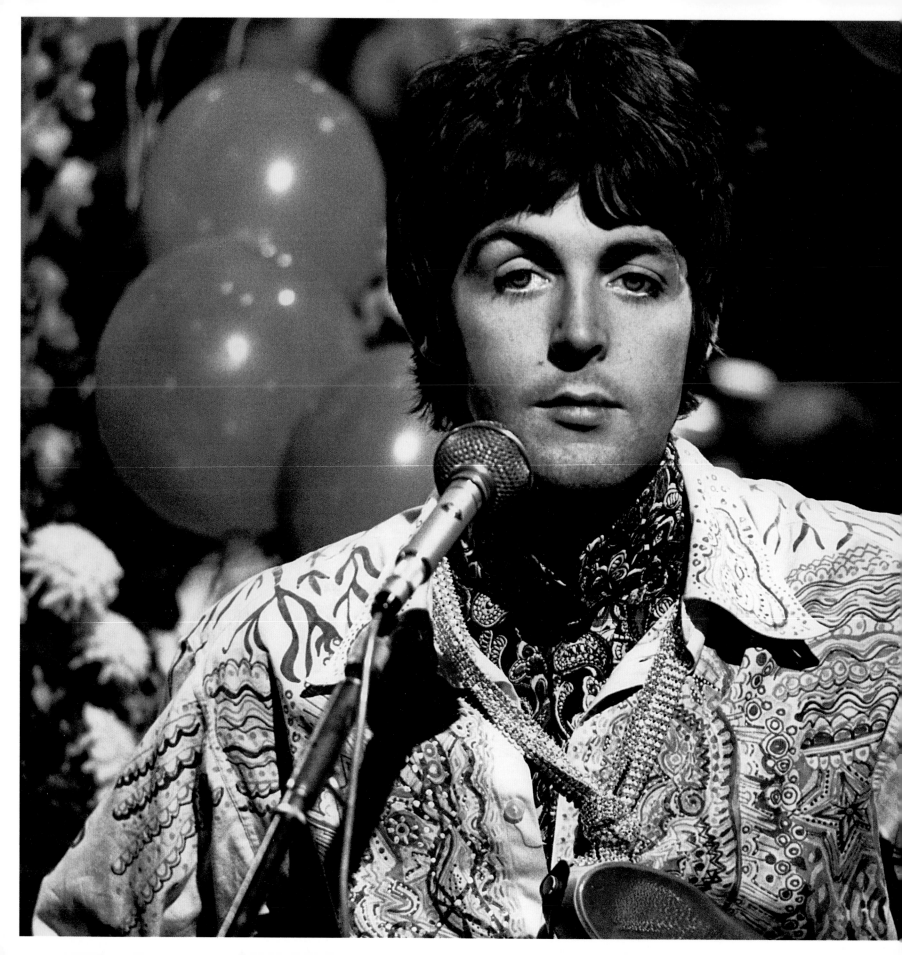

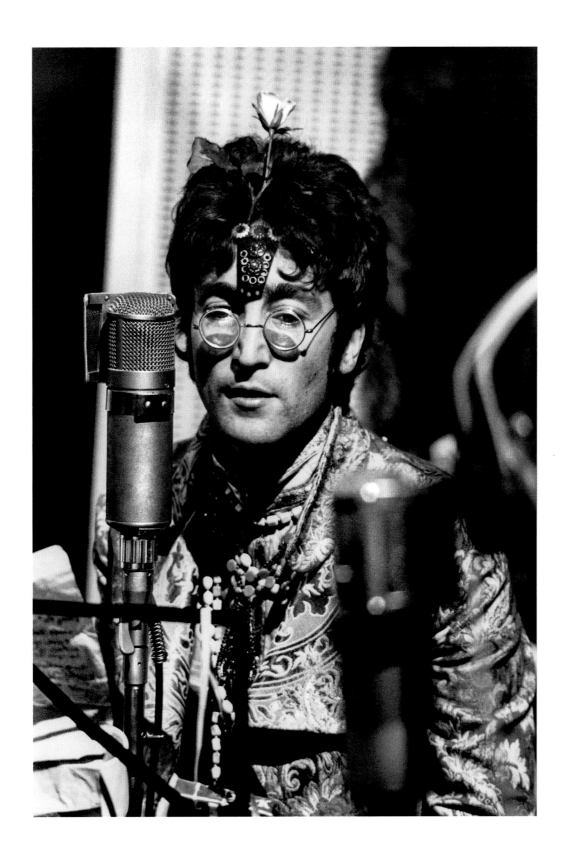

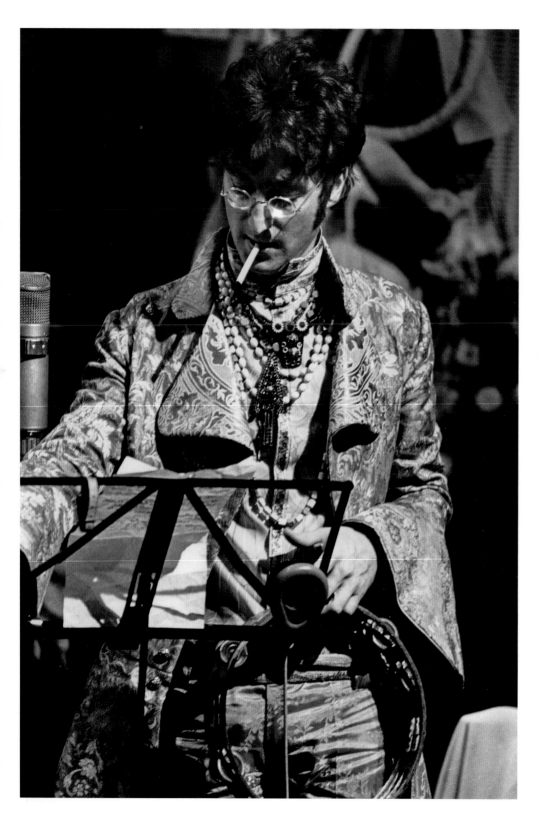

One of the Beautiful People
by *Paul Skellett*

BABY YOU'RE A RICH MAN

On the 7th of June 1967 The Beatles announced that they were to be involved with a full length animation entitled 'Yellow Submarine'. The film inspired by their 1966 song of the same title would feature a soundtrack by The Beatles as well as animated representations of themselves. The film would feature three new songs.
'Baby You're a Rich Man' was the first song to be crafted for the movie, although it was soon to be plucked from the roster to become the 'B' side for their next single 'All You Need is Love'. It's believed that the song takes inspiration from the experience of Alexander Palace as it hosted the 'Fourteen Hour Technicolor Dream.'

"How does it feel to be one of the beautiful people." Lennon

The West Coast hippies viewed themselves as 'the beautiful people'. The first UK tribal gathering of the British 'beautiful people was considered to be the 'Fourteen Hour Technicolor Dream.'

Maybe this was the initial inspiration for John to start writing a song entitled "One Of The Beautiful People." Paul, in his book "Many Years From Now," relates another of John's inspirations:

"There was a lot of talk in the newspapers then about the beautiful people. That was what they called them...the question then was, 'how does it feel to be one of the beautiful people?'

Paul stated in interview to International Times in January of 1967,

"there is something which tells me that everything is beautiful...that everything's great and there's no bad ever if I can think of it all as great."

John made a statement in Playboy during his 1980 interview regarding the writing of "Baby You're a Rich Man".

"That is a combination of two sperate pieces, Paul's and mine, put together and forced into a song. One half was all mine
(singing): 'How does it feel to be one of the beautiful people, now that you know who you are, da da da da...'
And then Paul comes in with (singing): 'Baby, you're a rich man...'

Because he just had this *'Baby, you're a rich man' around.'*

The writing of "Baby You're a Rich Man" is typical of how Lennon and McCartney wrote 'together'.
The reality of their collaboration is that an idea would be spawned and each would disappear to their own corner and do what they thought would work, they would then come together and wrestle to facilitate and combined the ideas. In this case John wrote the "How does it feel to be one of the beautiful people" and Paul contributed the "Baby you're a rich man", believed to be about Brian Epstein. Apparently John's reaction to this was "shut up moaning, you're a rich man, we're all rich men". Ethnic diversity had become the audio pallet of the day and many instruments were used within this track. John can be heard playing a piano, a Clavioline and some kind of strange French electronic keyboard that only played single notes. John also sang lead and backing vocals.

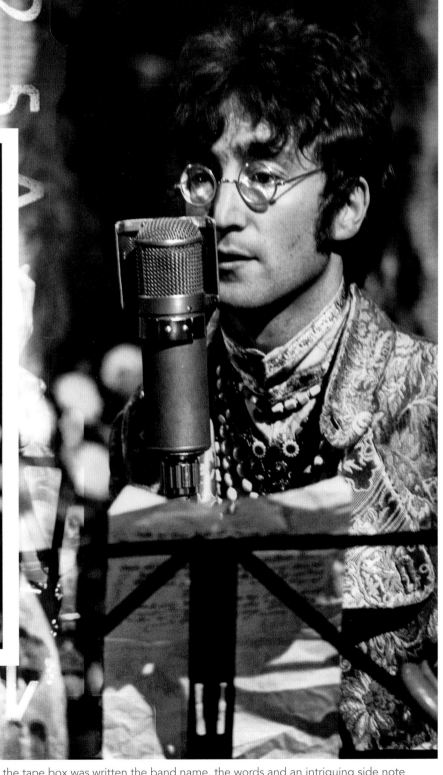

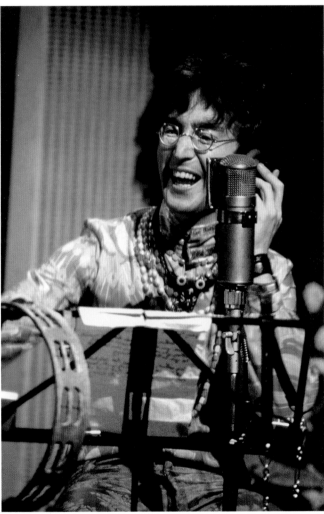

Paul played bass, piano and also contributed to backing vocals. George accompanied with a tamboura, as well as adding lead guitar, backing vocals and hand claps. Ringo played the drums and also added a spot of clapping. Eddie Kramer (future producer of Jimi Hendrix), at the time the second engineer is believed to have played vibraphone.

On the tape box was written the band name, the words and an intriguing side note "Mick Jagger". Mick was certainly at the recording session, so it is possible he contributed a clap or two, or even backing vocals towards the end of the song?

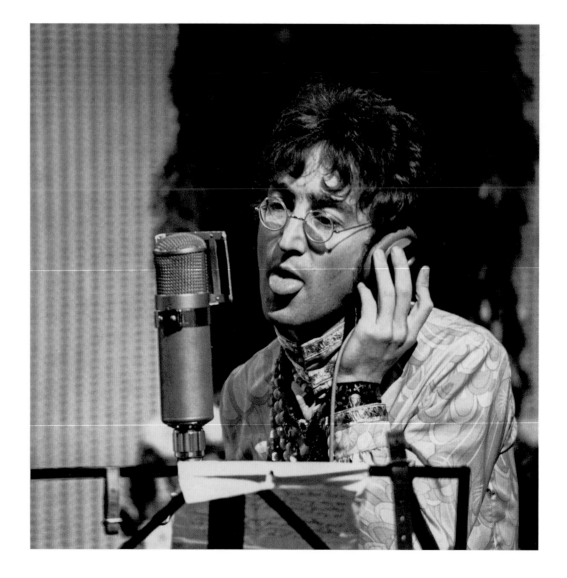

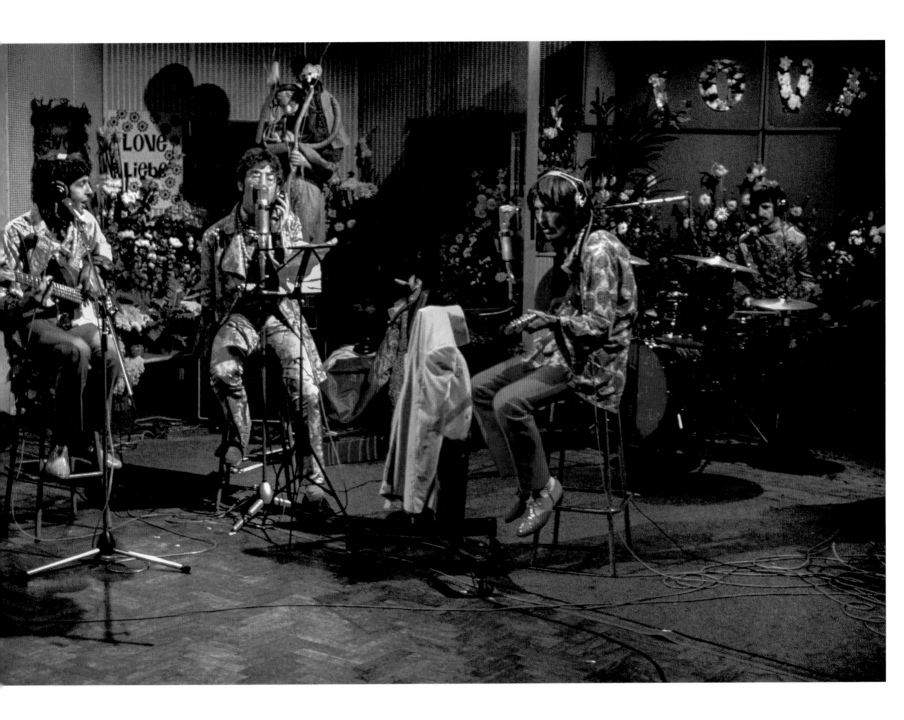

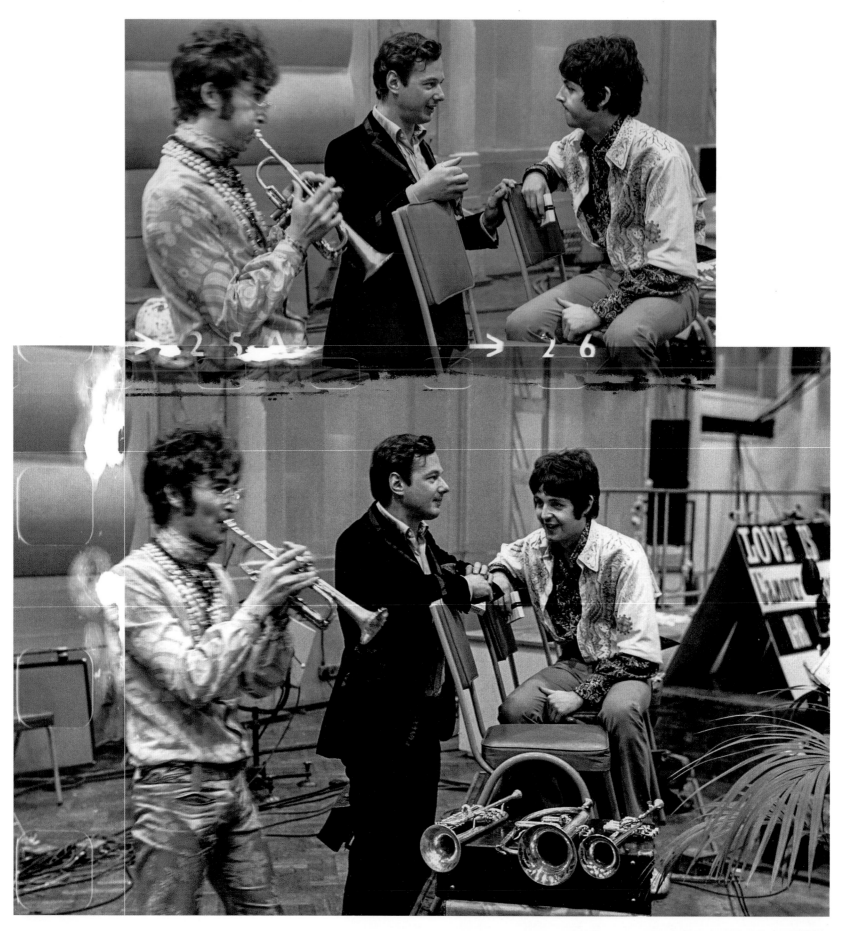

Come in Mrs Higgins!
by Simon Weitzman

WRITING THE BEATLES

One of the best interviews on the boys and their songwriting talents was conducted at Paul's home in 1966 by the BBC's Keith Fordyce, for a radio show entitled, 'The Lennon And McCartney Songbook'. It was a brief but fascinating insight into their world and work, only occasionally interrupted by an on-recording tea break and Paul's sheepdog puppy howling in the other room.

When you write the kind of songs that these boys did it would be easy to end up being precious about how other people interpreted them, but Paul and John never really minded anyone creating representations of their songs, whether it be as a rock pop homage, a classical piece performed by a brass band, by a latter day crooner, a renowned fellow songwriter or a hundred piece orchestra.
They've usually been happy to hear the results and have often thought that some renditions were better than the ones they originally recorded themselves. Paul has certainly always enjoyed other people's take on their music, even if John didn't agree with the direction it took every time.

The question was put to them in the radio interview and it turned out that Paul meant that he liked some soloists take on their work, with the likes of Peggy Lee, rather than the Doncaster under 15 brass band's attempt In Peggy Lee's rendition of Hard Days Night, and several others, they admired the artists and their different take on delivering the song. That's not to say that the Doncaster under 15 brass band were that bad.
They were just different, in their own way!
I get the feeling that at times the boys could be just a little too humble, or at least conscious of not offending in public, but it is nice to know that they genuinely liked other people's takes on their work, or at least had the grace to be kind.

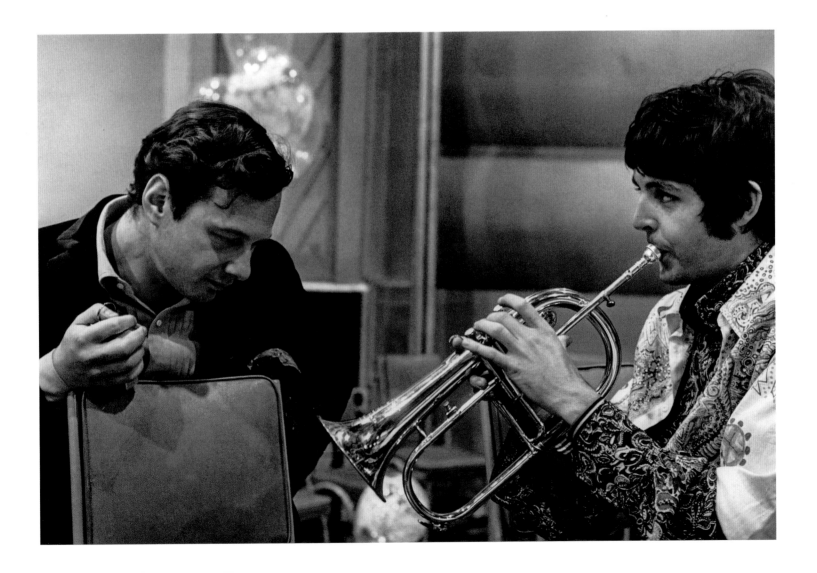

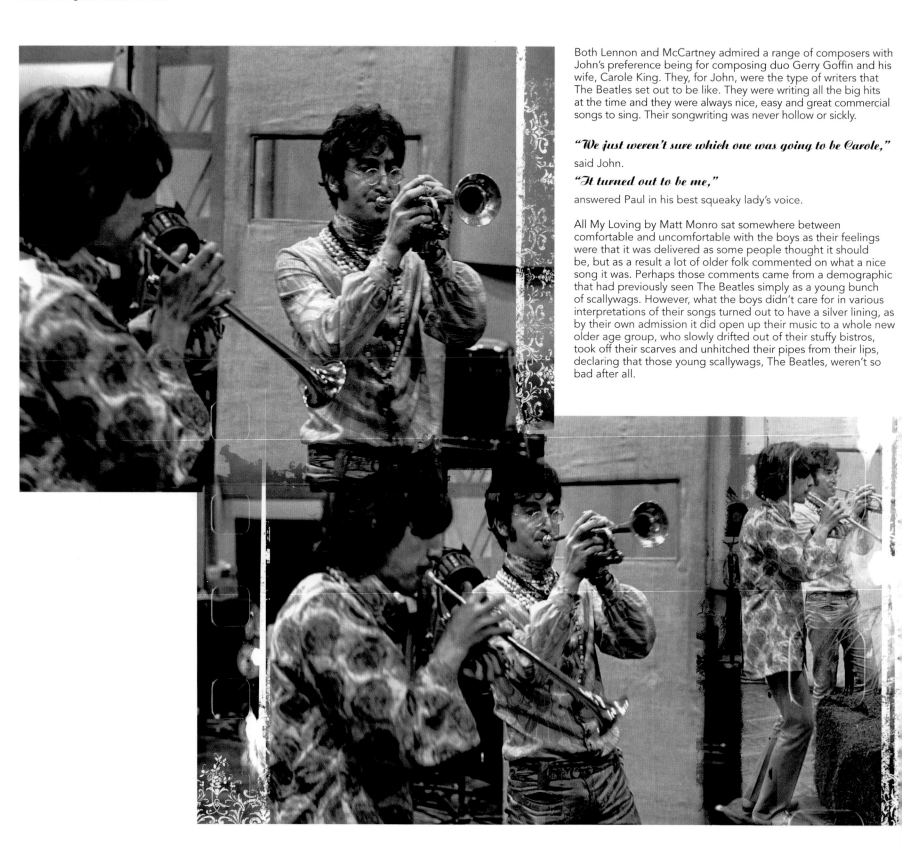

Both Lennon and McCartney admired a range of composers with John's preference being for composing duo Gerry Goffin and his wife, Carole King. They, for John, were the type of writers that The Beatles set out to be like. They were writing all the big hits at the time and they were always nice, easy and great commercial songs to sing. Their songwriting was never hollow or sickly.

"We just weren't sure which one was going to be Carole,"

said John.

"It turned out to be me,"

answered Paul in his best squeaky lady's voice.

All My Loving by Matt Monro sat somewhere between comfortable and uncomfortable with the boys as their feelings were that it was delivered as some people thought it should be, but as a result a lot of older folk commented on what a nice song it was. Perhaps those comments came from a demographic that had previously seen The Beatles simply as a young bunch of scallywags. However, what the boys didn't care for in various interpretations of their songs turned out to have a silver lining, as by their own admission it did open up their music to a whole new older age group, who slowly drifted out of their stuffy bistros, took off their scarves and unhitched their pipes from their lips, declaring that those young scallywags, The Beatles, weren't so bad after all.

Although the duo often composed their own songs they were never afraid to rely on each other to spread the load. When asked if they needed to compose together John was quick to say, *"No, not really, but it helps a lot... You get another point of view as well."*

"We can do our own thing and write a song, but there will often be one verse in it that's very bad, or something, or it's very corny, and if I've written it then I will take it along and sing it to John," explained Paul. *"And he'll say that verse is terrible."*

"Sometimes you can get so involved with it (song writing) and when you are on your own you haven't got the energy to go over it and make it exactly what you want," added John.
"So if you sing it to each other, even if it is a finished song, with all of the arrangements, then there's still a process of saying, yes, that's fine and so on."

"We think nearly alike and differently at the same time," concluded Paul. *"We can write a song, say like Day Tripper, where we've got to write one and at the same time be the same as each other while we are writing it. Thinking the same thing about it. But if we each wrote it individually it would be a completely different song."*

Early on in their careers the boys wrote a few songs for other people, including one for Helen Shapiro that ended up being sung by Kenny Lynch. They also wrote another for Cliff Richard, which they ended up keeping. Billy J Kramer's 'Bad to me' was written by the duo and a few other 'songs for' projects filled the coffers at the time, but as their time diminished and their fame grew most of those forays became a thing of the past, but there were a few exceptions.

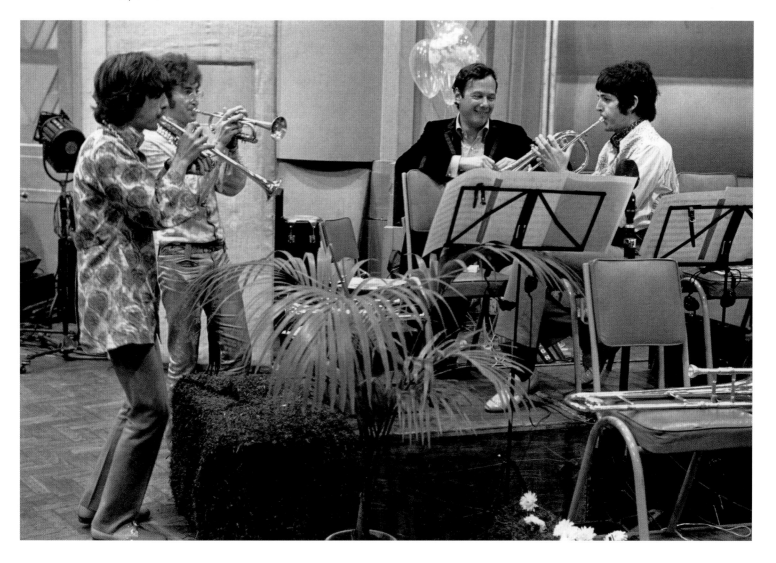

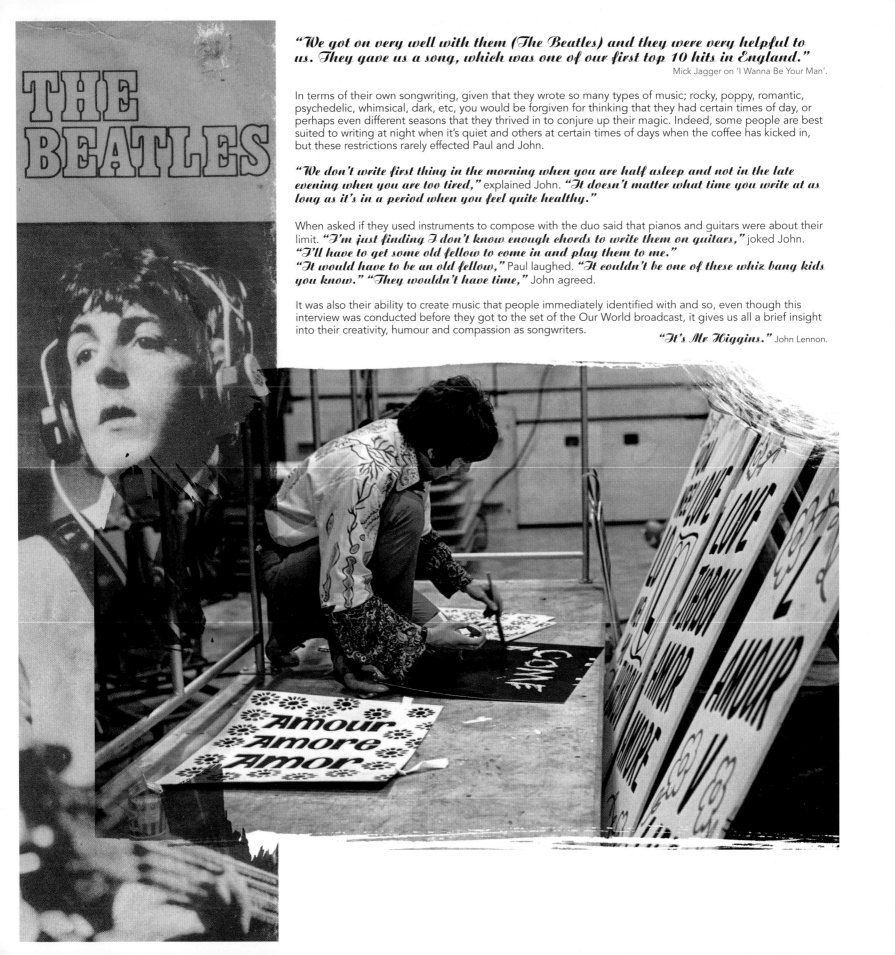

THE BEATLES

> *"We got on very well with them (The Beatles) and they were very helpful to us. They gave us a song, which was one of our first top 10 hits in England."*
>
> Mick Jagger on 'I Wanna Be Your Man'.

In terms of their own songwriting, given that they wrote so many types of music; rocky, poppy, romantic, psychedelic, whimsical, dark, etc, you would be forgiven for thinking that they had certain times of day, or perhaps even different seasons that they thrived in to conjure up their magic. Indeed, some people are best suited to writing at night when it's quiet and others at certain times of days when the coffee has kicked in, but these restrictions rarely effected Paul and John.

"We don't write first thing in the morning when you are half asleep and not in the late evening when you are too tired," explained John. *"It doesn't matter what time you write at as long as it's in a period when you feel quite healthy."*

When asked if they used instruments to compose with the duo said that pianos and guitars were about their limit. *"I'm just finding I don't know enough chords to write them on guitars,"* joked John. *"I'll have to get some old fellow to come in and play them to me."*
"It would have to be an old fellow," Paul laughed. *"It couldn't be one of these whiz bang kids you know." "They wouldn't have time,"* John agreed.

It was also their ability to create music that people immediately identified with and so, even though this interview was conducted before they got to the set of the Our World broadcast, it gives us all a brief insight into their creativity, humour and compassion as songwriters.

"It's Mr Higgins." John Lennon.

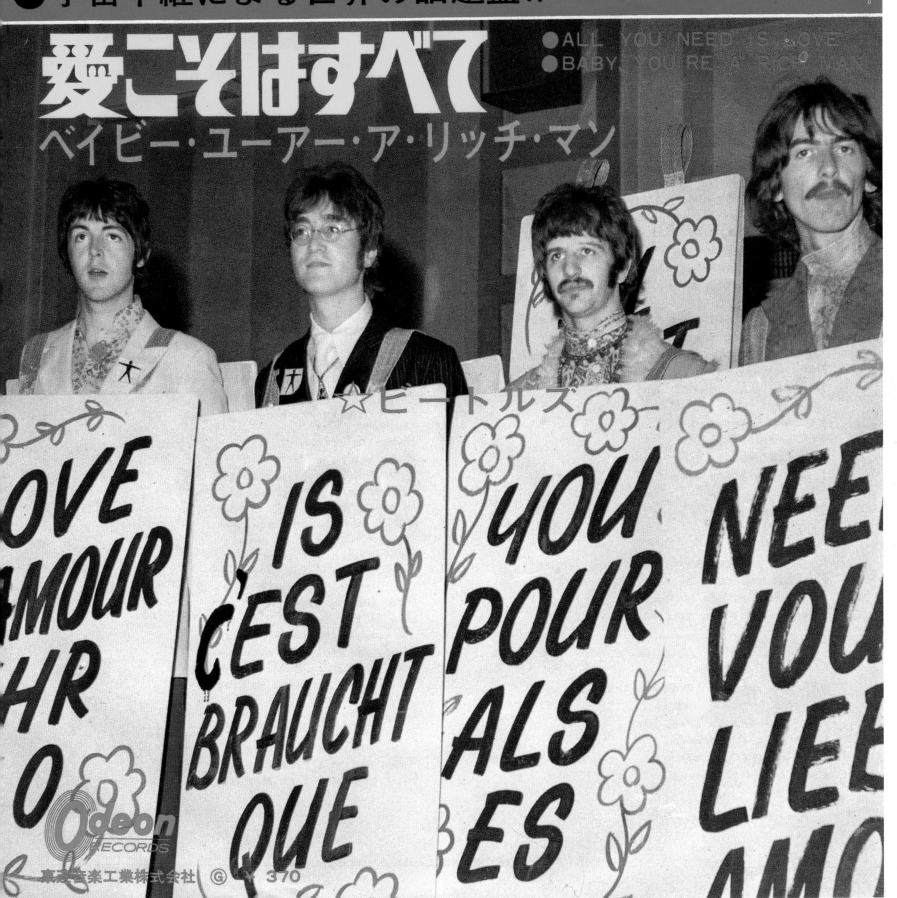

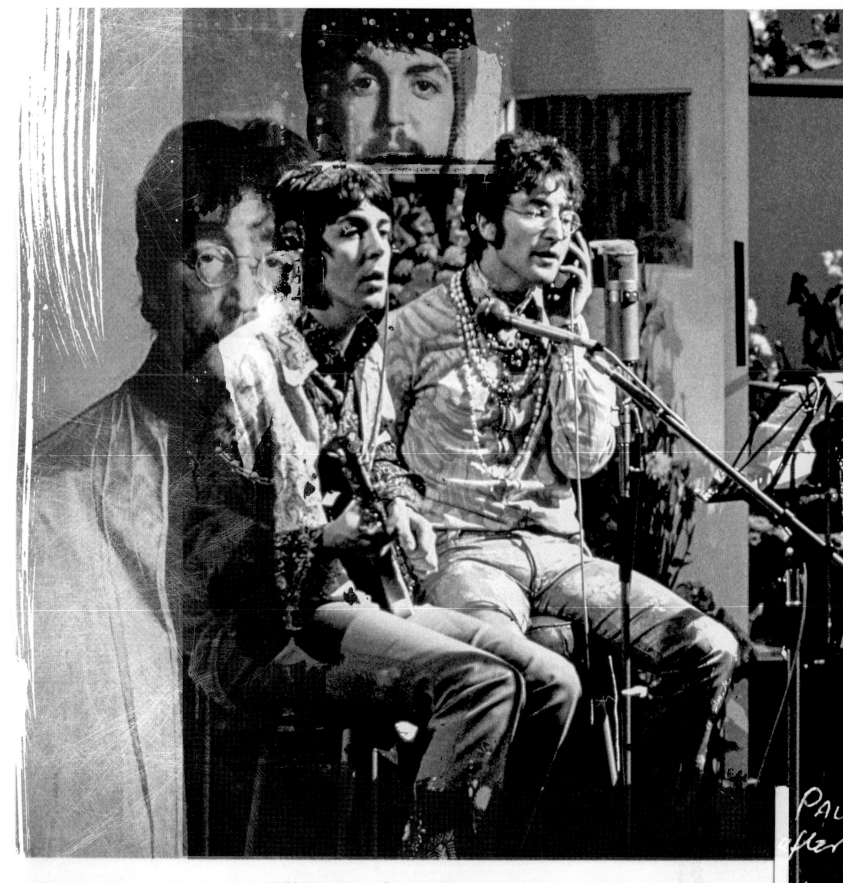

All You Need is Love *The Beatles* Baby, You're a Rich Man-5964

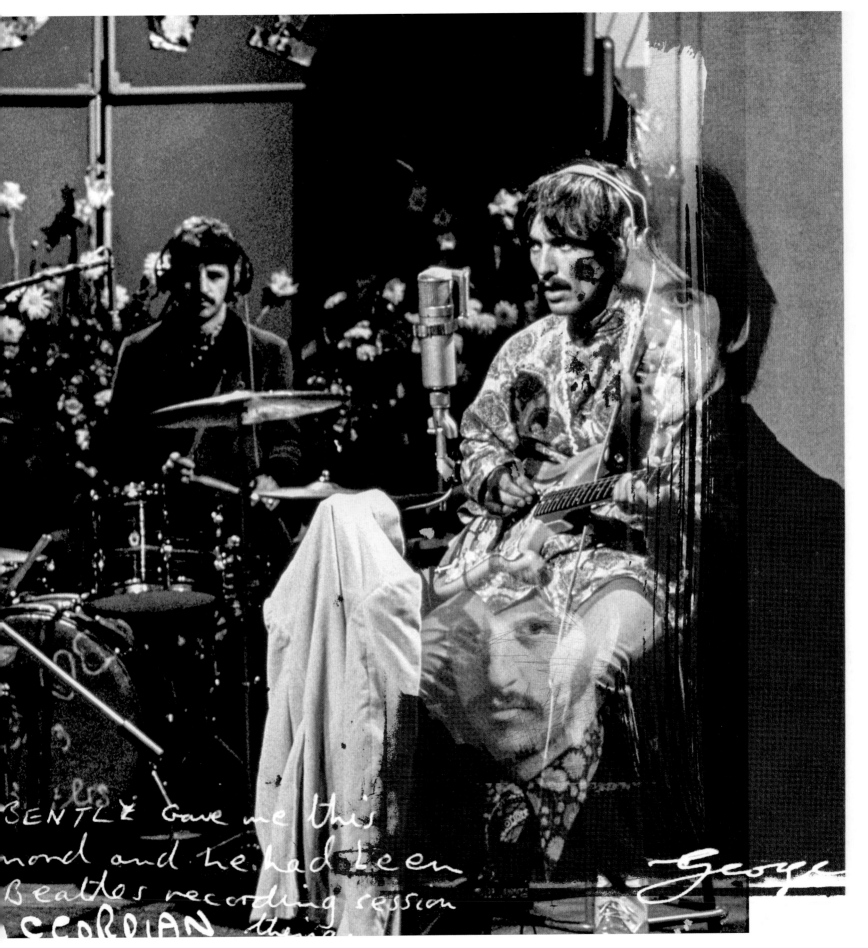

BENTLY gave me this
word and he had been
Beatles recording session
SCORPIAN thing

George

115

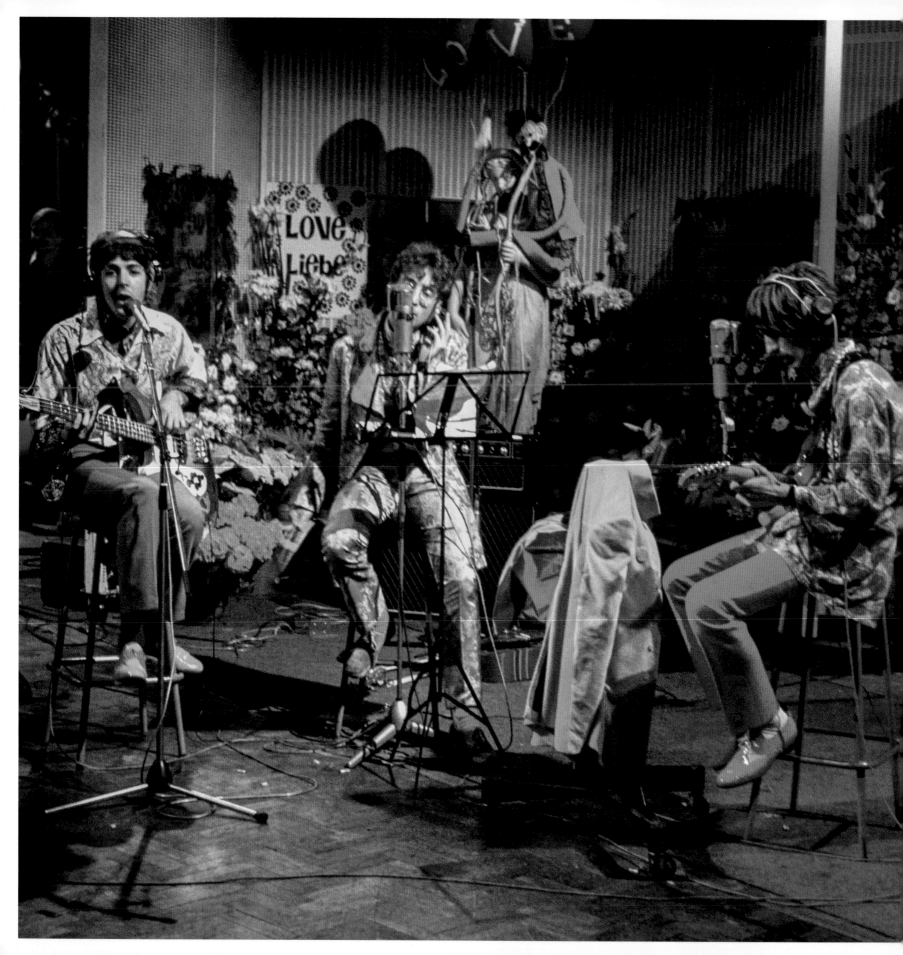

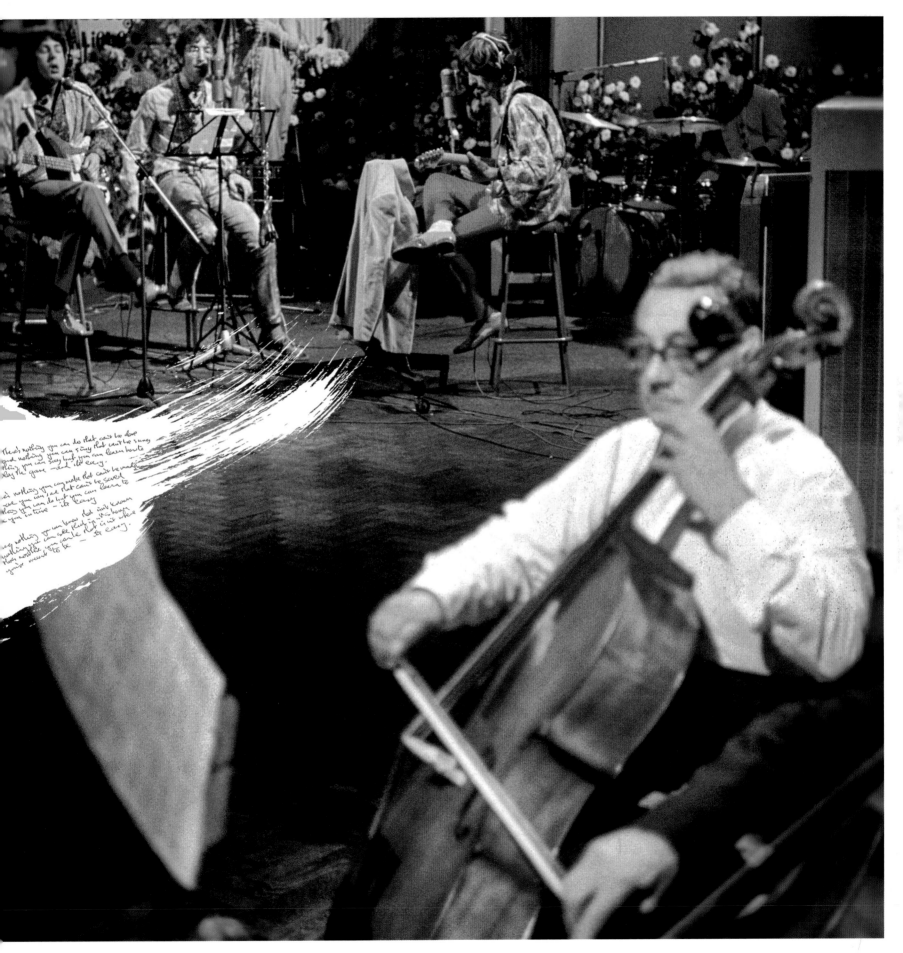

There's nothing you can do that can't be done
and nothing you can sing that can't be sung.
Nothing you can say but you can learn how to
play the game —and it's easy.

There's nothing you can make that can't be made.
No one you can save that can't be saved.
Nothing you can do but you can learn how to
be you in time — it's easy.

There's nothing you can know that isn't known.
Nothing you can see that can't be shown.
There's nowhere you can be that isn't where
you're meant to be — it's easy.

HISTORY IS MADE THIS WEEK

On Sunday one sixth of all the people on earth will be able to watch Our World, a programme which will circle the globe 'live' by television. Here SIR HUGH GREENE, Director-General of the BBC, explains the significance of this exciting venture

Our World is an audacious experiment in international communications. It is nothing less than an attempt to circumnavigate the globe by television. In spite of many satellite broadcasts in recent years *Our World* is unique and important because it is the first global collaboration in the making of a programme instead of in the relaying of an event. If successful it will be a threefold achievement.

First, it will be an achievement in international collaboration. The meetings between the broadcasters planning this project have been stimulating and fruitful occasions. Already they have found in the complexities and disciplines of television a common bond of mutual interest. The fact that the broadcasters of eighteen countries are working well together on this first global project will be of great benefit for world communication.

Secondly, *Our World* will give communications and satellite engineers the chance to extend and exploit their networks to the full. The fact that four satellite systems are being used, that vision signals will travel a hundred thousand miles, that over a million miles of telephone line will be in use in itself sets a challenge which must push engineering operational techniques a step ahead.

Finally, and most important of all, the building of an international programme originating in eighteen countries and being received in thirty is the greatest challenge. This is the first time that so many countries have joined together to make a 'live'

programme which is not merely a ssion of sovereign items. For in the same way that a studio ctor uses five cameras to build a studio programme, so on S ay the earth will be the studio and 300 cameras will ployed.

Our World looks for its raw material to the varied chieve ments of mankind. It presents to the people of the w the doings of sovereigns and statesmen—it was agreed tha nor would take part—but a dramatic picture of themselves.

All too often the pictures we receive of events abroad dea mainly with what divides mankind, the wars, the rac riets, revolutions. *Our World* is concerned with what unites human race, the problems which confront all nations, the endeavours which all men can share. It gives hope that perhaps television in bringing together sovereign states in every corner of the earth may be like the great railways of the nineteenth century which linked the scattered, diverse communities of the United States into one nation.

Our World is a co-operative venture. All the participating nations have pooled their skill and resources and shared the cost. But perhaps we at the BBC may be forgiven for taking a special pride in the fact that the project was born here in London, carried to completion under a Project Editor who is a BBC man and that on Sunday night it will be a BBC team in London which will be controlling the most complex and perhaps also the most hopeful, event in television history.

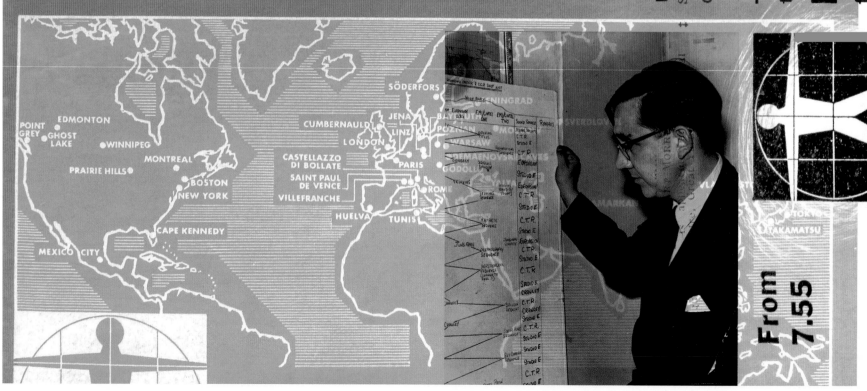

Veszelka.........................
First Interrogator...ZOLTAN LATIN...
Second Interrogator...ISTVAN A...
.................................LAJOS

See page 12

MEETING POINT
Shown at 6.15 p.m.
Close Down

This evening in Europe, tomorrow in Japan, this afternoon in America,
Live Television Circles the Globe
for the first time ever

From 7.55

Radio Times

SIXPENCE

Lights...Camera...Live!
by Simon Weitzman

The Unsung Singer

OUR WORLD

DIRECT
BY SATELLITE
ON BBC-1

Canberra and Cape Kennedy, Moscow and Montreal, Samarkand and Söderfors, Takamatsu and Tunis the television en nations, esents

The babies who are being born at this moment in time are joining a hungry and overcrowded human race, a race responding to the challenge of the physical world a race aiming at artistic excellence, a race striving to widen the frontiers of the mind, a race reaching out beyond its own planet, a race building for the world of tomorrow

OUR WORLD

UNSERE WELT

私達の世界

Lights...Camera...Live!

FOR THE FIRST TIME TV ENCIRCLES THE EARTH

Let's start this section with a little piece about an unsung hero. Aubrey Singer CBE, a British broadcasting executive who spent most of his active years at the BBC.

He was largely responsible for the historic 1967 Our World global satellite broadcast, featuring The Beatles and was described as "the greatest director general that the BBC never had."

Aubrey was born in Bradford, England and whilst still in his teens he trained as a film editor, joining the BBC in 1949. He went on the become the head of the Features Group, which included Science & Features, Arts Features and General Features, concentrating on documentary programmes. Never shy at going for the grand plan, Aubrey took the lead in finding international funding for hugely ambitious co-productions, leading to previously unimagined large scale projects, such as the 'Science Spectaculars' written by Nigel Calder and subsequently a 13 part series called 'Personal View', along with other highly successful programs including Civilisation (1969) and The Ascent of Man (1973).

the
EATLES

LES COLLECTION 1962/1970

10

All you need is love • Baby you're a rich man

EMI ODEON

J 006-04.476

"Aubrey makes a thousand flowers bloom,"

said his boss at BBC Television, Sir Huw Wheldon.
Another colleague summed up Singer's contribution to broadcasting:

"Aubrey has roughly 100 ideas every day, of which 98 are quite useless. The other two more than justify his salary."

One of his crowning glories was of course the historic 1967 Our World TV broadcast, the world's first live television satellite link-up, which was to be seen by around 400 million people across five continents.

This audacious plan was Aubrey's brainchild and he and his team at the BBC presented the idea to the European Broadcasting Union in 1966. The transmission was to include personalities such as Pablo Picasso, Maria Callas and other famous stars celebrating creative culture from a total nineteen nations. Each part was to be performed from the respective countries the personalities hailed from.

The BBC's vision for the show was to unite the world with culture and keep it out of reach for those who could potentially highjack it for political gain. As such politicians and heads of state were banned from taking part in the broadcast.

For the first time in history a show would go out that linked five continents, with broadcast feeds from places as far apart as Cape Kennedy, Moscow, Canberra, Montreal, Söderfors, Samarkand, Takamatsu and Tunis.

With the largest television audience to date tuning in it all had the potential to be a complete disaster and that meant finding technicians and stars who already knew how to deal with big audiences and adapt to the unknown.

To increase the risk factor pre-recorded videotape and film were not allowed. As such, this incredible feat saw 10,000 staff, including technicians, directors, producers, production hands, announcers and translators link together.

It was to be one of the most incredibly complex broadcasts ever made, even by today's standards. It relied on three geostationary communication satellites (Intelsat I, Intelsat II and ATS-1) with the production studios and control rooms reliant on over 1.5 million km of snaking cable.

Orchestrated with a masterful degree of precision by the BBC broadcast, companies around the world united to make the show happen. Partners included Australia (ABC), Italy (RAI), Japan (NHK), Mexico (TS Mexicana), Spain (TVE), Sweden (SRT), Tunisia (RTT), Austria (ORF), Canada (CBC), Denmark (DZR), France (ORTF), USA (NET) and West Germany (ARD) and the United Kingdom (BBC). All contributed sections to the transmission, with countries such as Holland, Norway, Portugal, Switzerland, Belgium, Bulgaria, Finland, Ireland, Luxembourg and Monaco transmitting the show, even though they weren't contributing content.

The transmission was to last two-and-a-half hours, with every contributing country expected to deliver a live performance that would keep a world audience enthralled.

'It took 90 phone calls to get the bloody Beatles to participate. They were just so obdurate. They didn't feel it was important to them. Thank God we got 'em, because we needed them to lift the whole thing.' Aubrey Singer, BBC
With each territory requiring key internationally respected representatives Aubrey knew there was only one choice when it came to the United Kingdom and on 18 May The Beatles signed a contract to represent the BBC and Britain on the broadcast. It had taken some effort.

A memo to Aubrey Singer of the BBC, 6th April 1967:
'It has been very difficult to contact Mr Epstein, since even his own offices in London and New York had difficulties tracing him. Brian Epstein's assistant has [now] telephoned me. He says that he doesn't feel there is much point in your meeting Mr Epstein next week since he is at the moment in the process of contacting each of the Beatles and sounding out their reactions. I learnt that he had already approached John Lennon.

Brown said that he preferred not to tell me [Lennon's reaction] but I could take it that it wasn't unfavourable, so – it looks like still more patience until all four Beatles have reacted'.
Aubrey Singer may not be a name that gets visited very often by Beatles fans around the world and although The Beatles were the biggest thing on the planet at the time, Aubrey was one of the key visionaries who managed to bring their talent to a world audience, delivered in one short burst of creative and technological brilliance.

"We were big enough to command an audience of that size, and it was for love. It was for love and bloody peace. It was a fabulous time. I even get excited now when I realise that's what it was for: peace and love, people putting flowers in guns."
Ringo Starr, quoted from Anthology

The announcement of the Beatles' appearance came on the 22nd of May. The brief was extremely simple. Write a song that could be understood by viewers around the world that carried a simple message. John Lennon, perhaps one of the greatest exponents of the universal language of simplicity, took on the main task of writing the song for the occasion.

All You Need Is Love was also something of a continuation of the ideas he had expressed in the song The Word two years previously. He was fascinated by how slogans could influence the masses and tried to capture the same essence and energy he saw in songs like We Shall Overcome.

John once commented,
"I like slogans. I like advertising. I love the telly." - And a few years after All You Need Is Love, in a 1971 interview about his song Power To The People he was asked if that song was about propaganda? He answered, "Sure. So was All You Need Is Love. I'm a revolutionary artist. My art is dedicated to change."

Meanwhile, the deadline loomed and although the band took the task in their stride the sands disappearing down the hour glass seemed to run even quicker as the broadcast neared. A point not lost on John.

"I don't know if they had prepared any ideas, but they left it very late to write the song. John said, 'Oh God, is it that close? I suppose we'd better write something.'" Paul McCartney proposed his composition Hello, Goodbye, which got released as a single five months later, but the group opted instead for John Lennon's All You Need Is Love. They started recording the song on June 14th, with Lennon on harpsichord, McCartney on double bass with a bow, George Harrison on violin (for the first time in his life!) and Starr on drums." Engineer Geoff Emerick.

121

Musically, while being celebrated for its simplicity, All You Need Is Love was a very unusual song. The chorus was only one note and the song was set to a rare 7/4 tempo. A fact identified by Dwight Rounds, the author of The Year The Music Died. A book that looked at musicians and social movements of the era. Although it was widely accepted that John had completed the majority of the songwriting for the piece it wasn't until the 1983 publication of John Lennon: **In My Life, by Pete Shotton and Nicholas Schaffner**, that it was finally revealed that John was the composer of the song.

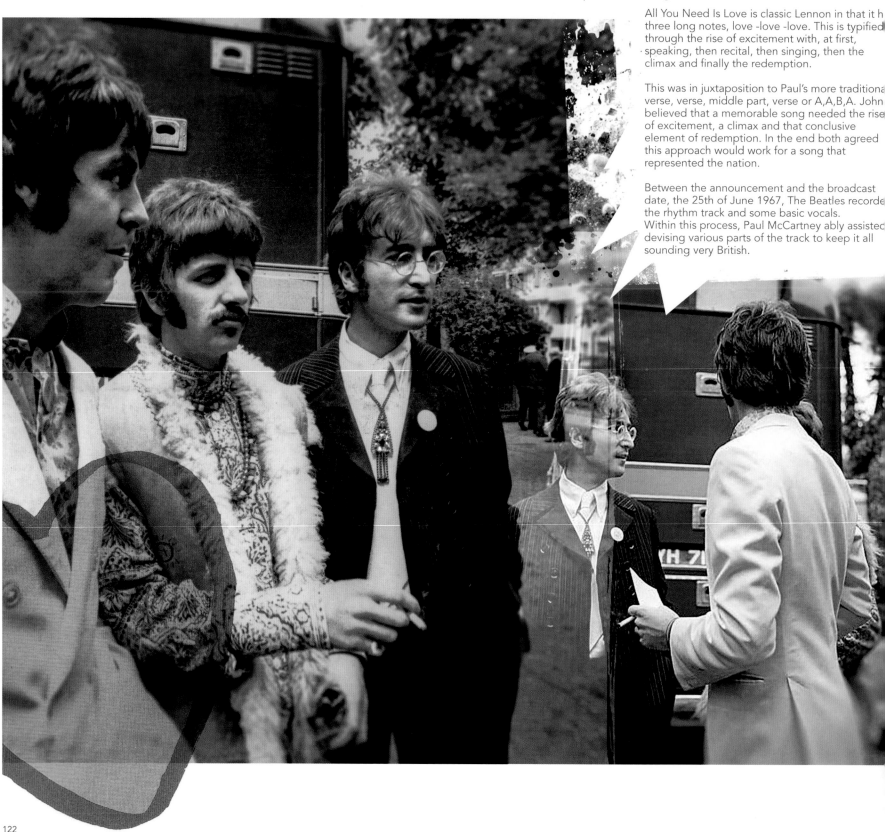

All You Need Is Love is classic Lennon in that it h[as] three long notes, love -love -love. This is typified through the rise of excitement with, at first, speaking, then recital, then singing, then the climax and finally the redemption.

This was in juxtaposition to Paul's more tradition[al] verse, verse, middle part, verse or A,A,B,A. John believed that a memorable song needed the rise of excitement, a climax and that conclusive element of redemption. In the end both agreed this approach would work for a song that represented the nation.

Between the announcement and the broadcast date, the 25th of June 1967, The Beatles recorde[d] the rhythm track and some basic vocals. Within this process, Paul McCartney ably assist[ed] devising various parts of the track to keep it all sounding very British.

"Think globally, act locally." Paul McCartney

The band recorded thirty three takes on June the 14th, selected take ten as the best and spent the next few days overdubbing vocals, the piano, which was ably played by George Martin and the banjo, which John took on, plus other guitars and a few orchestral movements.

Transmission of the Our World broadcast took place on the 25th of June 1967, between 9pm and 11pm CET on a barmy Sunday evening. Considering all the potential risks for it all to descend into catastrophe, in the end the show passed without any real creative hitches or technical breakdowns. At that time the audience were simply amazed that the broadcast had happened at all, so any minor glitches mainly went unnoticed.

The main technical issues for the show all occurred in the week leading up to the broadcast when seven Eastern Bloc countries led by the Soviet Union decided to pull out in protest for many Western nations' actions and lack of actions during the "Six-Day War" in the Middle East.

When we look back on the broadcast today we are reminded of some of the slightly more left field arts and music programming that followed on from this historic event, in the 1970s and 80s, where presenters looked script bereft, cameramen moved cameras left and right depending on who was shouting at them from the control room and artists often responded like rabbits caught in the headlights.

However, despite limited rehearsal time, most artists on the Our World broadcast and their respective creative and technical teams pulled it all off with a minimum of fuss.

The show opened on the Vienna Boys Choir singing its theme song in no less than twenty two languages. Not an easy way to kick off a live broadcast. Audiences were then catapulted over to Canada to watch a live interview with well known media commentator, Marshall McLuhan.

From there we headed south into the U.S. and Glassboro, New Jersey, where various leaders from America and Russia were meeting and then back to Canada to watch a rancher driving his cattle. From animal cattle we went onto the propulsion of 'human cattle' with a segment about a subway construction project in Tokyo, Japan, before bouncing over Melbourne, Australia to take in a day in the life of a tram station.

"Show me that I'm everywhere and get me home for tea." George Harrison

The show continued to bounce, somewhat crazily, around the world, culminating in the performance that most people had tuned in to watch. For this we headed back to London. Here were The Beatles, perched on stools and surrounded by a small orchestra, a group of friends, including Mick Jagger, Keith Moon, Keith Richard, Graham Nash, Hunter Davies, Marianne Faithfull, Eric Clapton, Pattie Harrison, Tony Bramwell and Jane Asher, along with an invited circle of people looking very slightly bemused on the studio floor. To heighten the love and flower power theme, the band and guests donned colourful clothes with flowers, balloons and waved painted placards around during the performance.

Of course the potential for disaster at this point was seemingly off the scale, but the BBC were extremely careful. To reduce the chances of an on-air catastrophe the whole sequence was brilliantly stage managed, with a little extra time taken to make it feel spontaneous.

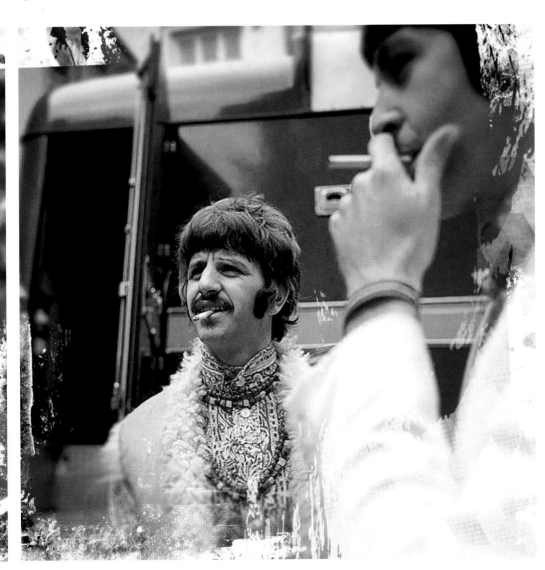

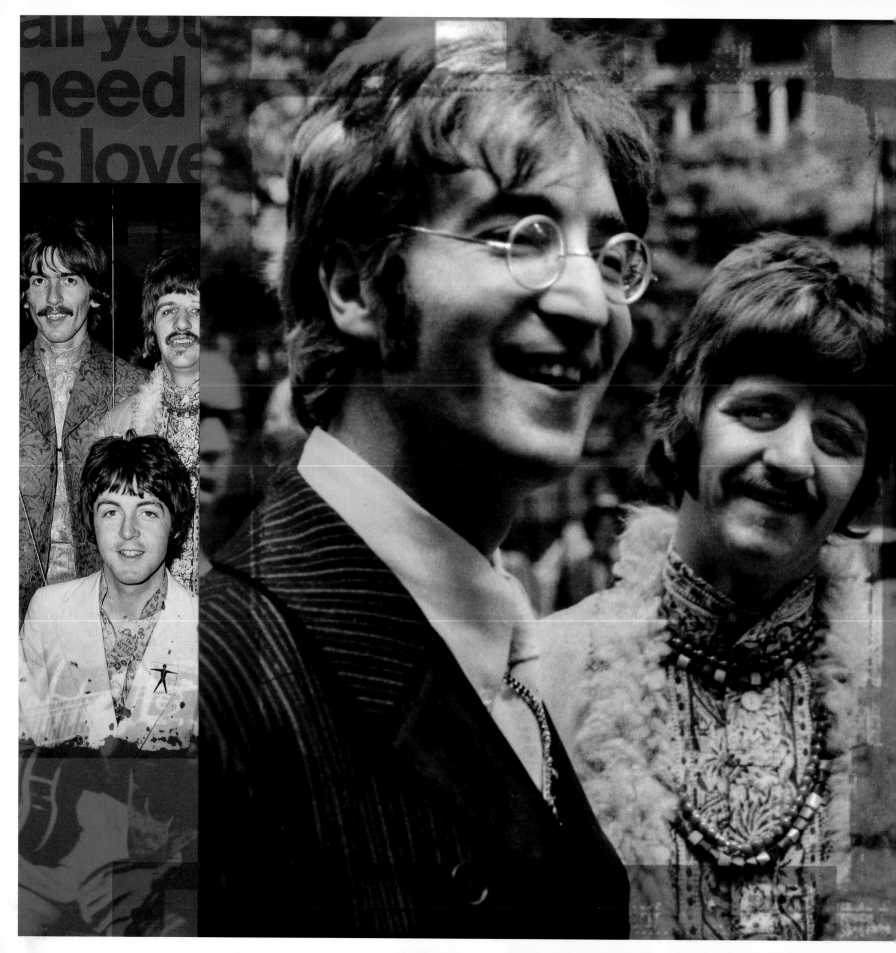

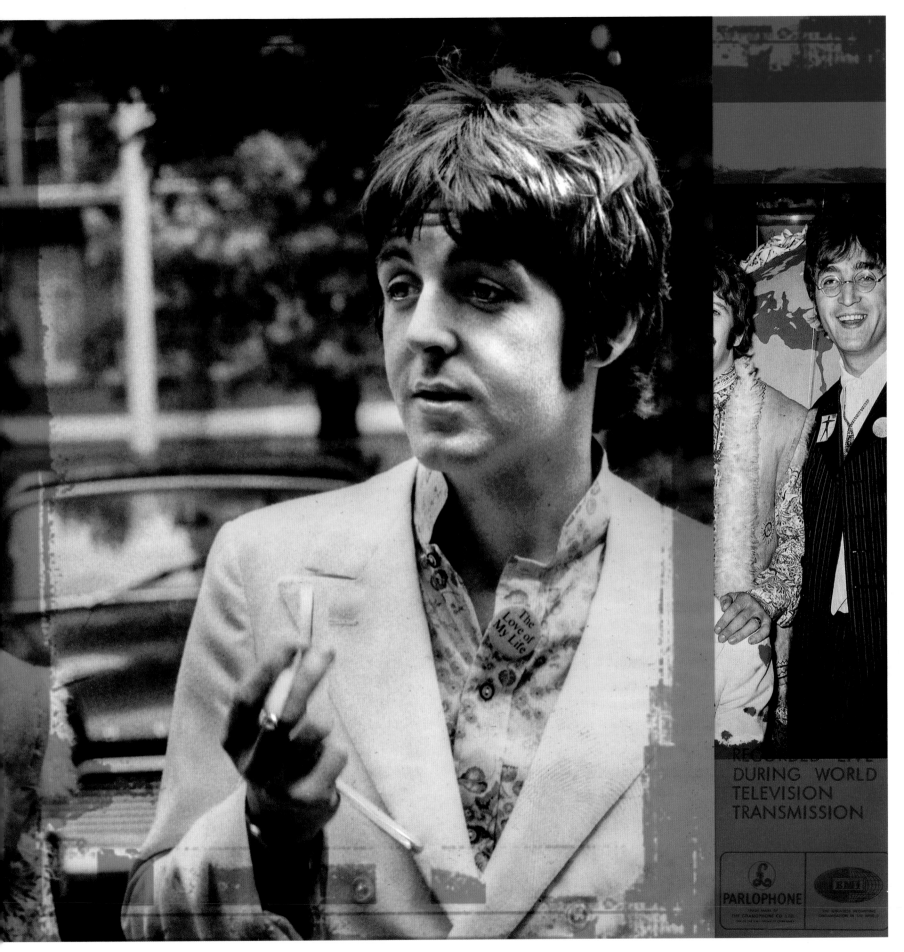

The Love of
My Life

RECORDED LIVE
DURING WORLD
TELEVISION
TRANSMISSION

PARLOPHONE

EMI

When the live sequence started reporter Steve Race introduced the group as the backing track started to roll. Sequence director Derek Burrell-Davis cut to the studio control room and George Martin, working partly on instinct, announced that the orchestra should be brought in.

George Martin and his team coped remarkably well considering that no one in the control room could hear anything back live, causing them to effectively 'wing it'.

Amazingly the 9.36pm GMT performance went off with an ease that few other territories managed to capture. The fail safes all worked and the band played along to a pre-recorded backing track. However, just to keep everyone on the edge of their seats, the vocals, bass guitar, guitar solo, drums and 13-piece orchestra all played live.

Considering the circumstances the musicians played as if they were performing just for the room and seemed oblivious to the 400 million sets of eyes trained on them from all four corners of the globe. Some of those unsung heroes on set included musicians Jack Holmes, Sidney Sax, Patrick Halling and Eric Bowie (violin), Evan Watkins and Harry Spain (trombone), Rex Morris and Don Honeywill (tenor saxophone), Jack Emblow (accordion), Stanley Woods and David Mason (trumpet), with Woods also playing the flügelhorn on the recording.

It seemed odd at the time that the British entry for the program kicked off with the introduction to the French national anthem, La Marseillaise, written and composed by Claude Joseph Rouget de Lisle in 1792. The piece was originally called Chant de guerre de l'Armee du Rhin or the Marching Song of the Rhine Army. It was dedicated to Marshal Nicolas Luckner, a Bavarian-born French officer from Cham. It was also the rallying call for the French Revolution and was sung on the streets by troops from Marseille when they arrived in Paris.

Now the national anthem of France, the song was also the anthem of the international revolutionary movement, which is perhaps why All You Need Is Love started with the piece, as it was by nature juxtaposed to the theme of the song. And yet the call for love instead of war was equally a peaceful rallying call to those who received the song's message.

At the end of the song Paul sang the chorus to the 1963 hit, She Loves You. The camera pulled away on the performance as people roamed around the set waving placards, throwing streamers and balloons. Eventually the song faded away to that chorus of She loves you yeah yeah yeah... She loves you yeah yeah yeah. It was a fitting end and acted as an lingering audio signature for the band.

Meanwhile, as the orchestral section also concluded the track you could also hear pieces of Greensleeves, a Bach two-part invention by George Martin merged with the sound of Glen Miller's In The Mood.

Post the live broadcast the studio guests were ushered out and John Lennon then re-recorded some of his vocal parts.
The session eventually concluded at 1am the following morning.

John wasn't altogether happy with his voice in the performance and after a rethink on his delivery he re-recorded his verses for the single. Ringo also took the opportunity to add a drum roll to the introduction, as well as a few other percussion elements.

The song was mixed on the 26th of June 1967 and All You Need Is Love was finally released as a single on July the 7th, where it took pride of place in the number one position on the UK charts for three weeks.
The single also featured Baby You're A Rich Man on the b-side.

All You Need Is Love went on to appear on the Magical Mystery Tour and Yellow Submarine albums to much acclaim. Not bad for a hastily written song created from a BBC brief for a one off live performance, proving, quite conclusively, that love is all you need.

'I think we all knew it would not necessarily meet with everybody's approval. This kind of epic has not always done so in the past as you may remember from the Telstar and Early Bird programmes. We could probably have written the newspaper criticisms in advance. Let me say that sheaves of letters have been descending on the BBC protesting about the Beatles so you can see "one man's meat is another man's Ringo".' Noble Wilson philosophically discussed various negative press comments about the programme with a viewer from Germany in a letter shortly after the broadcast.

"At the touch of love everyone becomes a poet." Plato

- Assistance in this passage from Angela Ballard.

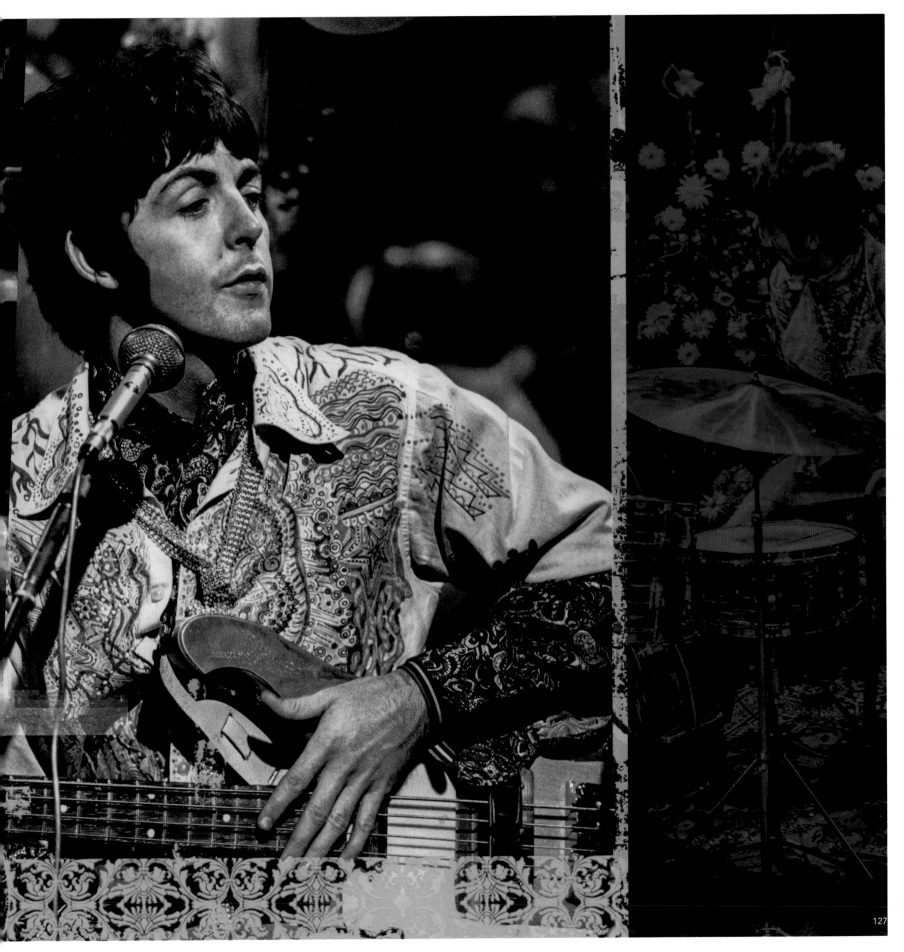

ALL YOU NEED IS
LOVE
THE BEATLES

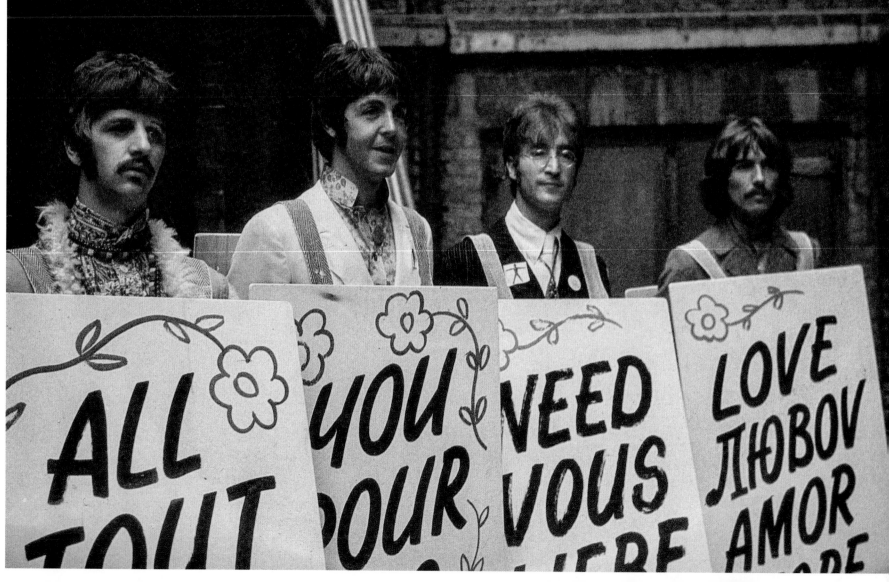

Aubrey Singer, Project Editor of tonight's historic television event, invites you to join him on a great global adventure

TONIGHT's programme is 'live.' It spans night and day, yesterday, today, and tomorrow. At 8.0 p.m. as you watch the programme in Britain it will be 10.0 p.m. in Moscow, midnight in Sverdlovsk, 3.0 p.m. in New York, noon in San Francisco. In Japan it will be 4.0 a.m. on the morning of June 26.

In time the programme embraces midnight and midday, midwinter and midsummer. In space the programme jumps from Samarkand to Mexico City, from Tokyo to Tunisia.

In content the programme ranges from a traffic jam in Paris to the D'Inzeo Brothers practising their horses in Italy; from a cowboy in Edmonton to a soprano in Bayreuth; from the airport in Sverdlovsk to the Beatles recording a new number in Britain; from a countdown or a moon rocket in Cape Kennedy to a children's camp in Crimea.

The programme, based on what is happening around the world during the two hours we are on the air, begins by visiting some of the latest additions to the family of man in places as far apart as Hokkaido, Edmonton, Warsaw, Mexico, and Samarkand.

Then after a look at what is happening around the world—a deliberate circumnavigation from Sverdlovsk to Vladivostok—the programme looks at some of the problems we are facing, our attempt to solve them and examines a range of humanities, aspirations, and ambitions.

The arranging of the forty-two major contributions in this programme has taken eighteen months. Born in the BBC, the idea was taken over in April 1966 by the European Broadcasting Union—the collective body of West European broadcasting organisations, based in Geneva, which is responsible for the international exchange in European broadcasting.

The problems facing the engineers are also enormous. The picture will travel about 100,000 miles in the journeys to and from the satellites and along the landline and micro-wave systems.

The sound links and communications are even more involved—an estimated million miles of communication.

Nevertheless, the communication problems are soluble ones of complexity. The real problem is the programme itself!

We hope, however, Our World will be the first of many global telecasts, for in spite of the language problem we feel sure that this first broadcast setting up a chain of communications ringing the earth must be a landmark—an end to continental isolation. We hope that by the year 2000 this type of broadcast will be commonplace.

Perhaps in that year people might like to look at this first offer and compare it with their own capabilities, so (on the suggestion of the Soviet Union and unanimously agreed) a tape of this programme will be deposited with the United Nations for posterity to judge.

OUR WORLD

PAUL

JOHN

Greetings the world...

RINGO

GEORGE

... it's the Beatles one of the British contributions to tonight's global entertainment

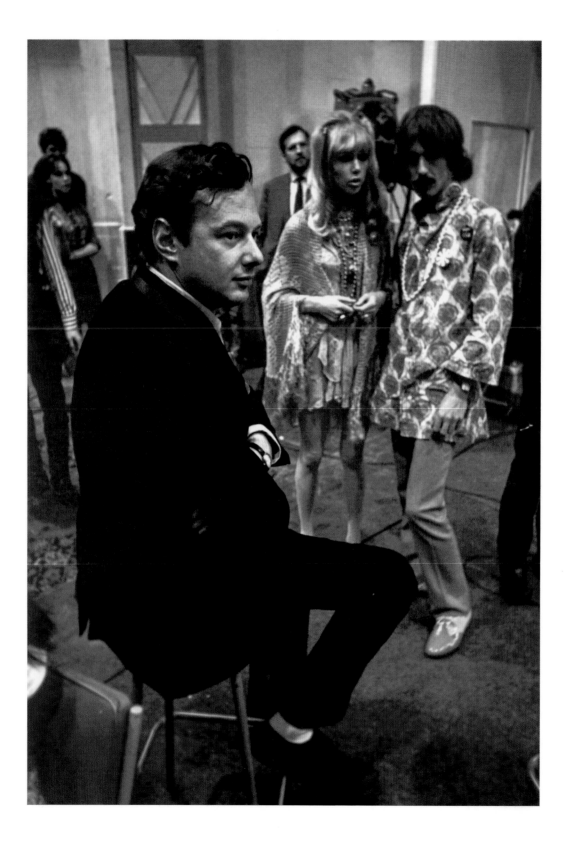

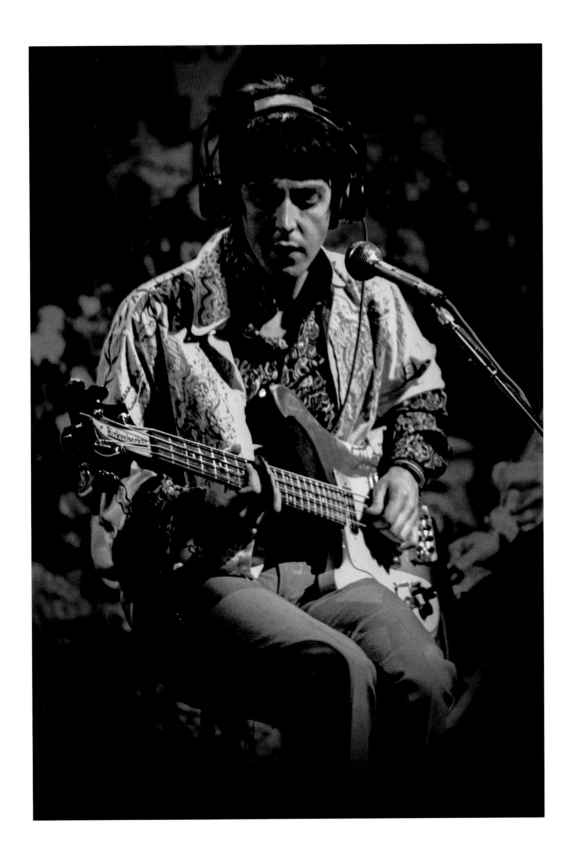

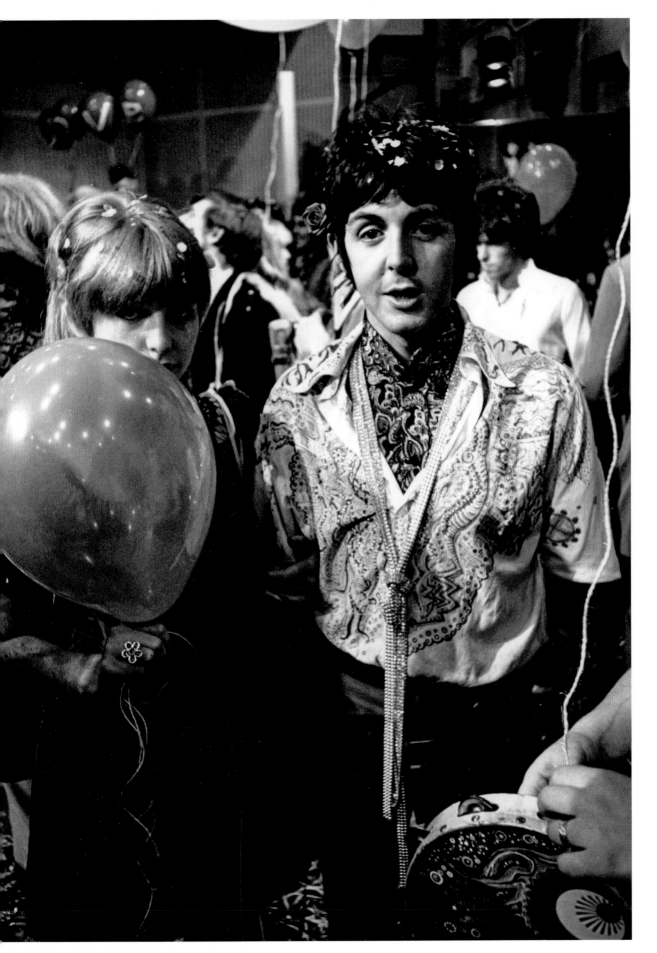

"*Throughout the afternoon and early evening the musicians and technicians rehearsed constantly. It must have been the most rehearsed spontaneous performance ever! The party guests arrived... they sat on the studio floor and waited as the clock ticked remorselessly towards 9:30 pm, the time set for the live transmission. Despite the relaxing effects of the 'whacky baccy' being smoked throughout the studio and the building, tempers became frayed and nerves raw. Then John threw everything out of kilter by claiming that he had lost his voice. Paul laughed at him and gently ribbed his song-writing partner. A glass of water and a few more barbed comments from McCartney put things right.*" Allistair Taylor

From the George Gunby book
"Hello Goodbye, The Story Of 'Mr. Fixit,"

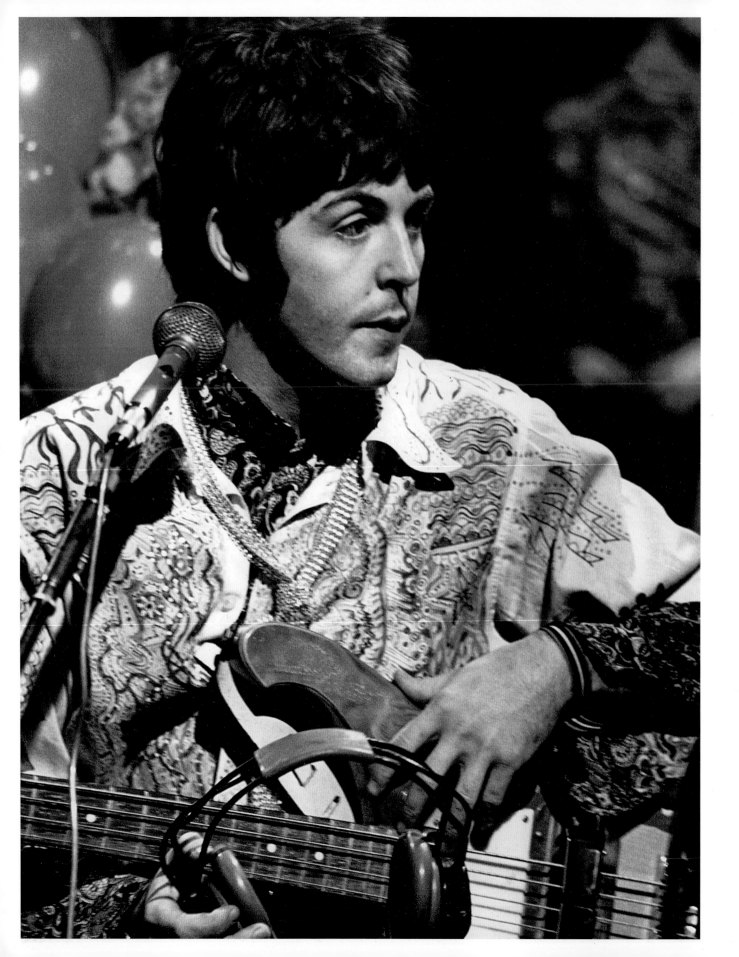

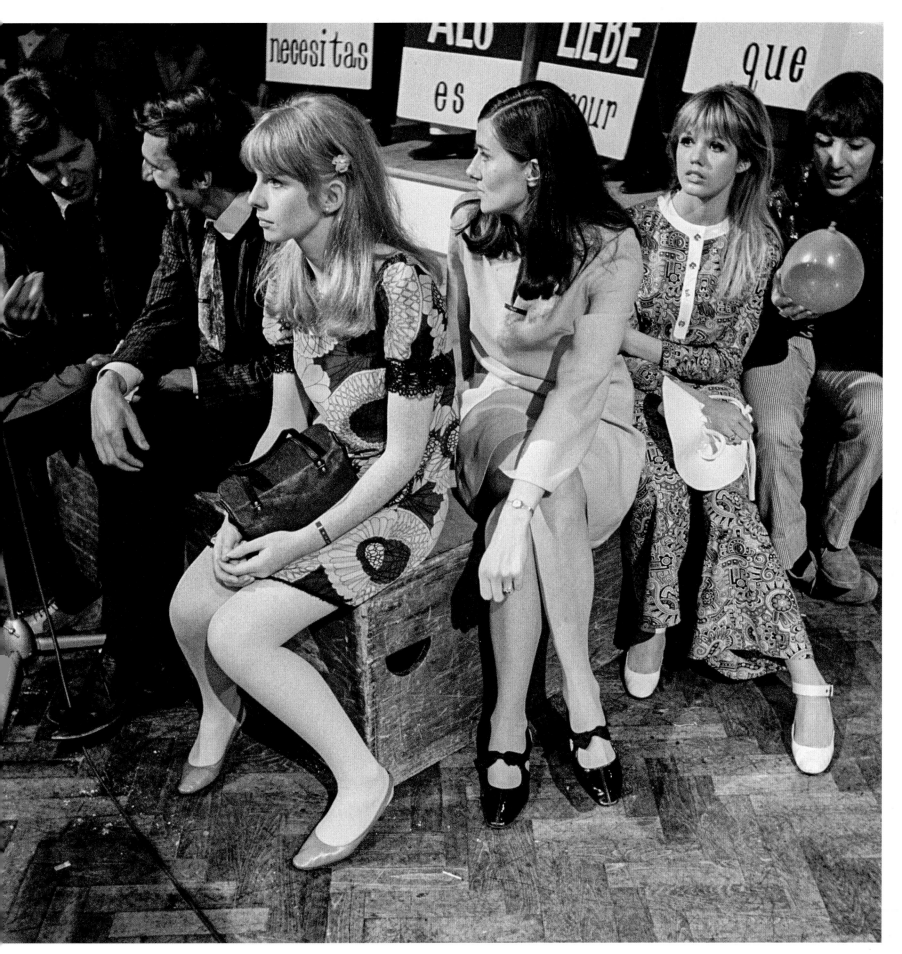

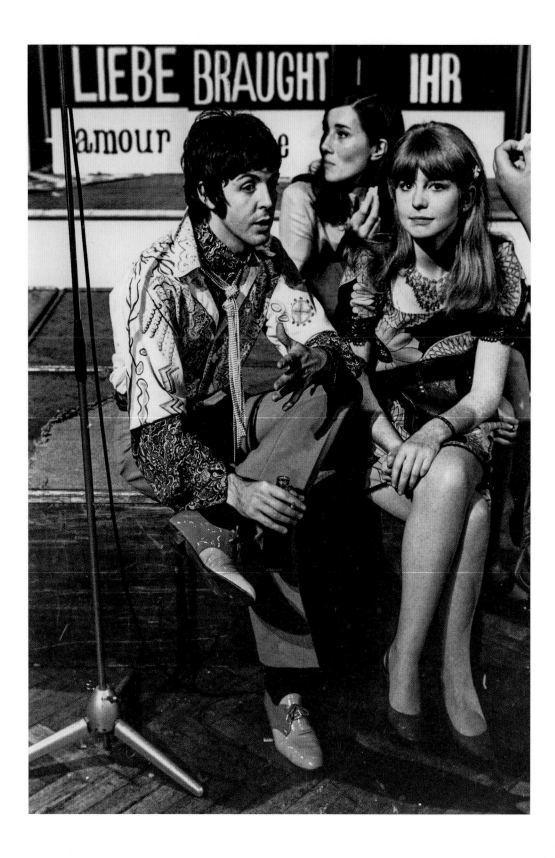

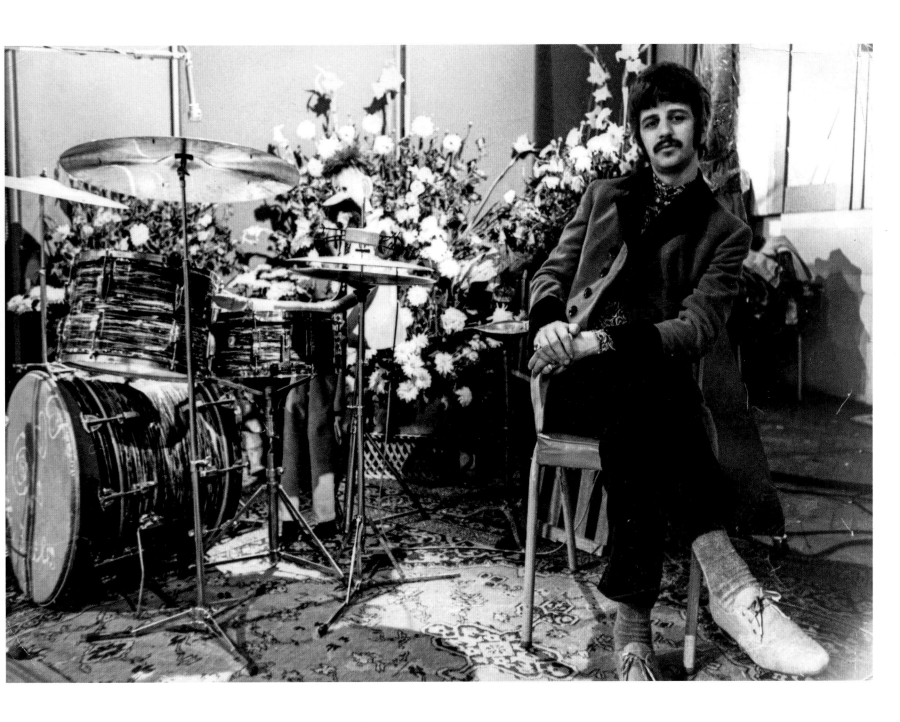

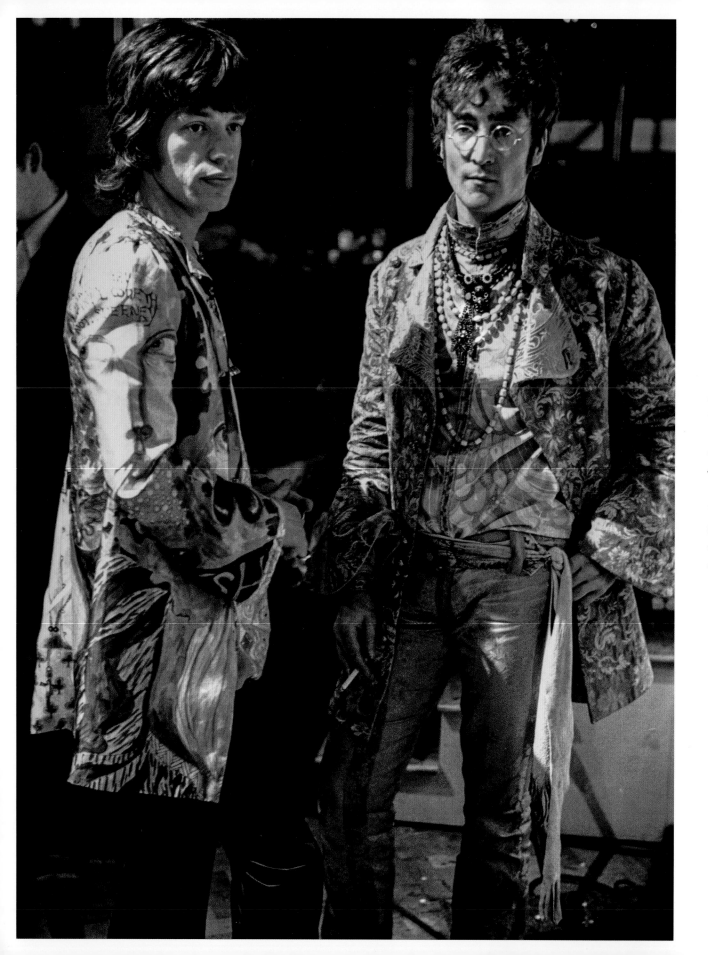

"We decided to get some people in who looked like the 'love generation', If you look closely at the floor, I know that Mick Jagger is there. But there's also an Eric Clapton, I believe, in full psychedelic regalia and permed hair, sitting right there." George Harrison

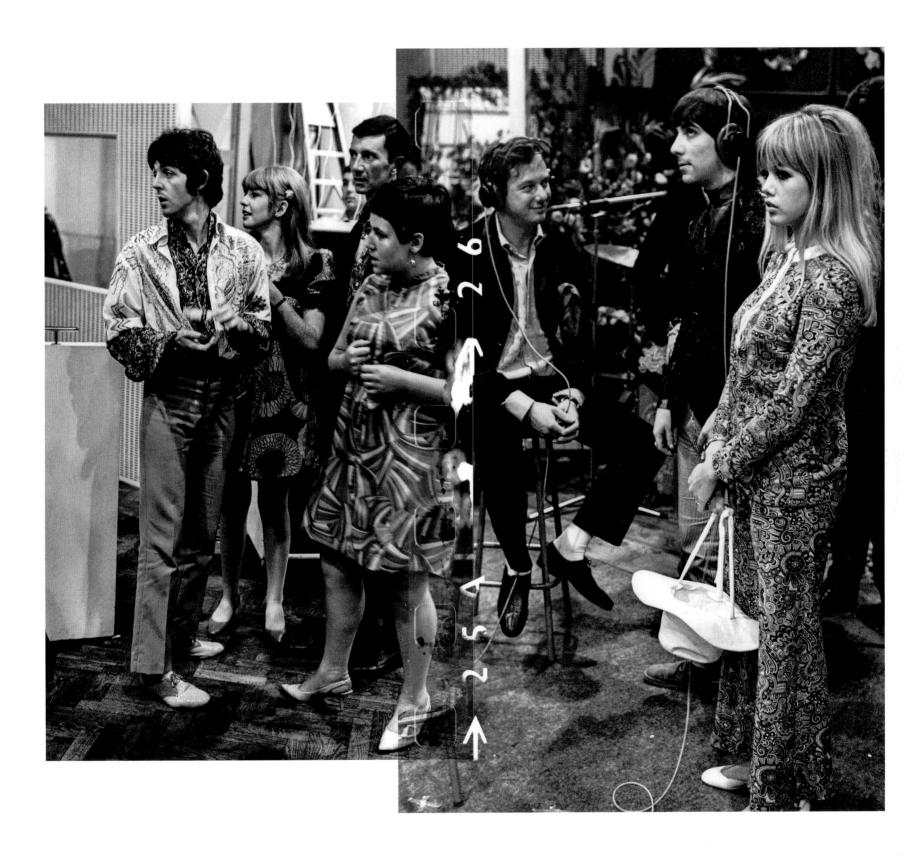

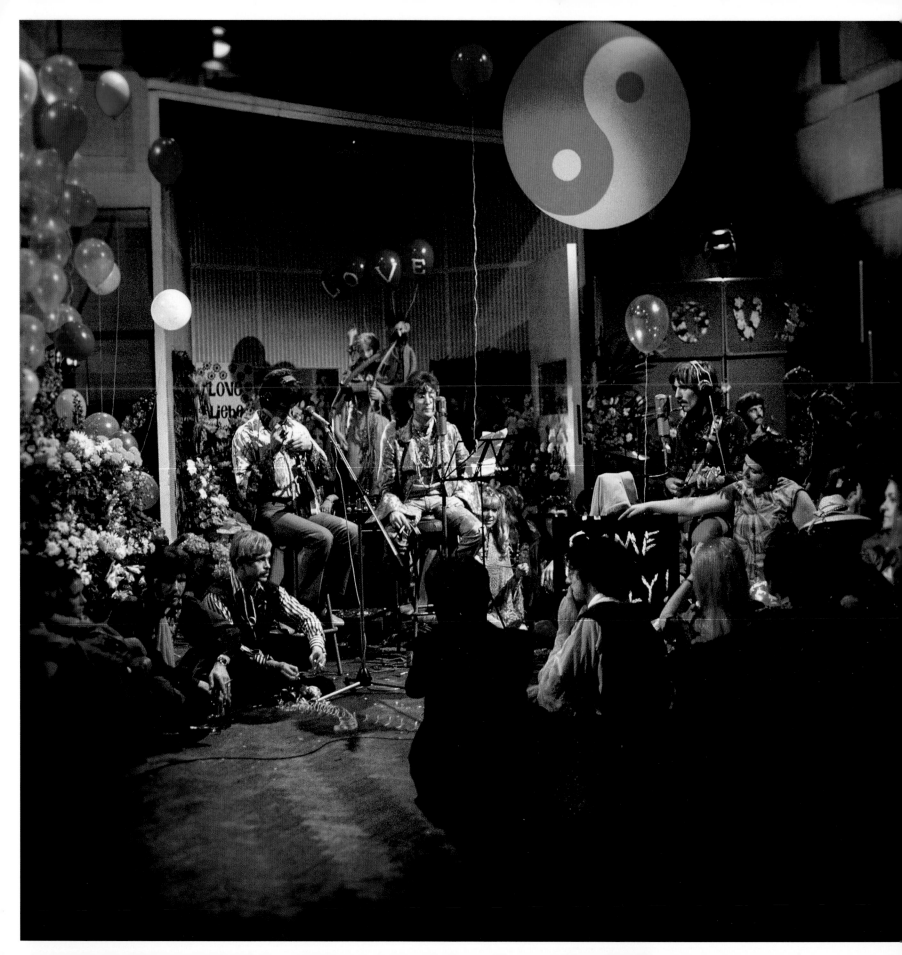

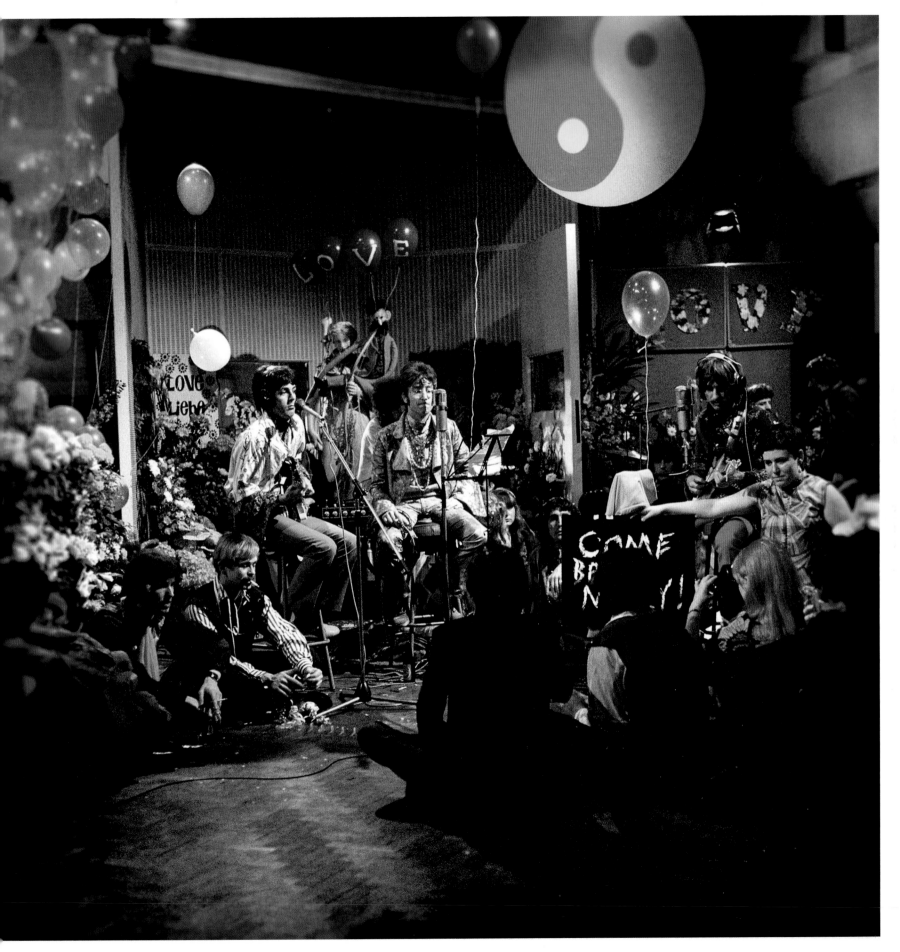

GATHERING OF HUMAN

BRING FOOD TO SHARE. BRING FLOWERS, BEADS, COSTUMES, FEATHERS, BELLS, CYMB

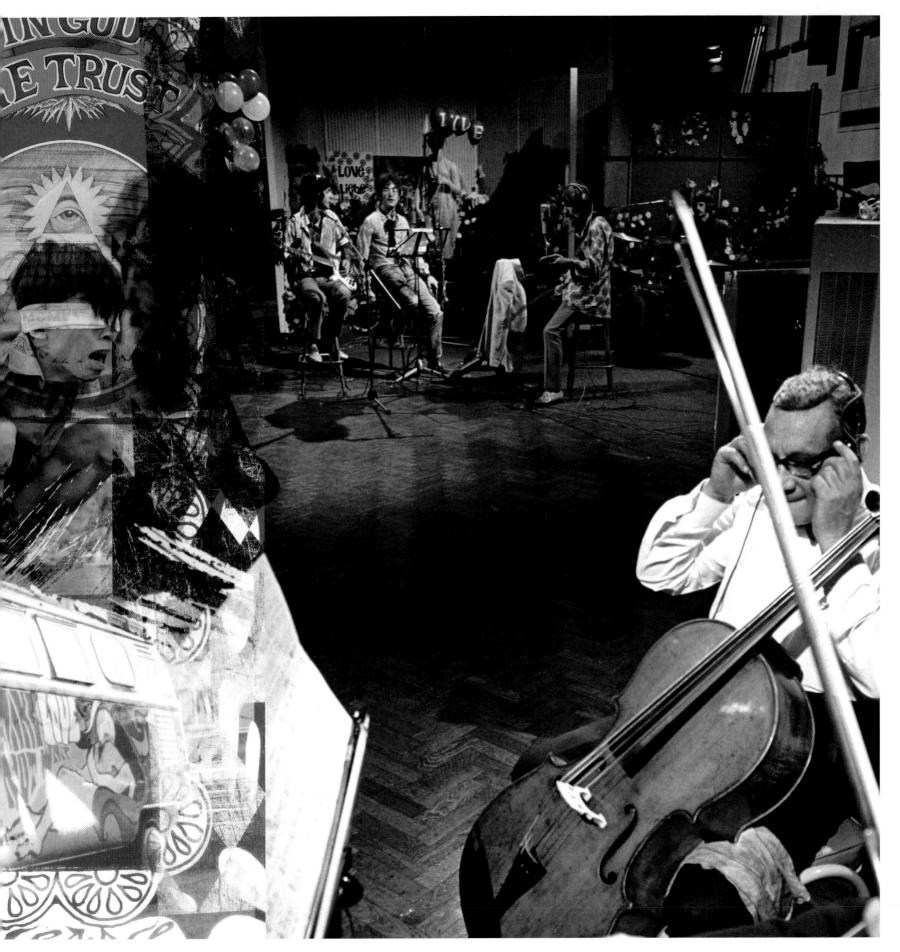

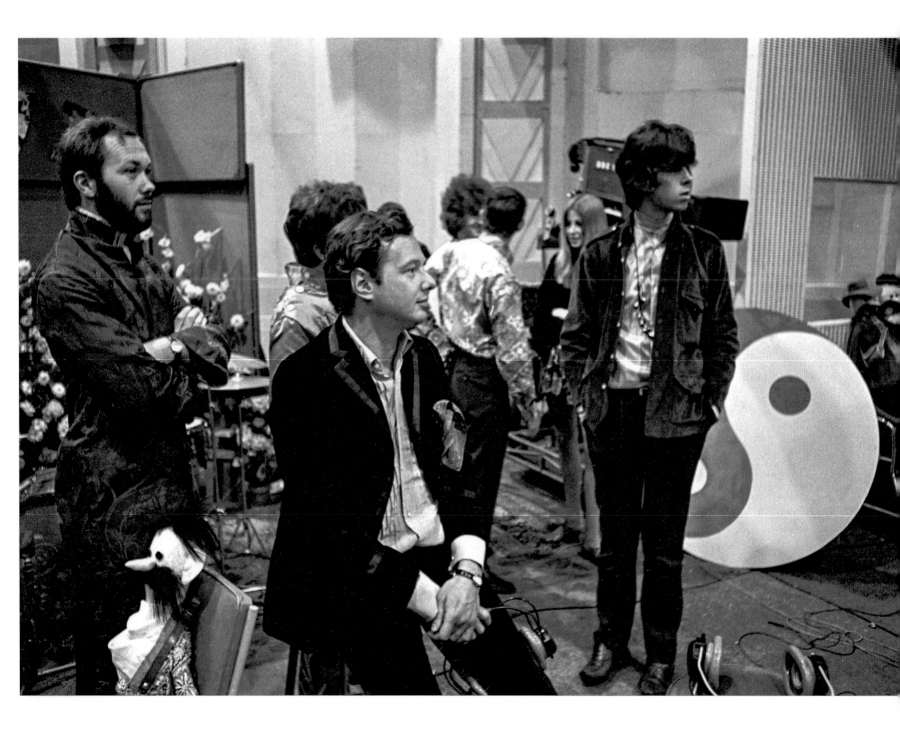

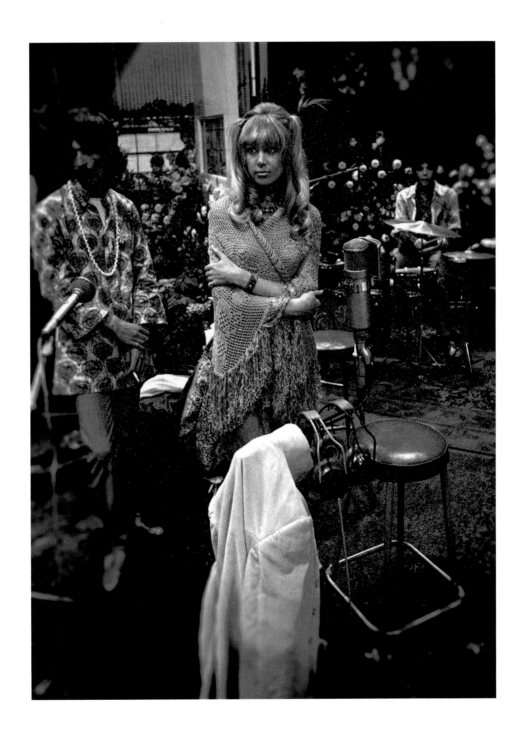

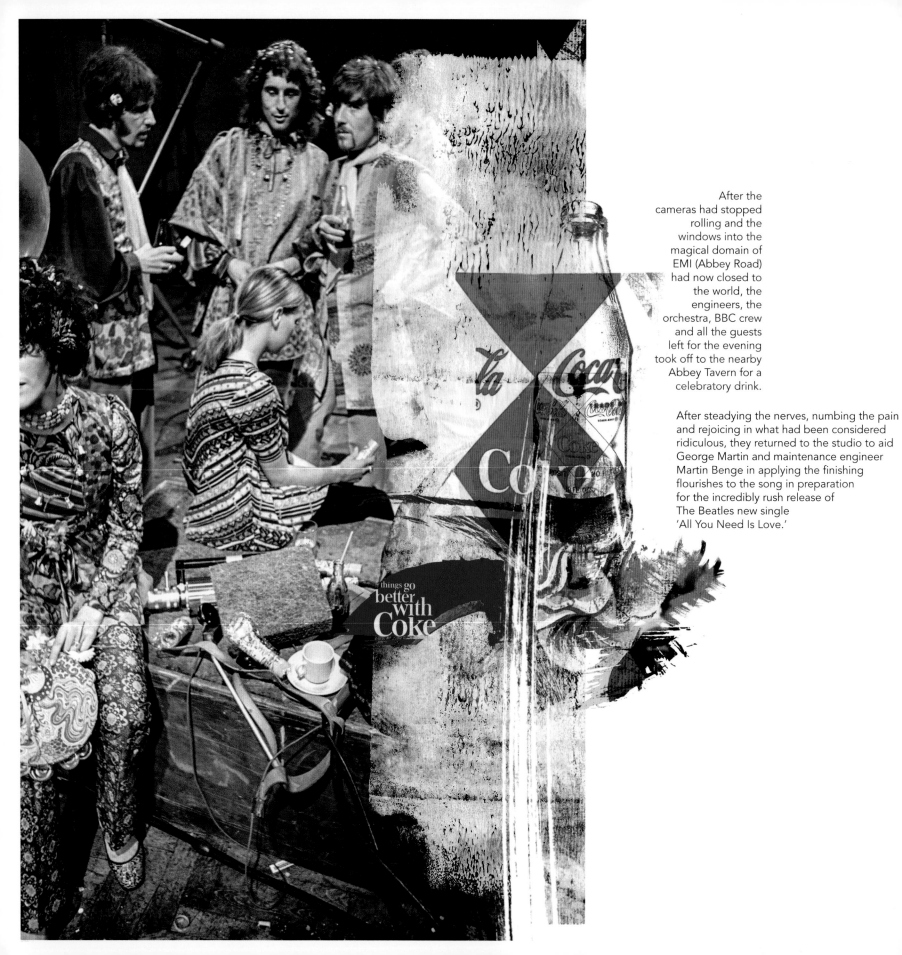

After the cameras had stopped rolling and the windows into the magical domain of EMI (Abbey Road) had now closed to the world, the engineers, the orchestra, BBC crew and all the guests left for the evening took off to the nearby Abbey Tavern for a celebratory drink.

After steadying the nerves, numbing the pain and rejoicing in what had been considered ridiculous, they returned to the studio to aid George Martin and maintenance engineer Martin Benge in applying the finishing flourishes to the song in preparation for the incredibly rush release of The Beatles new single 'All You Need Is Love.'

"Although John had added a new vocal, Ringo had added a drum roll and we had done a new mix, few people realized the single was any different to the TO version of the song." George Martin

June 26th, 1967, the engineering team of Martin, Emerick and Lush returned to the EMI control room of Studio Two.
The track was tweaked and prepared to produce a releasable mono mix. Mixing is an art form that is sometimes overlooked by the listener, before digital and automated desk programming it was a case of 'hands on' and human timing (and memory), mixing on analogue is a performance in its own right. Nine attempts were made at creating this crucial mix, but only five reached completion. The fourth mix was chosen as the mix that made the cut.
Ken Scott was given the task of transferring it to vinyl.

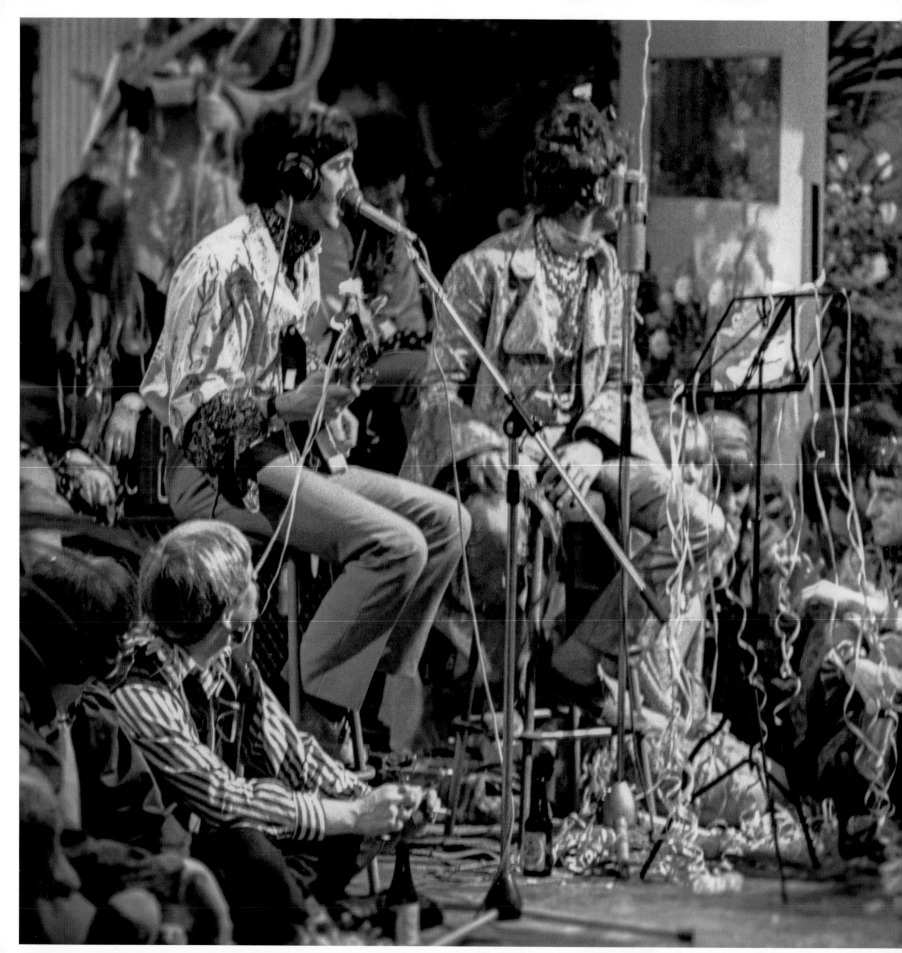

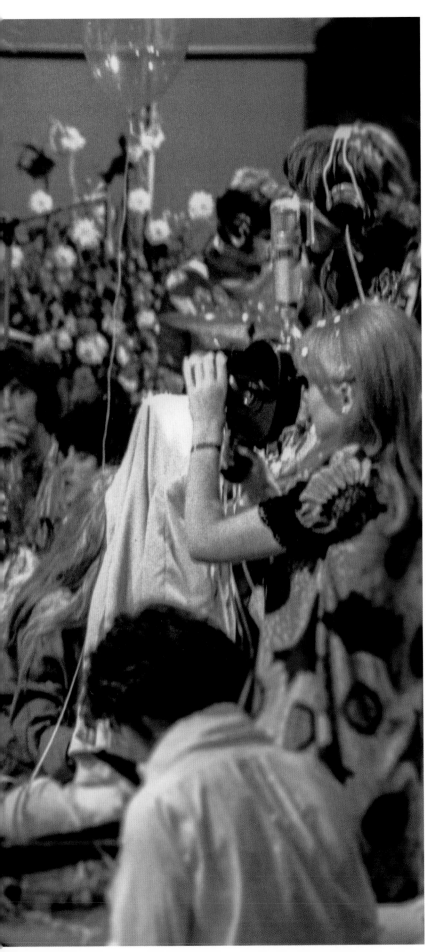

It's only my opinion, but I feel that song-writing for John was his way of trying to piece together who he really was, a way of analysing himself, his commitment to the beliefs he held, looking to see if they would stand up over time, a bit like a psychological profiler. By the time The Beatles had split he seemed as if he had reached conclusions. This may not have been the case but his opinions had solidified and had far more form.

John's opinions on the songs The Beatles wrote differed over time, which is why I feel he didn't just move forward, he always reflected and reassessed the content of a piece of work as he evolved. All You Need Is Love is believed to be a continuation of the idea he was trying to express in his 1965 song "The Word." John was fascinated by how slogans effect the masses and was trying to capture the same essence as songs like "We Shall Overcome." He once stated,

"I like slogans. I like advertising. I love the telly." In a 1971 interview about his song "Power To The People," he was asked if that song was propaganda. He said, "Sure. So was 'All You Need Is Love.' I'm a revolutionary artist. My art is dedicated to change."

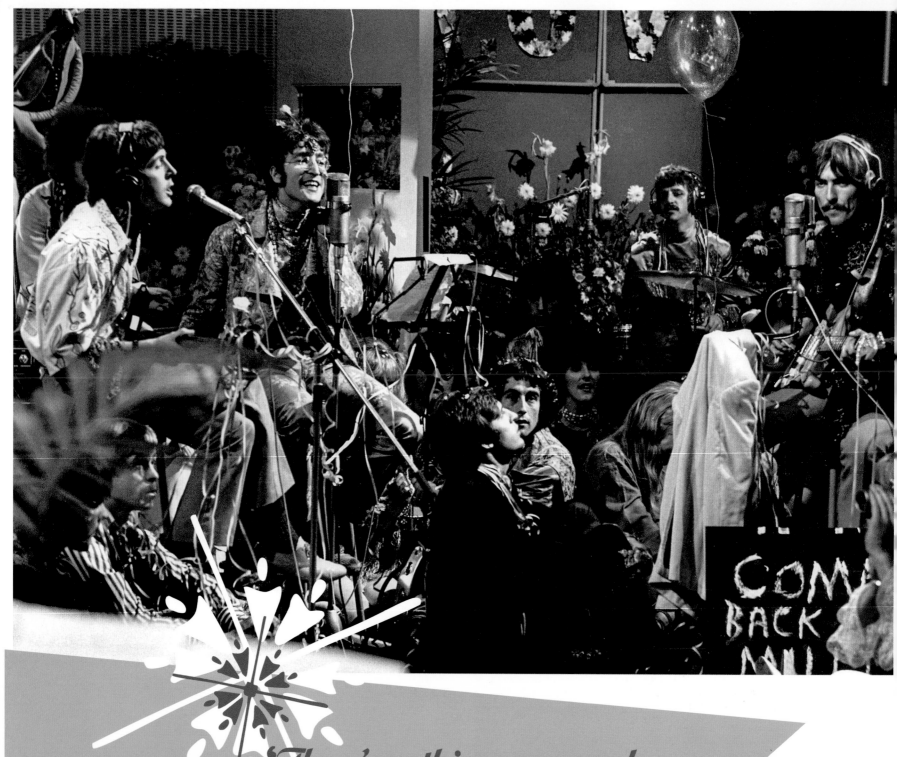

'There's nothing you can know
that isn't known
Nothing you can see that isn't shown,
Nowhere you can go
that isn't where you're meant to be.'

"ALL YOU NEED IS LOVE"

Written by: John Lennon / Paul McCartney

Song Written: June, 1967
Song Recorded: June 14, 19, 23, 24, 25
Release Date: July 17, 1967
Length: 3:57 (mono) 3:48 (stereo)
Key: G major
Producer: George Martin
Engineers: Geoff Emerick, Eddie Kramer, Richard Lush, George Chkiantz, Martin Benge
Studios: EMI Studios, Abbey Road, London, UK, Olympic Sound Studios, Church Road, Barnes, London, UK

John Lennon
Lead and Backing Vocals, Harpsichord, Banjo, Tambourine
Paul McCartney
Bass (1964 Rickenbacker 4001 S), Double-bass, backing vocals
George Harrison
Violin, backing vocals
Guitar (psychedelic 1961 Fender Stratocaster)
Ringo Starr
Drums
(1964 Ludwig Super Classic Black Oyster Pearl)
Brian Epstein
Manager
George Martin
Score / Piano (Hamburg Steinway Baby Grand)
Mike Vickers / Conductor
Sidney Sax / Voilin
Patrick Halling / Violin
Eric Bowie / Violin
Jack Holmes / Violin
Rex Morris / Tenor Saxophone
Don Honeywill / Tenor Saxophone
Evan Watkins / Trombone
Harry Spain / Trombone
Jack Emblow / Accordion
Stanley Woods / Trumpet, Flugelhorn
David Mason / Piccolo Trumpet
Keith Moon / Percussion
Assorted Guests / Handclaps

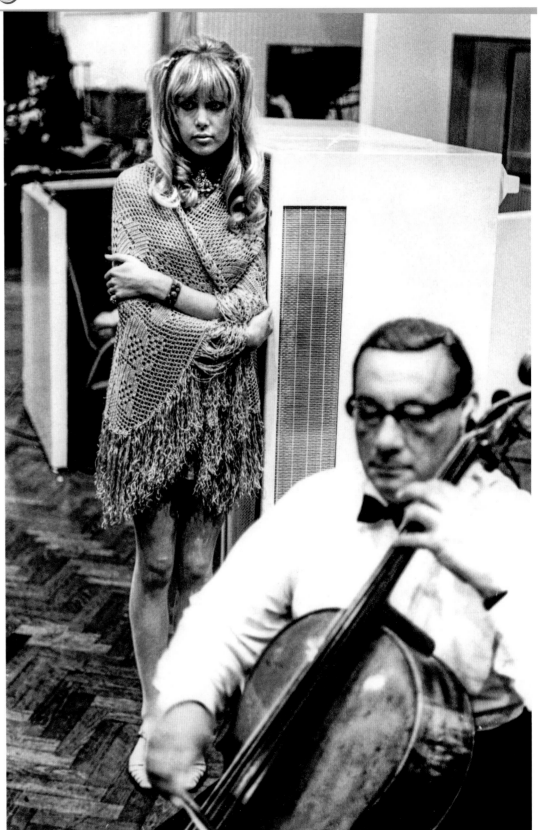

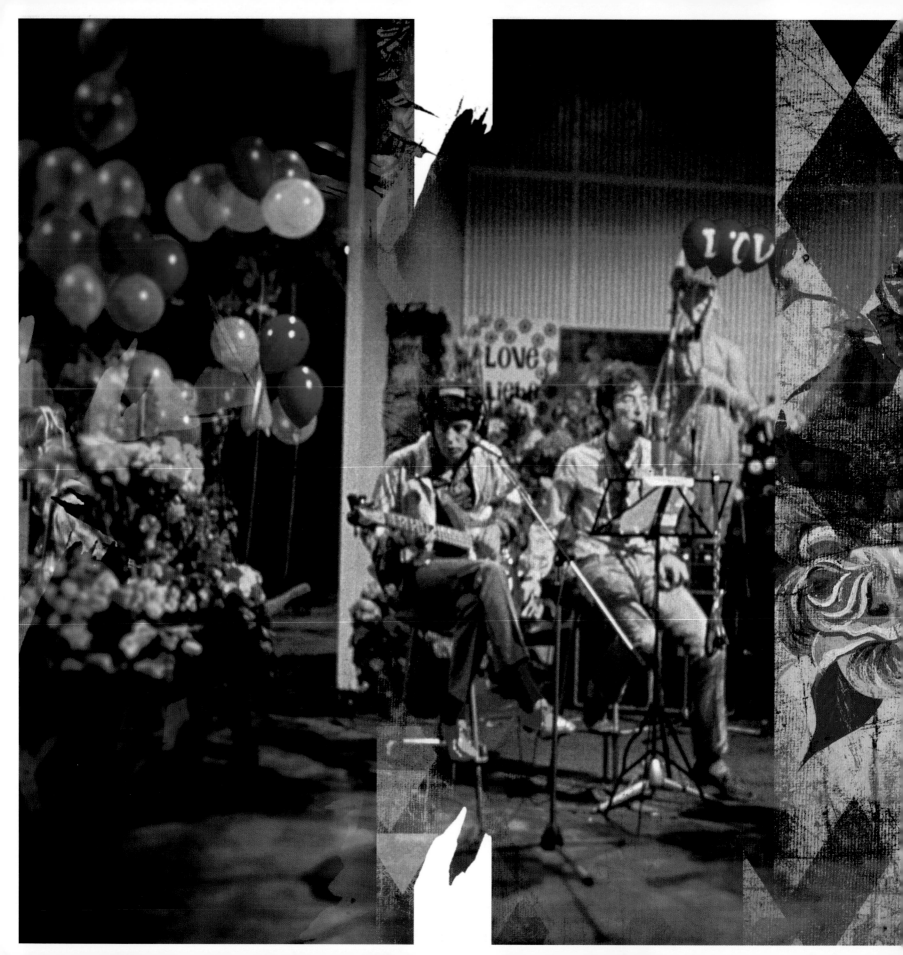

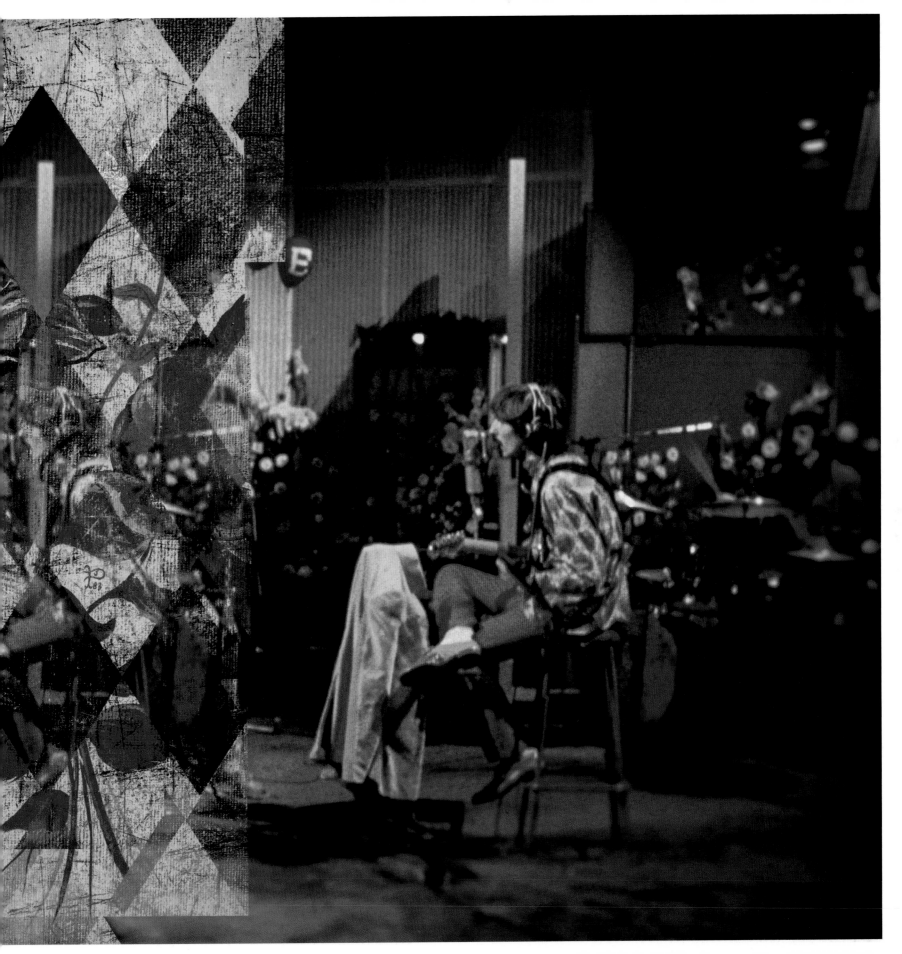

THE BEATLES

All You Need Is Love

Baby, You're A Rich Man

R 5620

The BEATLES
All You Need Is Love
Baby, You're a Rich Man

5964

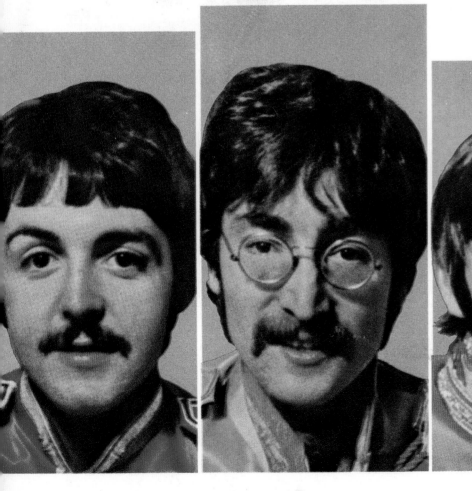
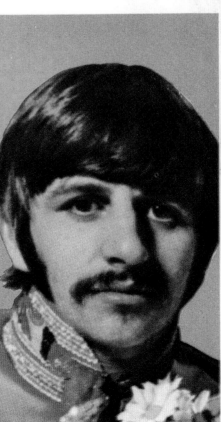

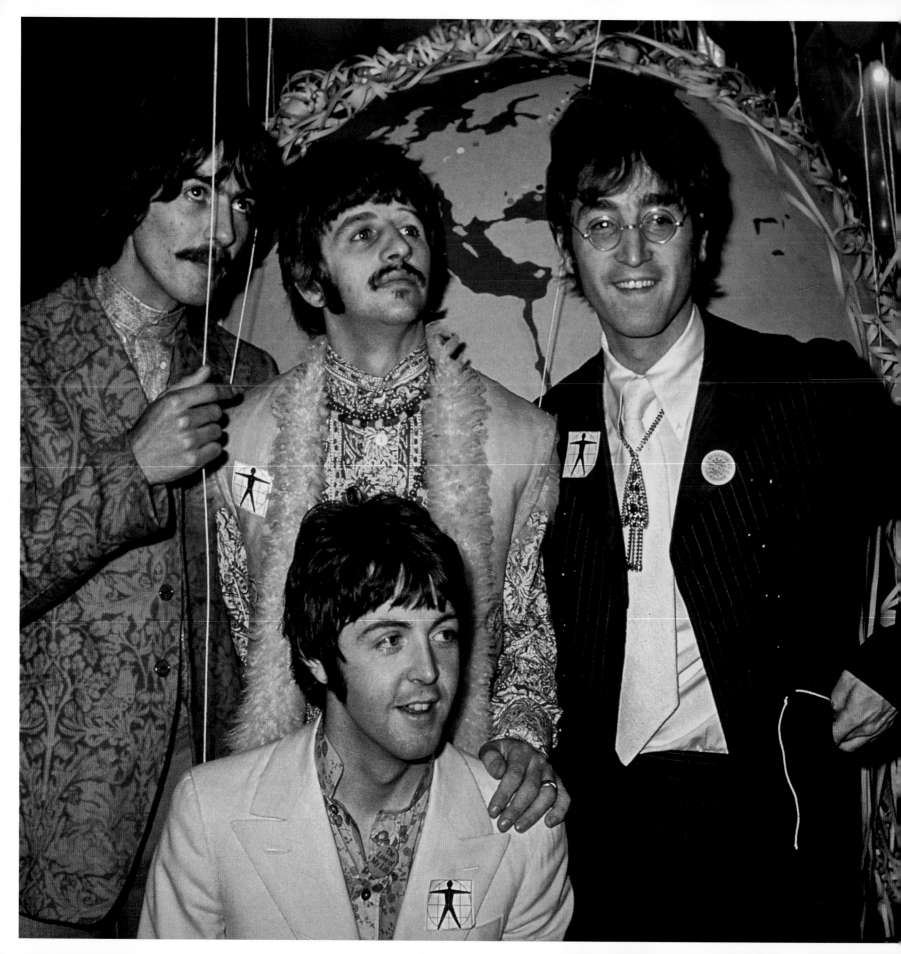

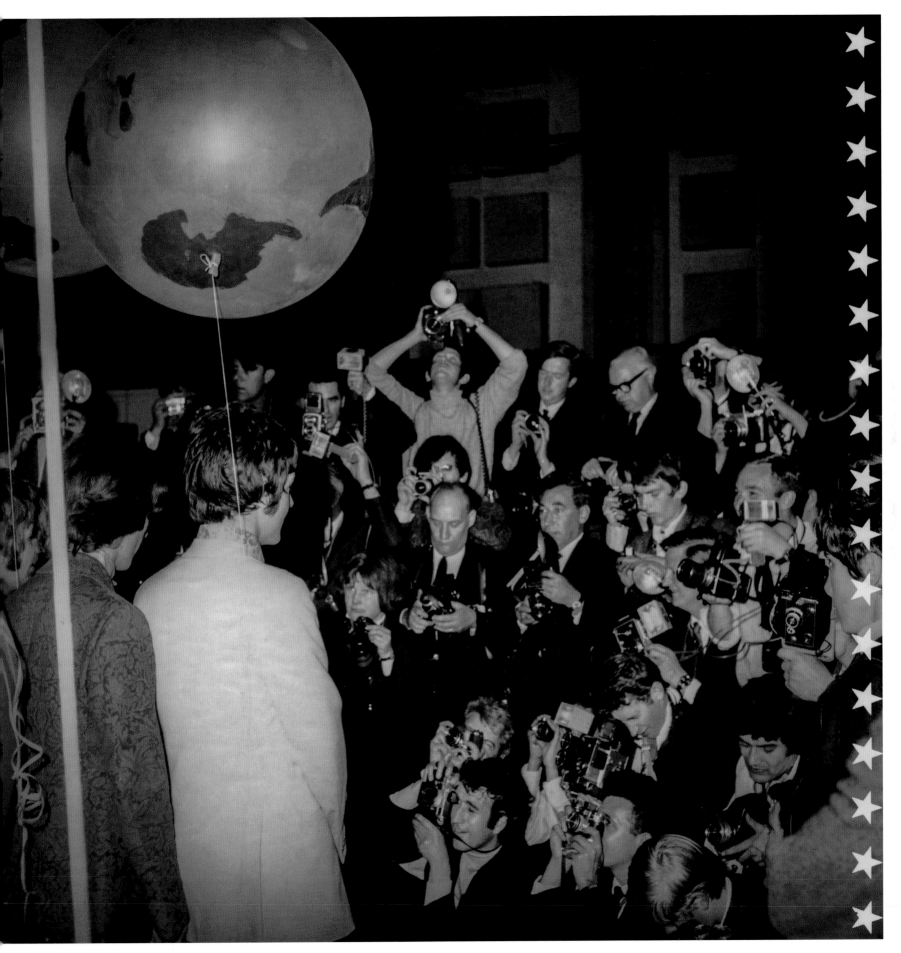

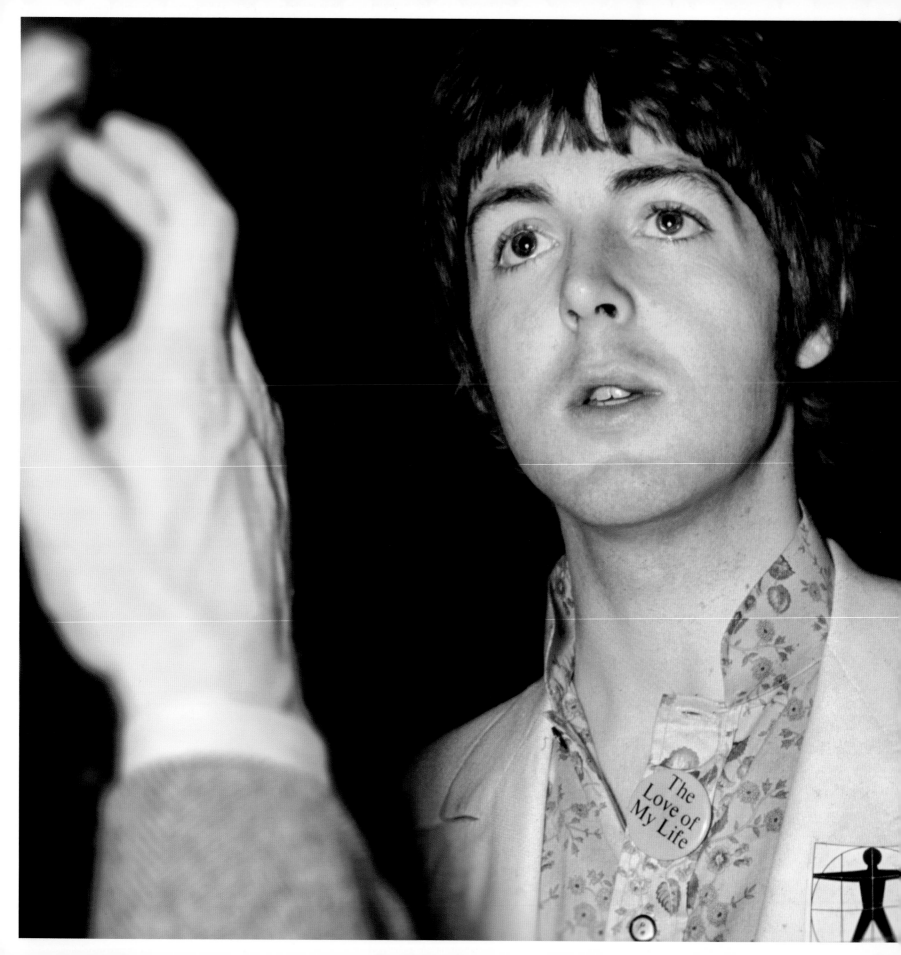

Scream if you can hear us?
by Simon Weitzman

Of course no band is bigger than its fans. Beatles fans are the most dedicated and well educated of them all. To be honest they probably know more about The Beatles than the four boys ever knew about themselves! It's the fans, as much as the music, that has kept such a legacy alive over five decades and counting.

All You Need Is Love brought the band to the world, once and for all, quite literally. 400 million people bought into the magic and genius of the boys. They were the UK's offering, but over the minutes they performed they finally belonged to the world.

'I saw the All You Need Is Love performance "live", along with 400 million other people! I was 6 years old at the time in 1967 and I think the following day was the last school day of the year. I remember the entire 50 foot-long school bus' kids singing the song's bridge repeatedly, like a mantra, on that next day.
I remember that much more than anything; right down to exactly where I was sitting in that school bus while I was singing it. It also signified the beginning of the Summer Of Love, The World's Fair in my hometown, Montreal's Expo '67. The most incredible summer I've ever seen, so far, to this day.

That song was being played constantly at Expo '67's amusement theme park named "La Ronde", as well as 5 other new Beatles songs on an endless tape, day in day out.
I think that as a social impact, there hasn't been any other song who has ever reached such incredible heights as "All You Need Is Love" did upon its release. I mean think about it;
For the Summer Of Love to be called that, all you need is love, after all.'
Eric Bourgouin - Beatle archivist, fan and collector

All You Need Is Love was written for the One World Broadcast as a song that could be understood by just about everyone around the world. To this degree The Beatles absolutely nailed the brief delivered to them by the BBC. Their key enduring legacy has been their supreme skill in writing lyrics and tunes that have been digested so easily by a global audience.

Even if you didn't understand English you loved the music and if you understood just a few words the lyrics still meant something. Boys wanted to be them and girls wanted to be with them. The bottom line was that everyone loved The Beatles. The Beatles had become hard wired into so many people's DNA that even the few who didn't like their music began to doubt themselves.

'Having been a Beatles fan since 1965, and from then on following the group's steps, I still remember when I first heard All You Need is Love, with that unexpected introduction using the French anthem, followed by the vocals 'love, love, love.' It felt like angels singing with John's uniquely beautiful voice taking the lead. It really blew me away. It is indeed a timeless song and I still love it.' Julio Serra - Beatles Fan

As the band ascended through their studio evolution their lyrics and musical arrangements became more sophisticated. However, the beauty of The Beatles remained their ability to make an instant impact on their audience. Indeed, many fans began to learn English simply so they could better understand Beatles lyrics.
Fifty plus years on you can stand in The Cavern with a room full of people from all four corners around the globe, many of whom speak only a few words of English and they will be word perfect on every single Beatles lyric. It's almost as if their lyrics have become an international language in their own right.

*"All you need is love.
Love is all you need."*
John Lennon

What the All You Need Is Love broadcast did so succinctly was give people around the world a common point of communication. You could go anywhere and meet people who didn't understand a word you said, but if you sang a Beatles song, or a Beatles song came on the radio or sound system, then you both started singing it and you were connected.

What is so wonderful is that 50 years on the connection is as strong as ever. Beatles is its own language and it's a language of friendship and love the world over. It doesn't start wars and it doesn't drive people apart. It brings people together and to that degree the language of Beatles is one of the most perfect languages ever created.

The great thing about this is that the language was created by four guys, not because it was in any way contrived, but because it was absolutely natural. Their life experiences were wide, but perhaps nowhere near as vast and diverse as ours are today in the 21st century. In that sense their appreciation of the word and the tune was a God given gift. They tuned into the world and ignited the imagination of numerous generations. Something that we will almost certainly never see again.

As a result you can listen to or sing a Beatles song with someone you have never met before, who also loves The Beatles and you'll have an immediate affinity with them. You may not have anything else in common and you may never see them again, but for that moment you will be connected. That's unique.
I mean, that really is unique.

"There is nothing more truly artistic than to love people."
Vincent Van Gogh

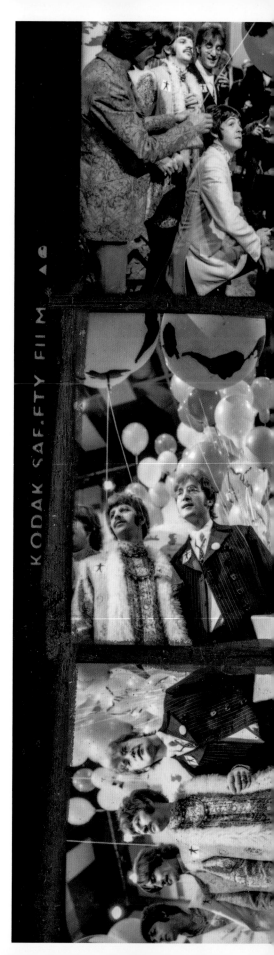

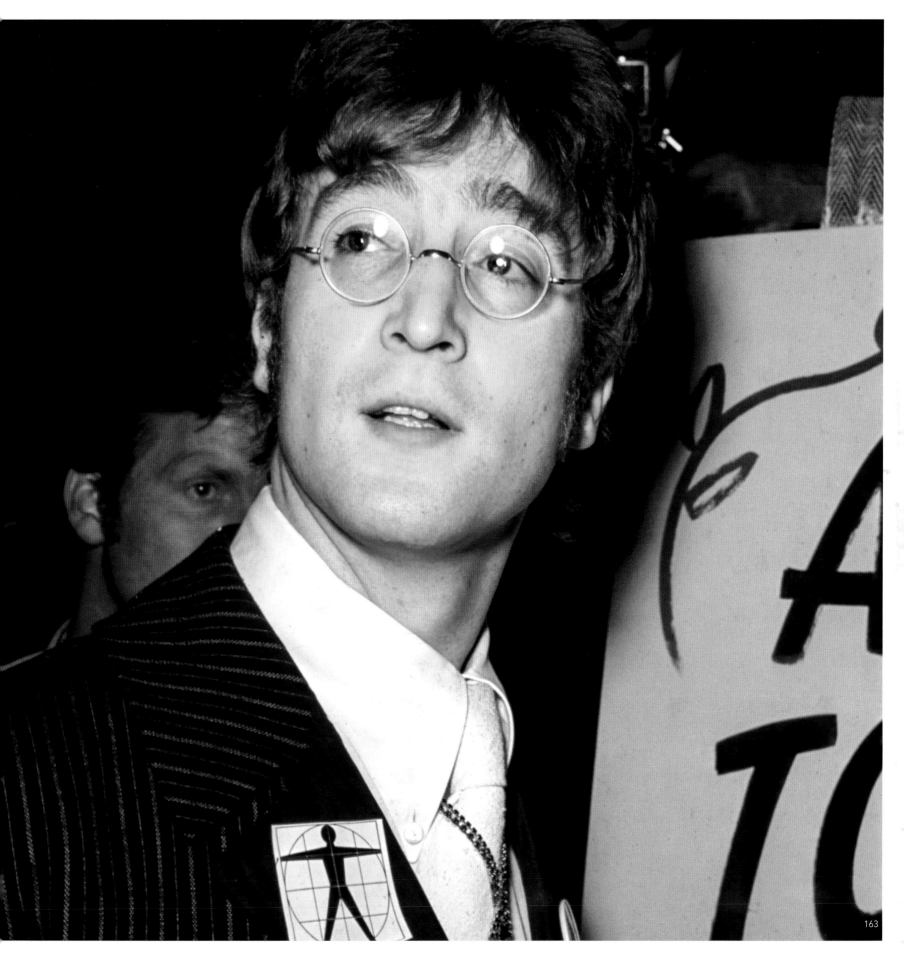

the BEATLES

ALL YOU NEED IS LOVE
BABY YOU'RE A RICH MAN

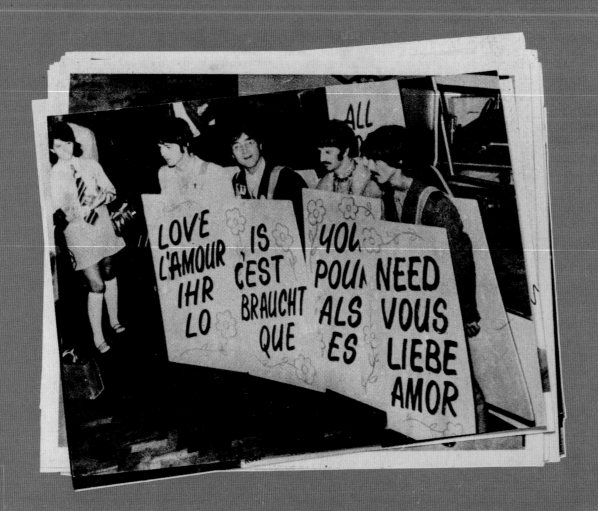

stereo

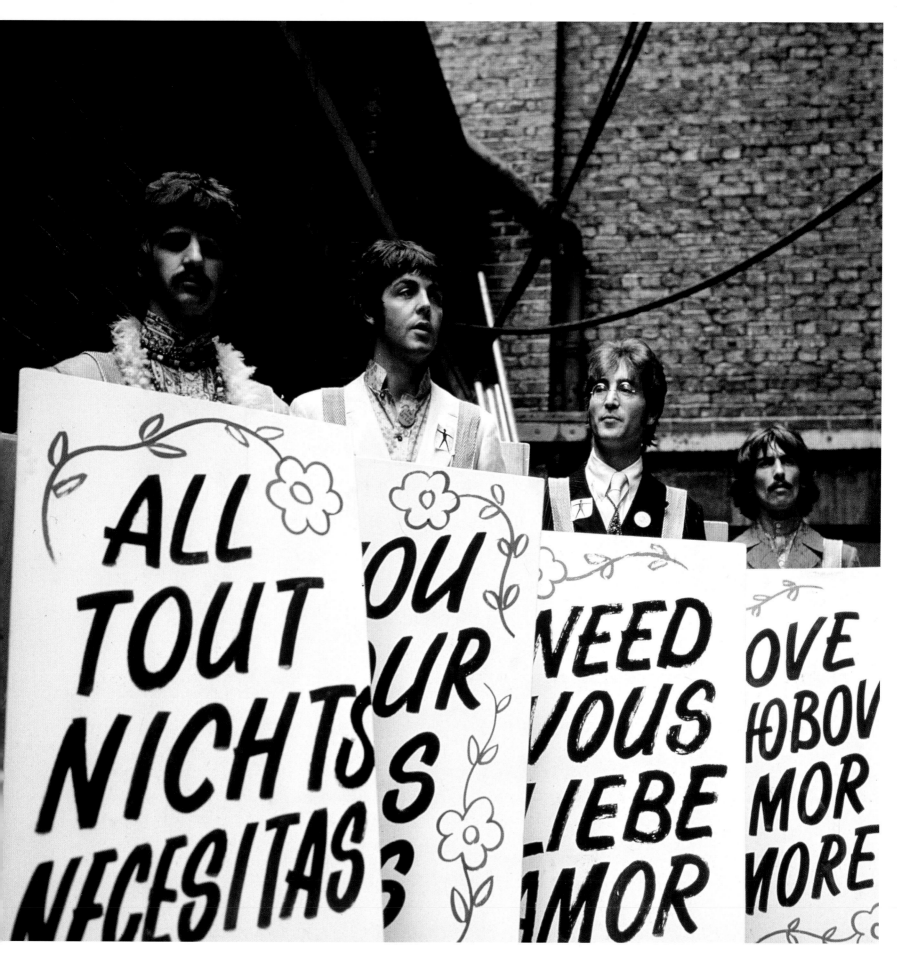

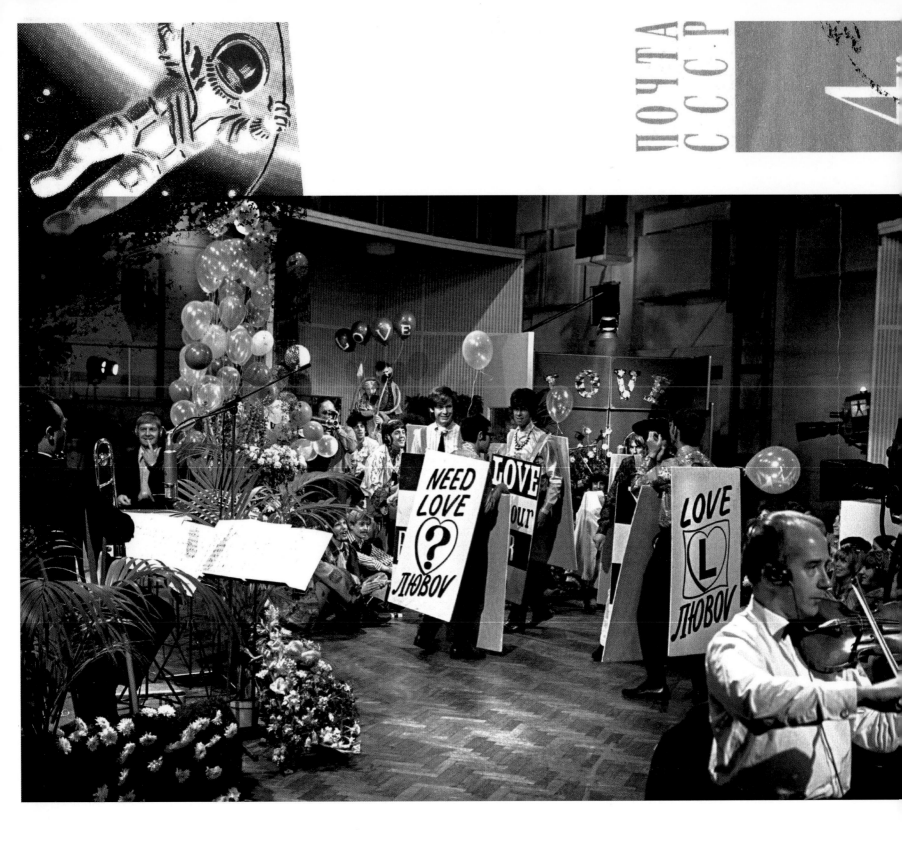

Is it all we need?
by *Paul Skellett*

"*Well, I'm really glad that most of the songs dealt with love, peace, understanding... You know, it really did. If you look back there's hardly any of 'em that says, 'Go on, Kes, tell 'em all to sod off, leave your parents.' It's all very, 'All You Need Is Love,' John's 'Give Peace A Chance.' There's a very good spirit behind it all.*"

Paul McCartney

George described the song as

"*A kind of subtle bit of PR for God, basically.*"

Was "All You Need Is Love" a band-aid for a generation, a global population witnessing the slaughter of innocence by corrupt governments as a form of passive entertainment. Was it a calming voice, a melody to sooth the unrest sweeping the streets?

"I believe that The Beatles were rebellious enough to be 'free thinking', honest enough to bare their souls and confident enough to let nature take its course. They were children that believed in the magic you can not see. What I have always taken from The Beatles is that anyone can achieve anything as long as they believe they can, and if you do it with humour and respect for those who want to shake your hand, maintain love for your family, your friends and even those you don't know, then maybe, just maybe, all you need is love." Paul Skellett

"I still believe 'All You Need Is Love,' you know,"
John related many years later,
"but I don't believe that just saying it is gonna do it. You know, I mean, I still believe in the fact that love is what we all need."

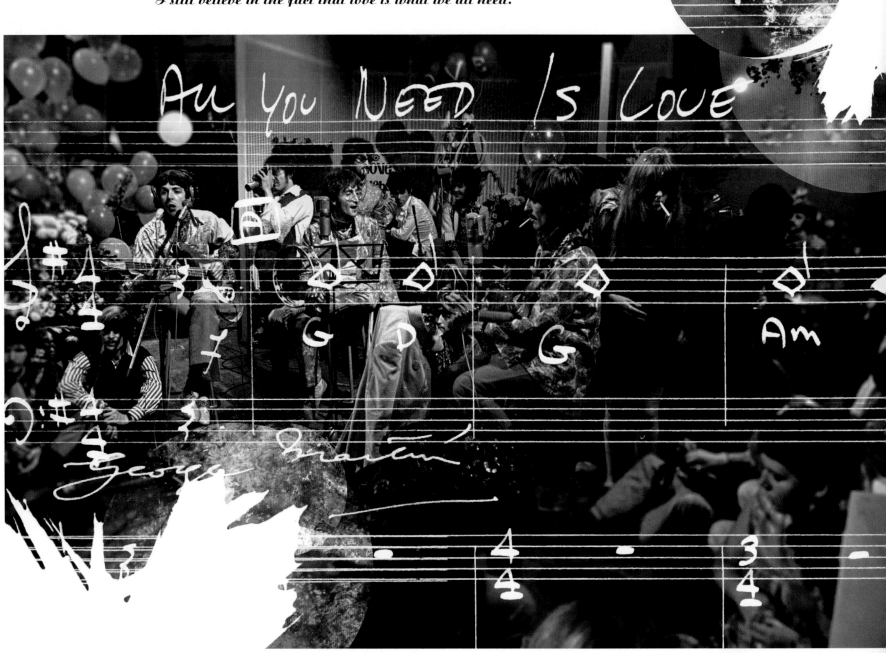

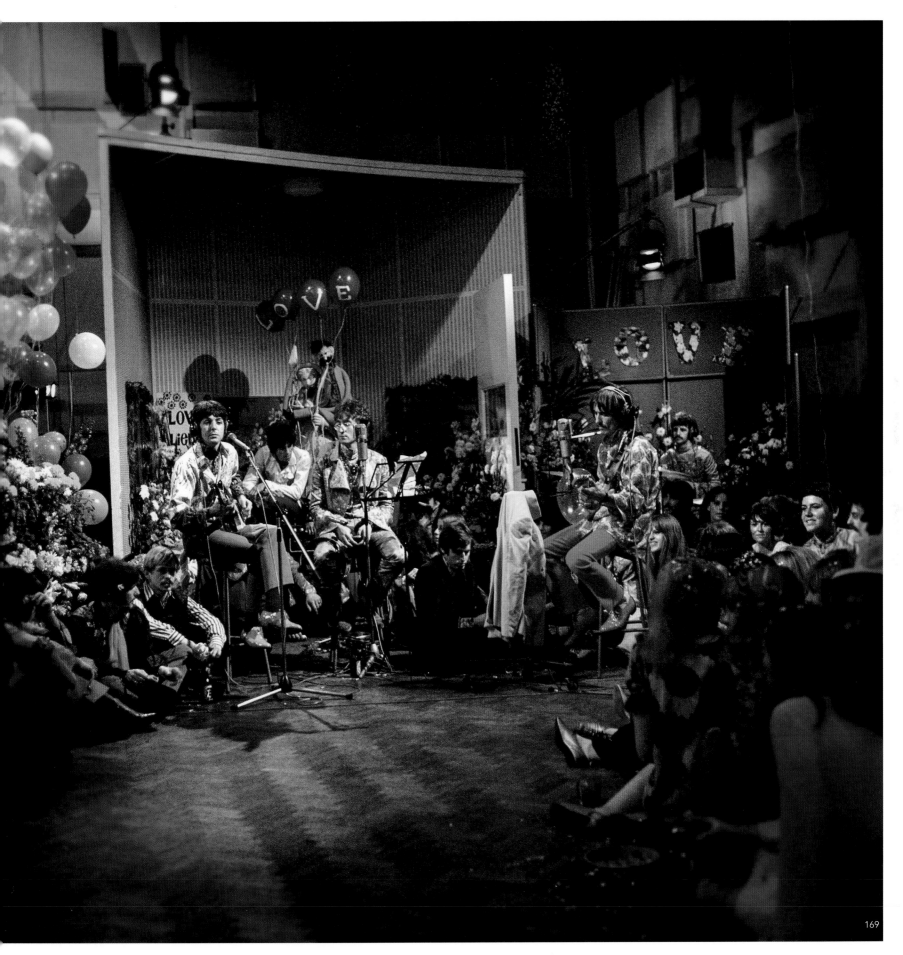

BE
THE SING

LES
ECTION 1962/1970

EMI

THE BEATLES
ALL YOU NEED
IS LOVE

Design concept, digital restoration and remastering, image curation, book design, art/illustration, editorial and research by Paul Skellett (For art by Paul; www.skellett.com)

Editorial, research and project wrangling by Simon Weitzman

Every effort has been taken in this publication to correctly source and use imagery. The authors have used their best endeavours to create the editorial. We apologise in advance for any overlooked corrections in this volume. Any editorial viewpoints, unless quoted, are those of the authors. This publication uses English spelling

The publisher (and this book) has no relationship with Apple Corps Ltd or The Beatles. There is no attempt in the book to pass itself off as an officially recognised or authorised publication

It does however, through some wonderful archives, many of which come directly from fans, pay homage to a particularly magnificent band, appreciated and loved by fans the world over.

Archive credits
Rex Features at Shutterstock
Pete Nash
Jim Berkenstadt
Robert Kern
Mark Hayward
Wikimedia Commons

Please also take a look at our website www.archivumuk.com to see more about our publications. We also love to hear from Beatles fans about new ideas and projects, so please feel free to contact us at info@archivumuk.com

ISBN number: 978-1-911374-14-5
Original Edition by Archivum Publications.

For more information about Archivum Publications: www.archivumuk.com

For more information about Studio Skellett: www.skellett.com

We got by with a little help from our friends!

A big thank you to my amazingly beautiful and understanding wife Vicki, to my beautiful daughter Darcie, and to all my amazing and supportive family!! A big thank you also to Simon, the greatest of friends and business partner. All we need is love! Paul Skellett xxx

A big thank you from Paul Skellett and Simon Weitzman to all our colleagues and contributors.

Love from all of us to John, Paul, George and Ringo.
Four boys from Liverpool who changed the world!

All you need is love • Baby you're a rich man

EMI OCEAN

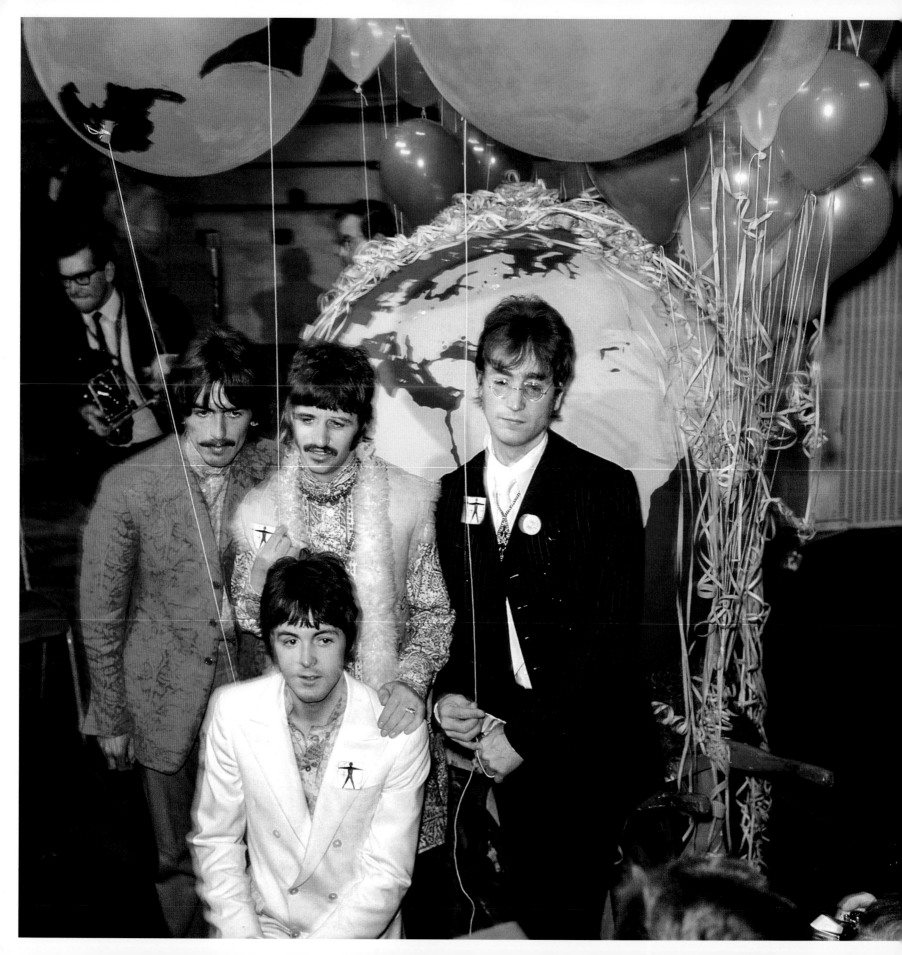

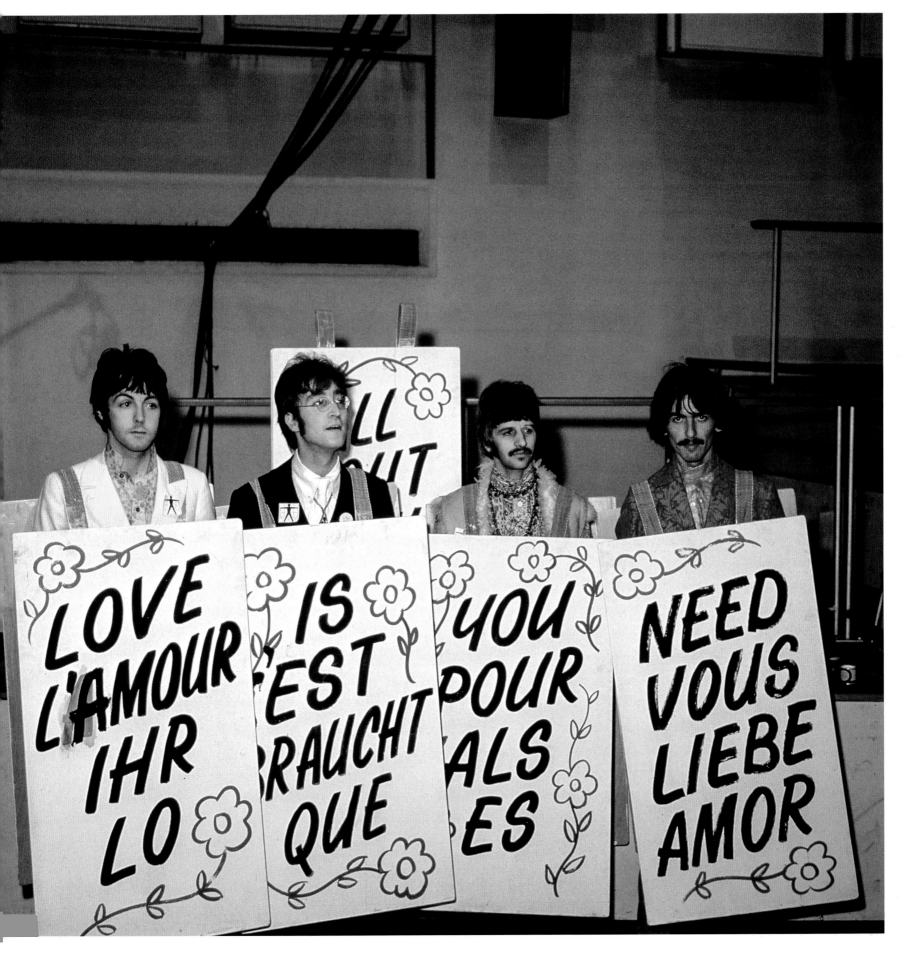